Vermeer

FAITH IN PAINTING

✛

Vermeer

FAITH IN PAINTING

✣

Daniel Arasse

Translated by Terry Grabar

PRINCETON UNIVERSITY PRESS

PRINCETON, NEW JERSEY

Copyright © 1994 by Princeton University Press
Published by Princeton University Press, 41 William Street,
Princeton, New Jersey 08540
In the United Kingdom: Princeton University Press, Chichester, West Sussex

Library of Congress Cataloging-in-Publication Data

Arasse, Daniel.
[Ambition de Vermeer. English]
Vermeer, faith in painting / by Daniel Arasse ; translated by
Terry Grabar.
p. cm.
Includes bibliographical references and index.
ISBN 0-691-03362-5
ISBN 0-691-02930-X (pbk.)
1. Vermeer, Johannes, 1632–1675—Criticism and interpretation.
2. Spirituality in art. I. Vermeer, Johannes, 1632–1675.
II. Title.
ND653.V5A9313 1993
759.9492—dc20 93-33549
CIP

Original French edition, published under the title *L'Ambition de Vermeer,* copyright © 1993 by Société nouvelle Adam Biro

Epigraph is taken from Edwin Curley, ed. and trans., *The Collected Works of Spinoza,* vol. 1 (Princeton, 1985), 26–27

This book has been composed in Linotron Galliard

Princeton University Press books are printed on acid-free paper
and meet the guidelines for permanence and durability of the
Committee on Production Guidelines for Book Longevity of the
Council on Library Resources

Printed in the United States of America

Second printing, for the Princeton Paperback edition, 1996

10 9 8 7 6 5 4 3

FOR LOUIS

✣

The less the mind understands and
the more things it perceives, the
greater its power of feigning is;
and the more things it understands,
the more that power is diminished.

Spinoza, *The Emendation of the Intellect*

❖ *Contents* ❖

CONTENTS

❖ List of Illustrations ❖

BLACK AND WHITE FIGURES

FIG. 1. J. Vermeer, *Christ in the House of Martha and Mary*, Edinburgh, National Gallery of Scotland

FIG. 2. J. Vermeer, *Diana and Her Companions*, The Hague, Mauritshuis

FIG. 3. J. Vermeer, *The Procuress*, Dresden, Staatliche Kunstsammlungen, Gemäldegalerie Alte Meister

FIG. 4. J. Vermeer, *The Concert*, Boston, Isabella Stewart Gardner Museum

FIG. 5. Dirck van Baburen, *The Procuress*, M. Theresa B. Hopkins Fund, Courtesy, Boston, Museum of Fine Arts

FIG. 6. J. Vermeer, *Lady Seated at the Virginals*, London, National Gallery, Courtesy of the Trustees

FIG. 7. J. Jordaens, *Christ on the Cross*, Antwerp, Terningh Foundation

FIG. 8. J. Vermeer, *Allegory of Faith*, New York, The Metropolitan Museum of Art, Michael Friedsam Collection, 1931

FIG. 9. J. Vermeer, *The Astronomer*, Paris, Musée du Louvre

FIG. 10. J. Vermeer, *Lady Writing a Letter with Her Maid*, Blessington, Ireland, Sir Alfred Beit

FIG. 11. J. Vermeer, *Lady Writing a Letter*, Washington, National Gallery of Art, gift of Harry Waldron Havemeyer and Horace Havemeyer, Jr.

FIG. 12. J. Vermeer, *Girl Asleep at a Table*, New York, The Metropolitan Museum of Art, bequest of Benjamin Altman, 1913

FIG. 13. J. Vermeer, *Girl Interrupted at Her Music*, New York, Frick Collection

FIG. 14. J. Vermeer, *Lady Standing at the Virginals*, London, National Gallery, Courtesy of the Trustees

FIG. 15. G. Metsu, *Young Woman Reading a Letter*, Dublin, National Gallery

FIG. 16. P. de Hooch, *Couple with a Parrot*, Cologne, Wallraf-Richartz Museum

FIG. 17. J. Vermeer, *Love Letter*, Amsterdam, Rijksmuseum

FIG. 18. P. de Hooch, *A Woman Weighing Gold against Silver Coins*, Berlin, Staatliche Museen Preussischer Kulturbesitz, Gemäldegalerie

COLOR PLATES

Vermeer

FAITH IN PAINTING

✛

✛ CHAPTER 1 ✛

"The Mysterious Vermeer"

T HE GREATEST PLEASURE of the admirable exhibit of Dutch art now at
the Jeu de Paume in the Tuileries is that it brings to Paris three paintings by
Jan Vermeer of Delft."[1] The opening lines of Jean-Louis Vaudoyer's review
in *L'Opinion* of 30 April 1921 reveal his commitment to the painter, for
whom he feels, as he elaborates a few lines later, an admiration that "resem-
bles . . . love." He is writing, he says, as an advocate, to arouse envy in
others, in those, that is, who are not fortunate enough to be "enamored of
Vermeer."

The title of Vaudoyer's series of articles, "The Mysterious Vermeer," was
not original. Vaudoyer in fact took it from Thoré-Bürger, who, in 1866, in
the first important historical reevaluation of the painter, already called Ver-
meer his "sphinx."[2] But Thoré-Burger wrote as a historian, proposing the
first catalogue raisonné of Vermeer's work, while Vaudoyer wrote as an art
critic, one who wanted to make his readers *feel* Vermeer, and who under-
took also to "define the unusual and profound attraction" of his pictures, to
evoke the "impression of grandeur and mystery, nobility and purity" that
emanates from them. He wanted to understand "by what witchcraft did
Vermeer, representing the most daily and commonplace sights, manage to
give the viewer so mysterious, so grand, so exceptional an emotion." "The
Mysterious Vermeer" is quite dated, particularly when Vaudoyer's reserva-
tions about literary painting and its subjects lead him to reduce Vermeer's
art to a formal object and to maintain that "this prodigious genius, this king
of painters," is the epitome of painters because the power of his canvases "is
uniquely determined by the way in which the paints are arranged, treated,
worked." Certainly it is his manner of painting that accounts for Vermeer's
particular originality: the modernity of his paintings, their greater esthetic
appeal to today's viewers, depends upon Vermeer's being less restricted
than his contemporaries were by descriptive and narrative conventions then
considered appropriate to genre painting. To try to understand the impres-
sion made by a Vermeer canvas is certainly to try to see *how* his pictures are
painted. But reducing his art to a kind of "pure painting" impoverishes both
its intellectual content and its esthetic effect. Is it likely that the painter who
for his own reasons produced a work so ambitious and so carefully thought
out as the allegory *The Art of Painting* (fig. 27; plates V–VI) was indifferent

3

to the subjects of his paintings? Clearly it is not. An exclusively formal approach to Vermeer causes us to miss the very meaning of his work.

Vaudoyer's article, however, is well worth reading. Compared to the lackluster notice that Clotilde Misme published at the same time in the *Gazette des Beaux-Arts*,[3] it is a crucial document in the critical fortunes of Vermeer and even more so in what could be considered a history of the way we look at painting, of the complex relationship, through time, between painted surfaces and their viewers.

One passage will serve to demonstrate the point. In *L'Opinion* of 14 May, Vaudoyer supposes that, "when we enter a museum," we are always somehow drawn by a "sensual appetite," a gustatory expectation. If "the color and the material of a picture by Vermeer sate" that appetite, it is because the "succulence of the matter and the color exceeds, after the first taste (if one can use the term), the satisfaction of the gourmand, the lover of good food." Vermeer's painting is thus seen as appealing to gourmets. It first makes us "think about things that one can touch, like enamel and jade, lacquer and polished wood, then about things that result from complicated and delicate recipes, like a crème, a coulis, a liqueur," before leading us finally to "reflect on the living things of nature: the heart of a flower, the skin of a fruit, the belly of a fish, the agate-like eye of certain animals." Finally, as this metaphor of a pictorial cuisine is elaborated, the color of Vermeer "causes us to ponder the very source of existence, to reflect on blood." This mysterious and very peculiar association of ideas and sensations introduces one of the strangest, most beautiful, and wildest pages ever written on Vermeer: "Although Vermeer makes us reflect on blood, he rarely uses reds. But blood is evoked here not by nuance, but by its essence. It can be, if you please, yellow blood, blue blood, ocher blood, since we are dealing with a magician. This heaviness, this thickness, this sluggishness of the material in the pictures of Vermeer, this dramatic density, this cruel depth of tone . . . often gives us an impression such as when we see the shiny surface of a wound, covered as it were with rich varnish, or, perhaps, a spot made on the kitchen tile by the blood that drips and spreads itself beneath a suspended carcass."

The extreme subjectivity of this reverie is the basis of its critical effectiveness: one knows what appeal it would have had for Proust, who asked Vaudoyer to lend him his arm for a visit to the exhibit.[4] It is also a measure of the author's success in that its rambling rhetoric reflects his original intention "to try perhaps to define the unusual and profound attraction that [these paintings] exercise over us." The response is without doubt valid only for its author, but the undertaking proves Vaudoyer's point: the "mystery"

of Vermeer lies first of all in the astonishing *effects* that these works have on modern viewers.[5]

It is these *painterly effects* that I wish to address, using the available methods and interpretive tools of art history to assess the work of a painter who seems to frustrate all definition. This research began with an observation that is both self-evident and surprising: Vermeer, the "fine painter" by the criteria of the time—that is, the painstaking, exacting recorder of scenes whose worth lies in the meticulous description of place—is an artist whose painting is *blurred*. He neither draws nor depicts what he paints and, even in the smallest of his pictures (*The Lacemaker*, fig. 40 and plate XIV), the outline and inner modeling of his figures are both present and at the same time allusive, evocative, and invisible. The paradox is that of a miniaturist who paints inexactly, whose "descriptive" imprecision is a fundamental part of his pictorial method.

This phenomenon has been noted by many Vermeer scholars. Some of them have seen in it the transcription of an effect of the optical tool that Vermeer used in working his canvases, the camera obscura. Vermeer certainly knew the camera obscura and probably did use it in preparing his pictures. But the elaboration of this effect in painting and the subtle shifts, calculated and repeated, to which Vermeer subjected this effect suggest that he was not transcribing what he saw in the camera obscura.[6] Instead, the device gave him guidelines and a kind of model that functioned as a preparatory sketch would. Vermeer's "descriptive indifference" was an esthetic choice and contributes to the specific effect his pictures exert—the effect that constitutes the most personal aspect of the content with which he imbued the subjects that he treated.

This book rests on the conviction, which developed slowly, that the "mystery" of Vermeer we hear about is not a quality solely of a "poetic" order, of some value mysteriously added to the painted surface by an unfathomable pictorial device. If there is "mystery" in Vermeer, it is not an "enigma" or a "secret"; it is rather an objective of the work, which is deliberately wrought by the painter so as to achieve this effect. Nor is the mystery a caprice of the painter. It is related to the circumstances in which Vermeer worked for twenty-two years at Delft, between 1653 and 1675. Vermeer utilized the common language of the painters of his day, elaborating it in his own way so as to express a position with regard to contemporary issues, whether of a specific artistic order (the intellectual status and theory of painting in Holland at the time) or of a broader historical order.[7]

We cannot explain the art of Vermeer by any conjunction of historical circumstances. But in order to isolate the *effect* that is particular to Vermeer

within the framework of Dutch painting, I have chosen a historical approach, using available material in an attempt to differentiate Vermeer from his contemporaries. His work has its own *structure* and, to adopt Merleau-Ponty's terms, this "Vermeer structure" is made up of a "system of particular equivalences in which all the moments of the picture, like a hundred needles on a hundred dials, show the same characteristic deviation."[8] This deviation constitutes the individuality of a painter otherwise rooted in the common, even banal, pictorial practices of his time. It is this deviation that will be the object of our attention.

The successive chapters of this study correspond to the path I followed. Research in various archives over the last century has unearthed a considerable number of documents and a large amount of information about Vermeer. He is no longer the "forever unknown" artist who fascinated Proust.[9] We understand better now the specific circumstances of the life of the painter and of his artistic practice. These will be the point of departure for this analysis, the prerequisite to distinguishing the conditions that made his work possible and that define his originality as a painter.

I will not give an account of work-to-date on this subject. That has been done in erudite and remarkably intelligent fashion by John Michael Montias.[10] But I will point to what the historical information can teach us about the originality of Vermeer. What we know about him remains, all things considered, rather limited, and as Montias himself points out, the kinds of documents that can be found in archives deal with questions far removed from the intellectual and artistic interests that might have concerned him.[11] Still, they do permit us to correct some long-held errors and put an end to some false ideas, fictions born of the ignorance of his admirers. The documents also have the merit of partially reconstructing the "social web," the common framework within which Vermeer established his personal "deviation." Even if it is true, as Malraux suggests, that Vermeer from the standpoint of the sociologist, not the painter, is a "Dutch intimist," it is still obvious that in order to understand and describe the difference between him and De Hooch or Ter Borch, it is better to base our conclusions on knowledge of the artistic milieu and its practices than to evoke "atmosphere," "poetry," and Greek "korai."[12]

Research has brought to light two significant facts. Just as Vermeer participated very little in the "normal" social activity of his time,[13] so his paintings of interiors reveal nothing of the interior life of his own home, where he had his studio on the upper floor. "Genre painting" was, for him as for his contemporaries, a genre *of* painting; but, for Vermeer more than for

his contemporaries, it was first of all a question of "interior painting," carried out and thought through independent of the interiors where it occurs and which it represents.

My reflections begin with these considerations. The second chapter takes up an analysis of Vermeer's pictorial method through the intermediary of the pictures that Vermeer painted within his own pictures. I use this oblique approach for the sake of efficiency. In Dutch painting of the seventeenth century, the device of the picture-within-the-picture is quite common. Evoking the real decor of Dutch interiors of the period, these pictures-within-pictures allowed the artist to develop iconographic allusions that suggest a moral for the principal scene. Vermeer made special use of this practice. Not only are his iconographic allusions far from explicit, but, much more systematically than in the work of his contemporaries, his pictures-within-pictures become instruments for the inner construction of the surface to which they belong. They demonstrate forcefully that the law of Vermeer's representation is not so much truth to the appearance of objects as it is to the demands of the construction of the painted surface. Thus they permit a glimpse of the painter's conception of his own creation. Rigorously, and with a special clarity, they play the role of picture-within-the-picture of which André Chastel aptly said that it gave, within the painting itself, a "scenario of its production."[14] This "reflecting" character of the motif is especially relevant when one of the "pictures" in question is a mirror that reflects the painter's easel: *The Music Lesson* in the collection of Buckingham Palace in London (fig. 24; plate IV) merits special attention.

The third part of this study deals exclusively with *The Art of Painting*, in Vienna (fig. 27; plates V–VI). As its title suggests—the title is Vermeer's own—this picture was conceived as an "Allegory of Painting." The content of the picture thus aims explicitly at what Vermeer saw as the end and purpose of his art. And, in its structure as well as in what it sets forth for us to see (its "subject"), *The Art of Painting* is quite different from what any of Vermeer's contemporaries could have done with the theme. It is thus possible to identify some elements of the theoretical conception of his art that Vermeer personally expressed.

We then turn to the description and decipherment of the "Vermeer structure," or rather, to use the title of an earlier brief sketch of these reflections, the "Vermeer locale."[15] It is a question of identifying the dominant choices that the painter made in organizing the surface of the picture. Research is particularly helpful with regard to the interplay of a constant "surface effect" and the suggestion equally elaborated of a three-dimensional space. It is clearly evident here that Vermeer's use of the camera obscura had very little

to do with a transcription of "visual truth." As Vermeer used it, the camera obscura revealed certain phenomena that cannot be seen with the naked eye. We have obviously not adequately examined what the use of such an optical device implies or what it meant as regards either the theoretical conception or the mental and spiritual content of Vermeer's pictures.

My analysis of the "Vermeer locale" is not an end in itself, nor is it meant to lead to yet another "plastic" analysis of his art. This study is concerned with the iconographic themes that Vermeer used to give shape to his scene. In this context, the description and decipherment of the "Vermeer structure" can be articulated not only in terms of pictorial theory but also in relation to the themes that Vermeer shared with his contemporaries and by means of which he demonstrated his individuality.

In the following pages I do not claim to explain the "genius" of the painter or to reveal his "secret." What I want to do is more concrete: to uncover the aspects of Vermeer's work that make use of the commonplace pictorial and intellectual material the painter shared with his contemporaries, organizing it in a particular way and transforming it into a picture. It is in this process that we see Vermeer's "genius," to use the term in its simple and ancient meaning of *ingenium*: the inner qualities of a thing, the natural predispositions of human beings, their intellectual aptitudes, talents, inventiveness, inspiration, genius.

The predispositions, the tendencies, and the choices written into the pictures of Vermeer are what makes them works of genius. To attempt to unravel these it will be necessary to look closely at the canvases, following the labor of the painter along the paths of his creation. The documents that truly permit us to analyze the paintings of Vermeer are the paintings themselves.

✣ CHAPTER 2 ✣

The Professional Context

O NE WOULD BE ill-advised, today, to interpret Vermeer's art without taking into account what we know from archival research both about the concrete circumstances in which he practiced his art and about the reputation he enjoyed during his lifetime. Contrary to what was thought for a long time, Vermeer was neither unknown nor unrecognized in seventeenth-century Holland.

By practically ignoring his name for almost two centuries before abruptly discovering in him one of the geniuses of European painting, art historians have themselves contributed to this notion of the unrecognized genius. This situation is all the more surprising since Vermeer's works enjoyed a high reputation among collectors and art lovers during the whole of the eighteenth century. The paradox is startling: from the very beginning, Vermeer's reputation restricted his art to a private circle of admirers. What one now knows of his past renown casts some light on his practice and his conception of painting.

VERMEER'S REPUTATION

As Albert Blankert has shown, Vermeer's work was regularly shown and highly esteemed in private collections and their sales catalogues.[1] Admittedly it was under another name that between 1710 and 1760 four of his canvases came into the collections of the Duke of Brunswick, the Prince Elector of Saxony, and the King of England. Already in 1719 *The Milkmaid* (fig. 21) was called "the famous Milkmaid of Vermeer," and, in his *Letter on the Choice and Arrangement of a Curiosity Cabinet*, published in the *Mercure de France* in June 1727, Dezallier d'Argenville cites "Vandermeer" in his (long) list of northern painters worthy of inclusion in a good collection. Vermeer's reputation as a painter well suited to private collections was later confirmed when Jean-Baptiste Le Brun included an engraving of *The Astronomer* (fig. 9) in his *Gallery of Flemish Painters* published in 1792. Le Brun points out that historians have "not spoken at all" of Vermeer and stresses that he merits "particular attention": "He is a very great painter, in the manner of Metsu." In 1804, *The Concert* (fig. 4) came up for sale in Paris and the

catalogue emphasizes that Vermeer's productions "have always been regarded as classic, and worthy of ornamenting the most beautiful cabinets." The end of the eighteenth century and the beginning of the nineteenth were marked by a decided taste for Vermeer's painting. Prices rose sharply. (*The Geographer*, fig. 31, purchased for seven louis in 1798, was resold for thirty-six louis in 1803; and in 1822, the *View of Delft*, fig. 44 and plate XIII, was purchased by the Mauritshuis at the extraordinary price of 2900 florins.) Vermeer's paintings inspired contemporary Dutch artists, and some of his works were copied, among them *The Milkmaid*, *The Little Street*, the *View of Delft*, *Woman with a Pearl Necklace* (fig. 22), *The Astronomer*, and *The Lacemaker* (fig. 40)—this last copy going on sale in Rotterdam in 1810 as by "Van Der Meer of Delft or in his manner."[2]

In 1816, art historians took note of the existence of Vermeer. In their *History of the Painting of Our Country*, Van Eynden and Van der Willigen officially consecrate the painter. They can cite only three of his works and still depend heavily on the reputation of Vermeer among collectors: there exists "no lover of art who does not know and is not ready to pay a very high price for one of his canvases" because they are "worthy of the most important collections." But they also place him in the history of painting as the "Titian of Dutch painting for the depth of his color and the mastery of his stroke."[3]

The silence of historians before 1816 has several precise causes. Some lie in the practice of art history at the end of the seventeenth century and the beginning of the eighteenth; others stem from a particular aspect of Vermeer's method of production.

Throughout the eighteenth century, the history of Dutch painting relied on the three volumes of Arnold Houbraken's *Groote Schonburg der Nederlantsche Konstschilders en Schilderessen,* published in Amsterdam between 1718 and 1720. Beginning in 1729, this "grand theater of Dutch painters (men and women)" was plagiarized by Jacob Campo Weyerman; it was continued in 1750 by Jan van Gool and, between 1753 and 1764, by Jean-Baptiste Descamps in Paris. Rather like Vasari for Italian Renaissance painting, Arnold Houbraken's work is the source from which all later historians borrowed. And Houbraken says nothing about Vermeer beyond mentioning his name. Generally this silence is explained by the fact that, however well informed he was about the painters of Amsterdam and his native city of Dordrecht, his knowledge of Delft relied on a work published in 1667 by Dirck van Bleyswijck, *A Description of the City of Delft*. But, according to a respected tradition, Van Bleyswijck praised his city's celebrated citizens only if they were already dead. In 1667, Vermeer was indeed alive and Van Bleyswijck only cites his name.[4]

This explanation, however, is insufficient. *A Description of the City of Delft* indicates, in fact, that in 1667 Vermeer had a brilliant reputation in his own city. In commenting on the death of the painter Carel Fabritius after the explosion of the city's powder magazine in 1654, Van Bleyswijck cites in compliment a short poem written by the local printer Arnold Bon. The last stanza places Vermeer among the glories of the city: at the death of the "Phoenix" Fabritius, Vermeer rises from the ashes. This text indicates that in 1667 Vermeer was considered the greatest painter of Delft.[5] Houbraken, however, does not cite this stanza; its omission suggests that he, being ignorant of Vermeer's existence and his work, preferred to omit the last verses of the poem rather than reveal his own ignorance about the "resuscitated Phoenix."

This omission explains the silence of later historians, but does not explain why Houbraken knew nothing of a painter whose prestige Van Bleyswijck had obligingly pointed out, and twenty-one of whose pictures came up for auction in Amsterdam in 1696.[6] His ignorance no doubt has to do with the practice of Vermeer himself, the rhythm of his production and the way that he fit into the contemporary art market.

In twenty-two years, between 1653 and 1675, Vermeer painted between forty-five and sixty pictures. That is, he painted two or three pictures a year.[7] In comparison with his colleagues, this production was astonishingly small.[8] We will come back to this since it constitutes one of the singular traits of his artistic practice; it is enough for the moment to note that the small number of pictures painted by Vermeer certainly contributed to Houbraken's ignorance—all the more so since a good part of this production was bought by the same collector in Delft.

In contrast to Gerard Dou, who received an annual "fixed payment" of 500 florins from a collector who thus secured a preemptive right over the painter's output,[9] Vermeer was not regularly remunerated on account toward the purchase of his work. But between the end of the 1650s and 1674 (that is, during almost all of his artistic career), the same collector purchased his paintings regularly, occasionally lending him money or making limited financial advances for a work to come.

The identity of this assiduous collector is not without importance. For a long time he was thought to be the printer Jacob Dissius, whose collection (with twenty-one Vermeers) went on sale in Amsterdam in 1696. Montias has shown that this was not the case. Jacob Dissius, born in 1653 (the year in which Vermeer joined the Guild of Saint Luke), became the owner of the pictures through his wife, who inherited them from her parents, Pieter Claesz. van Ruijven (1624–1674) and his wife. They belonged to the haute bourgeoisie of Delft and enjoyed a considerable fortune. Within the city's

patrician milieu they occupied a special place. At the beginning of the century, the Van Ruijven family had sympathized with the tolerant religious attitude advocated by Arminius and the Remonstrants, a fact that barred Pieter Claesz. from attaining any of the highest municipal posts. The archives also reveal that the relationship between Van Ruijven and Vermeer was excellent and indeed went beyond the usual one of patron or collector and painter. We need to forget the traditional idea that Vermeer was unrecognized in Delft, that his only local admirer was the corner baker.[10]

The privileged relationship between Vermeer and Van Ruijven was, however, a mixed blessing for the painter. Of course it assured him financial security and a certain social prestige, and it put him in touch with a milieu of possible buyers. But it also restricted the circulation of his pictures, since almost half of his limited production went to the same local collector. As Montias remarks, "his reputation might have spread in wider circles and his name might have been better remembered after his death had there been more collectors eager to trumpet his fame." Vermeer's reputation might also have profited "if the Van Ruijven collection had been located in a cosmopolitan center like Amsterdam rather than in a provincial town like Delft."[11]

In any event, Johannes Vermeer was neither unknown nor unrecognized in his lifetime. This is confirmed by other documents. In May 1672, when he was for the second time syndic or headman of the Guild of Saint Luke at Delft, he was called to The Hague to give his expert advice on some Italian paintings that were about to be purchased by the Great Elector of Brandenburg.[12] Moreover, on at least two occasions, in 1663 and 1669, foreign art lovers passing through the city came to see him in his studio. These two visits are worth some attention. Later we will consider the passage from the *Journal de voyage* published at Lyons in 1666, in which the Frenchman, Balthazar de Monconys, recounts the visit he made to Vermeer on 11 August 1663; his testimony is interesting for what it reveals about the commercial practices of Vermeer. Another journal, discovered recently, by Pieter Teding van Berckhout, reports the visits that its author made to Vermeer on 14 May and 21 June 1669. The first visit is summarized in one line: "Estant arrive ie vis un excellent peijntre nomme Vermeer, qui me monstra quelques curiositez de sa main." The term *curiosities* is, today, unexpected, and upon first consideration more difficult to interpret than the simple adjective *excellent*, which shows that in 1669 Vermeer's reputation went beyond the boundaries of Delft. On 21 June, Van Berckhout is more precise: "a celebrated painter named Vermeer . . . showed me several examples of his art, the most extraordinary and curious feature of which is the

perspective." Vermeer thus is not only "excellent," he is "celebrated," and we learn that if Van Berckhout called his pictures "curiosities" a month earlier, it was because of the painter's extraordinary skill in perspective. This brief observation suggests an aspect of Vermeer's art to which we have been insufficiently attentive.[13]

These few lines are significant because, in the same year, Van Berckhout also visited Caspar Netscher at The Hague, the "famous" Gerard Dou at Leyden, and Cornelius Bischop at Dordrecht, whose mastery of perspective he also singled out.[14] As Montias notes, the fact that a contemporary and well-informed amateur of painting uses equivalent terms for Vermeer, Dou, Netscher, and Bischop ought to put to rest definitively the legend of a Vermeer neglected in his own day.

He was most certainly one of the best-known living painters of Delft, a local celebrity from the 1660s on. When he was named syndic of the Guild of Saint Luke in 1662, his election came at an exceptionally youthful age for such responsibility. One should not, however, overvalue this fact in estimating Vermeer's fame at the age of thirty. In 1662, the state of the guild of Delft was not particularly advantageous for painters. Most renowned artists had left the city for Amsterdam or The Hague and, because of the absence of younger painters of sufficient quality, the syndics had gotten older and older.[15] Furthermore, in 1661, one year before Vermeer's nomination, the Guild of Saint Luke had celebrated its fiftieth anniversary. It had changed its headquarters but had confirmed the statutes adopted in 1611. In doing so, it had reaffirmed its attachment to an artisanal tradition, separating itself from the movement that had led the painters of many Dutch guilds to demand and obtain the right to establish autonomous brotherhoods to distinguish themselves from artisans, workers in faience or glass, and others.[16] This had occurred in Dordrecht in 1642, in Utrecht in 1644, Hoorn in 1651, Amsterdam in 1653, and The Hague in 1656. It was thus within a particularly conservative guild that Vermeer was elected as one of two syndics of painters, in an association including also representatives of other artisanal groups.

VERMEER AND MONEY

Very little information is available about the circumstances of Vermeer's life. One thing is certain: three years after he became, for the second time, a director of the St. Luke's Guild, he died, heavily in debt. The cause of his financial collapse, which came at the beginning of the 1670s, is generally

thought to be the war that Louis XIV carried on in Holland. In April 1676, when Catharina Bolnes, the artist's widow, asked the High Court of Holland for, in effect, a moratorium on Vermeer's debts, she stressed the fact that he "had been able to earn very little or hardly anything at all" by his art during the war years and that he had even had to sell at a loss some paintings that were part of his business.[17] The war waged in Holland by the armies of Louis XIV was unfavorable to the art market, which was essential for the revenue of artists in the country. But should one take Catharina Bolnes' statements literally? A closer reading of the archival documents allows us to reconstruct, in part, the artist's sources of revenue, and leads us to ask whether in fact Vermeer painted to sell, and whether his final ruin was really due to the poor sale of his work. This question is not idle or secondary, since if Vermeer did not paint in order to sell his work, his attitude would constitute a remarkable divergence from most of his colleagues. One of the characteristics of Dutch painting is precisely that it was intended for sale in an open market functioning on the principle of supply and demand. Since public religious art was no longer in demand and the need for official secular art was relatively limited, the potential purchasers of art on this market were private individuals.[18] In showing a relative indifference in this matter, Vermeer demonstrated an original conception of the painter's profession that can be confirmed in several ways.

First, as we have seen, his production was far from abundant, and even in the years 1670–1675, when he began to feel economic pressures, he did not increase it. Moreover, Vermeer never repeated a motif or a composition that had been successful—as De Hooch, for example, did, not hesitating to repeat with minuscule variations his successful compositions, or even to enlarge a detail lifted from a successful one to make another painting.[19]

Moreover, when Balthazar de Monconys visited Vermeer in 1663, the painter did not have a single picture to show him.[20] This demonstrates an attitude on Vermeer's part that was extraordinarily noncommercial (so much so that one even wonders whether perhaps he preferred not to show his paintings to a foreign visitor). The petition that Catharina Bolnes addressed to the High Court of Holland does of course indicate that Vermeer, like his father and many of his colleagues, carried on a trade in pictures. Vermeer did so on a much-reduced scale. At the time of his death, he had a stock of twenty-six pictures with a total value, at an average value of forty florins each, of less than 500 florins. In 1675, when the Amsterdam merchant Gerrit Uylenburch went bankrupt, he had five times as many canvases in stock, worth 100 florins apiece on the average. The difference is considerable; it shows that the art business Vermeer involved himself in was quite modest.

The more significant point, however, is that Vermeer was not poor. His life was relatively comfortable: without counting the sale of paintings (his own or those from his commercial stock), his total annual revenue was at least 850 florins, an amount that corresponds to the income of the owner of a faience factory in Delft in the 1660s. In fact, painting was only one resource for Vermeer, complementing several other sources of income.

This situation is not in itself exceptional in seventeenth-century Holland. What is particular to Vermeer's case is that, while his practice demonstrated his dedication to painting as an occupation, he did not work at it as if to assure his own material ease—or even to earn a living. We have to conclude that, even if Vermeer does not belong in the category of "gentleman-painters" like Ferdinand Bol, Jacob de Gheyn, or Albert Cuyp, who were free to practice their art as they pleased, even to the point of renouncing it, still his relatively comfortable family situation freed him from the necessity of painting for a living and allowed him to paint relatively little—whether or not this practice was an expression of his individual temperament.[21]

VERMEER AND PAINTING

These facts are not just anecdotal if they allow us to reach a better under-standing of Vermeer's approach to painting and to see more clearly the relationship of the world of his pictures to the actual world in which he lived.

Vermeer's poverty at the end of his life was not due simply to failure to sell his pictures (either his own or those from his stock). He also experienced a decrease in his family income as a result of the war, particularly a decrease in land rents from various holdings. And most especially, there was the increasingly exorbitant expense of rearing eleven children.[22] While the household inventory after his death shows the house invaded by this plenti-ful progeny, there is never a single child in his interior scenes. Such an omission, or exclusion, is rare in contemporary Dutch painting; it suggests that, for Vermeer, his paintings had little to do with the reality of his life.

The documents also show that Vermeer's brother-in-law was involved several times in extremely violent scenes, until 1664 when he was finally confined, once beating Vermeer's wife black and blue when she was "preg-nant to the last degree."[23] And yet the paintings of Vermeer impress us with the peace and calm of their domestic atmosphere.

The archives thus suggest that the actual conditions in which the art-ist lived left no direct trace in his work. On the contrary, despite the fact that the great majority of his paintings are domestic scenes clearly tied to

the habits of contemporary daily life, his real life and the life represented in his painting seem to constitute two different worlds, separate, and irreconcilable.[24]

The idea that there must be a relationship between an artist's life and his work only leads to illusory explanations of the work. Vermeer's interiors must be seen in the context of contemporary pictorial practice, its rules, conventions, and modes, if we want to understand what it is in his painting that is specifically his own. The "real world" of Vermeer's pictures is the world the pictures themselves inhabit, a world of painting; and painting was, for him, an exact and specific activity. In refusing to be ruled by social or commercial aspirations, Vermeer was able to use his paintings as a work-place, his laboratory for constant pictorial research. The meticulousness of this work is above all the expression of a need that is personal, individual, intimate. While Vermeer did not attempt to increase his production of paintings so as to make more money, neither did he renounce painting for another more lucrative activity.[25] Nor did he relocate to Amsterdam, the artistic capital of the time, as did Emanuel de Witte and Pieter de Hooch, who left Delft at the end of the 1650s.As long as the financial support provided by his mother-in-law and his wife was sufficient for a comfortable life he did not need to. For Vermeer, painting seems to have constituted a clearly defined world, the self-sufficient object of his artistic preoccupations.

The development of his painting does, however, correspond generally to that of his contemporaries, in particular his shift from religious and myth-ological themes to interior scenes. A closer look reveals that within this common development, Vermeer's art is distinguished by its continually posing new problems. Although he never repeats motifs for commercial ends, he does repeat over and over again a few pictorial elements and compositions, combining, modulating, and varying them in different ways. These variations allow us to trace the evolution of certain themes or of groups of figures. It is not, however, a linear evolution: certain works act as points of reference—particularly the Dresden *Girl Reading a Letter at an Open Window* (fig. 33; plates VII–VIII)—from which stem various artistic problems to be successively elaborated and resolved. The intensity of his artistic research is clearly observable at the beginning of his career, in the 1650s, in the way that he gradually assimilated the manner of certain mas-ters before passing on to that of others.[26] The praise that Van Berckhout had in 1669 for his mastery of perspective is particularly revealing, for Ver-meer's first works display his inability to treat the geometric construction of spaces "correctly" (or perhaps his indifference to their "correctness"). The definition of space and the position of objects in that space are quite approx-

imate in the earliest paintings, whether *Christ in the House of Martha and Mary* (1654-1655; fig. 1), or *Diana and Her Companions* (1656; fig. 2) or, even more so, in the pivotal work, *The Procuress* (1656; fig. 3). The *Girl Asleep at a Table* (c. 1657; fig. 12) is by contrast a veritable exercise in the construction of space. Vermeer never repeated this sort of demonstration and later renounced any display of his technical ability. The elaboration of perspective remained important in his paintings; but, to borrow the Italian formula, "art conceals art" in this regard. We will see later how the subtle effects that he gets by meticulous attention to perspective are among the most easily identifiable characteristics of the "Vermeer structure."

Here we touch upon an essential aspect of his artistic attitude: his ambition as a painter. It is not a question of social ambition. His business choices make that clear, as does the fact that, except for the *Head of a Girl* in The Metropolitan Museum (fig. 41),[27] he never painted portraits. Portraits were an important source of income and an excellent means of publicizing one's name in the milieus that might have promoted the social advancement of a career, and the number of portraits painted in Holland in the seventeenth century was considerable. The portrait, however, did not enjoy much prestige among painters. At the beginning of the century, Van Mander had thought that it was "a secondary track for art" and, according to him, Abraham Bloemart (under whom Vermeer perhaps finished his apprenticeship)[28] would have nothing to do with the life portrait "so that it might not disturb his spirit." Samuel van Hoogstraten, a contemporary of Vermeer, does not place the portrait very high in the hierarchy of genres and, at the beginning of the eighteenth century, Gérard de Lairesse finds it "strange" that an artist should "lose his liberty and make a slave of himself, demean the perfection of this noble Art in order to submit to all the defects of Nature."[29] Vermeer never demeans this perfection in his interior scenes.[30] His ambition is neither commercial nor social but instead is directed toward painting; it is an ambition truly artistic in the sense that it is the art of painting that the painter aspires to.[31]

In Vermeer's own artistic evolution, two paintings stand apart from the rest: *The Art of Painting* (fig. 27; plates V–VI) and the *Allegory of Faith* (fig. 8; plates II–III). In them, the expression of Vermeer's ambition is demonstrated with particular clarity. They stand apart first because in both Vermeer treats allegorical subjects but also because in them he returns to the dimensions of his earliest works, taking up again between 1665 and 1670 a format not usual for him at that time.

We will return to the *The Art of Painting* at some length, and will see how this allegorical painting fully confirms his intellectual ambition. One can

simply note here that the artist's pose, his dress, and the general framework of his "allegorical workshop" evoke the celebrated description that Leonardo da Vinci gave of the painter at work. Unlike the sculptor covered with marble dust and deafened by the noise of the hammer, "the painter is seated at ease before his work, well dressed, handling a lightweight brush and using pleasing colors; he is dressed in clothes that accord with his taste, and his room is clean and filled with beautiful paintings."[32] It is not surprising that painting for Vermeer too, should have been a *cosa mentale*.

The *Allegory of Faith* deserves an extended discussion here as it reflects a social condition of Vermeer's artistic practice that may well be a fundamental basis for his artistic ambition: his Catholicism. The work is incontestably Catholic, probably done in response to a private commission. The serpent crushed by a block of stone, an allegorical representation of heresy overcome, would have shocked a Delft Protestant; the work can only have been intended for a Catholic chapel or, more likely, the home of a fervent Catholic.[33]

Vermeer came from a Calvinist family, but, before entering the Guild of St. Luke and upon the occasion of his marriage to Catharina Bolnes in 1652, he converted to Catholicism. Very soon after his marriage, he was living in his mother-in-law's home in the Catholic section of Delft called "Papists' Corner." An important aspect of Montias' work is his demonstration that Vermeer's conversion was not just one of convenience; he was deeply involved in the Catholic milieu of his in-laws, beyond mere family relationships.[34] To be Catholic in Delft between 1650 and 1675 had its consequences. Persecution was less virulent than in the recent past, but the city was far less tolerant than more progressive and broadminded cities. It was not only that Calvinists alone could hold positions of civic responsibility in Delft but also that the Catholic cult, even though it was tolerated, was practiced in "hidden churches" and was regularly called into question— more frequently by the people themselves than by the authorities, who understood the role that Catholics played in the city's prosperity.[35]

Vermeer scholars have not usually taken his Catholicism into account in analyzing his work. Common sense would seem at first to support this approach. Except for the case of the *Allegory of Faith*, the patrons and known clients of Vermeer did not include a single Catholic, and there is no record of any picture having been sold to any of the numerous Catholic relatives to whom his marriage gave him access. It would be wrong, however, to conclude too quickly that a religious approach to his art is useless. Well before the *Allegory of Faith*, his first two religious works, *Christ in the House of Martha and Mary* (fig. 1) and especially *St. Praxedes* (plate I), were already

18

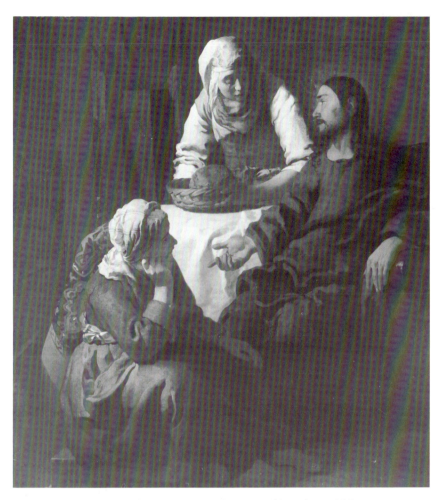

FIG. 1. J. Vermeer, *Christ in the House of Martha and Mary,*
Edinburgh, National Gallery of Scotland

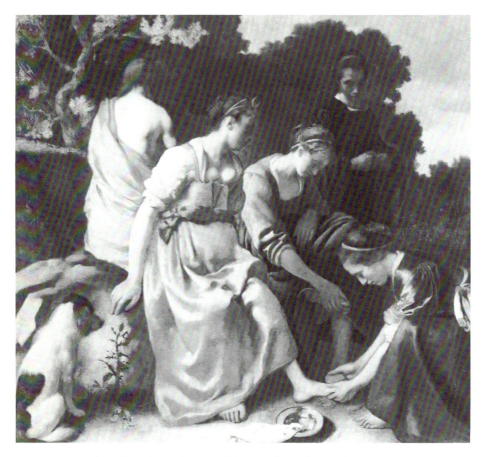

Fig. 2. J. Vermeer, *Diana and Her Companions,*
The Hague, Mauritshuis

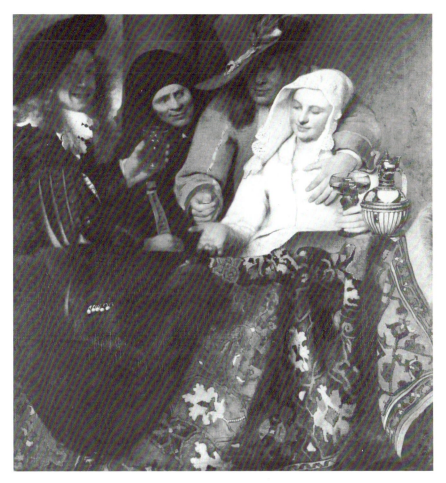

FIG. 3. J. Vermeer, *The Procuress*, Dresden,
Staatliche Kunstsammlungen, Gemäldegalerie Alte Meister

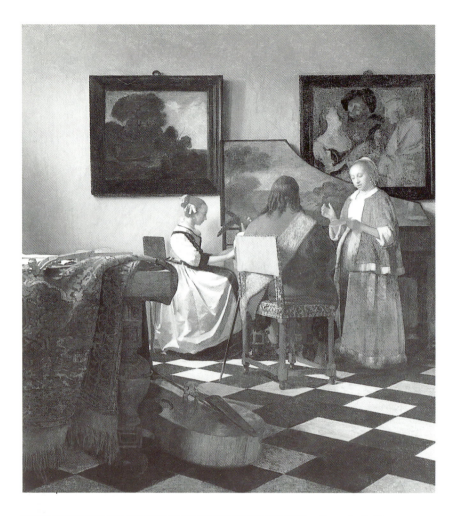

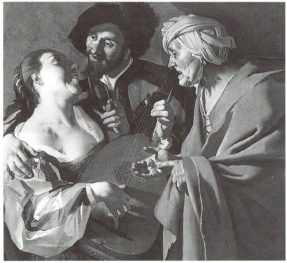

FIG. 4. J. Vermeer, *The Concert*, Boston, Isabella Stewart Gardner Museum

FIG. 5. Dirck van Baburen, *The Procuress*, Boston, Museum of Fine Arts

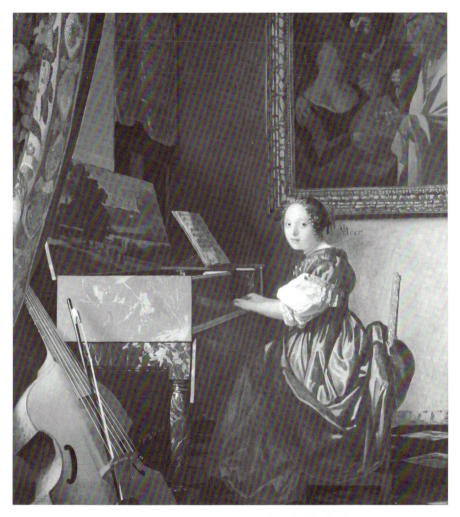

FIG. 6. J. Vermeer, *Lady Seated at the Virginals*,
London, National Gallery

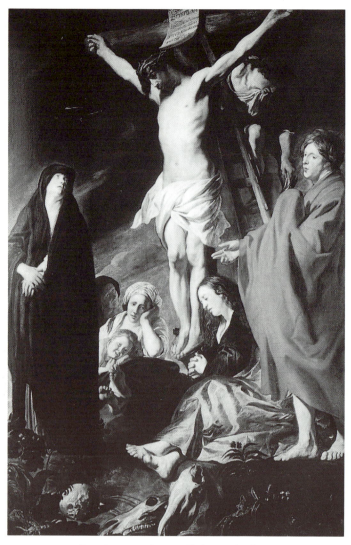

FIG. 7. J. Jordaens, *Christ on the Cross*,
Antwerp, Terningh Foundation

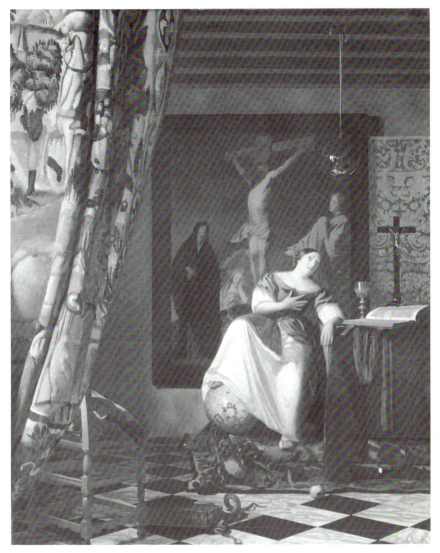

Fig. 8. J. Vermeer, *Allegory of Faith*,
New York, The Metropolitan Museum of Art,
Michael Friedsam Collection, 1931

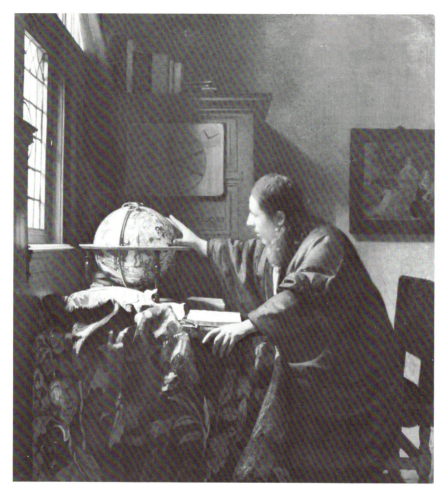

Fig. 9. J. Vermeer, *The Astronomer,* Paris, Musée du Louvre

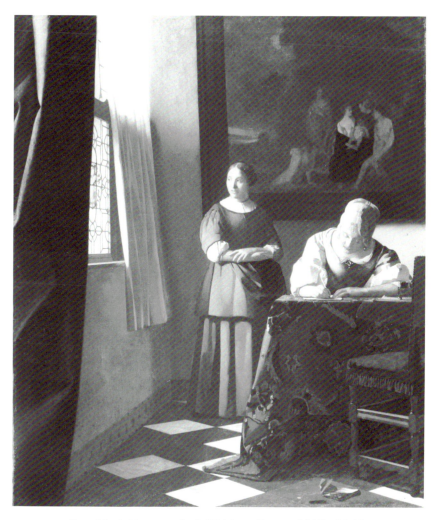

FIG. 10. J. Vermeer, *Lady Writing a Letter with Her Maid*,
Blessington, Ireland, Sir Alfred Beit

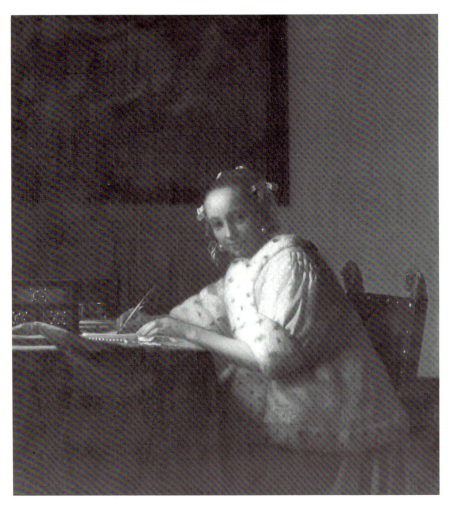

Fig. 11. J. Vermeer, *Lady Writing a Letter*,
Washington, National Gallery of Art,
gift of Harry Waldron Havemeyer and Horace Havemeyer, Jr.

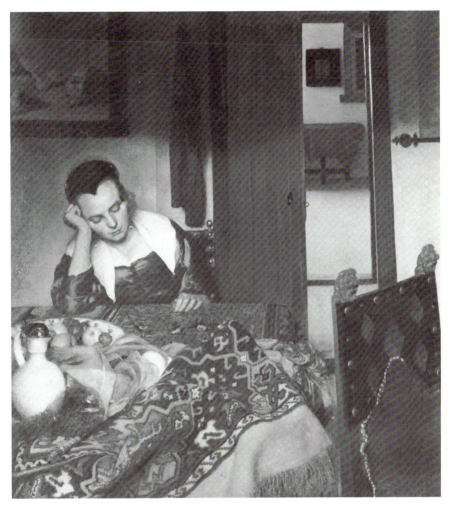

Fig. 12. J. Vermeer, *Girl Asleep at a Table,*
New York, The Metropolitan Museum of Art,
bequest of Benjamin Altman, 1913

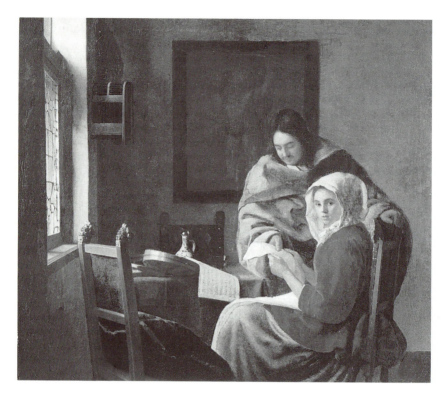

FIG. 13. J. Vermeer, *Girl Interrupted at Her Music*,
New York, Frick Collection

FIG. 14. J. Vermeer, *Lady Standing at the Virginals,*
London, National Gallery

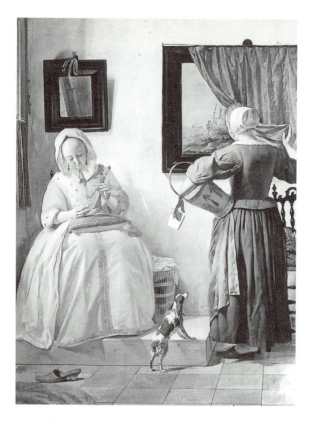

FIG. 15. G. Metsu, *Young Woman Reading a Letter*, Dublin, National Gallery

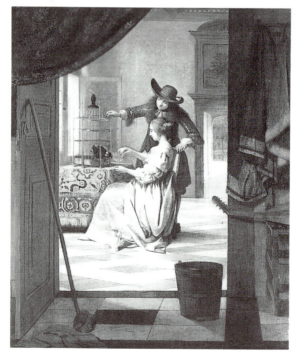

FIG. 16. P. de Hooch, *Couple with a Parrot*, Cologne, Wallraf-Richartz Museum

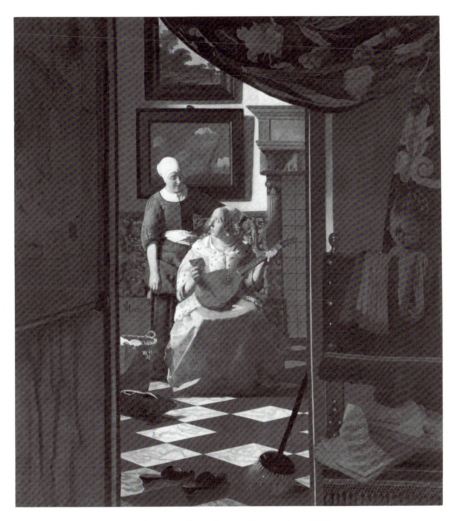

Fig. 17. J. Vermeer, *Love Letter*, Amsterdam, Rijksmuseum

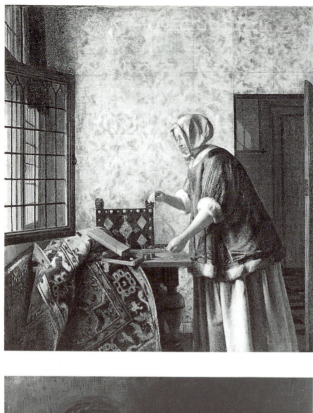

FIG. 18. P. de Hooch,
*A Woman Weighing Gold
against Silver Coins,* Berlin,
Staatliche Museen
Preussischer Kulturbesitz,
Gemäldegalerie

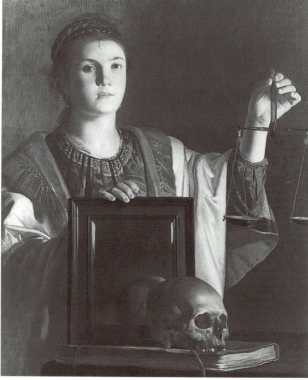

FIG. 19. N. Tournier,
*Truth Holding a Mirror to
the Vanities of the World,*
Oxford, Ashmolean
Museum

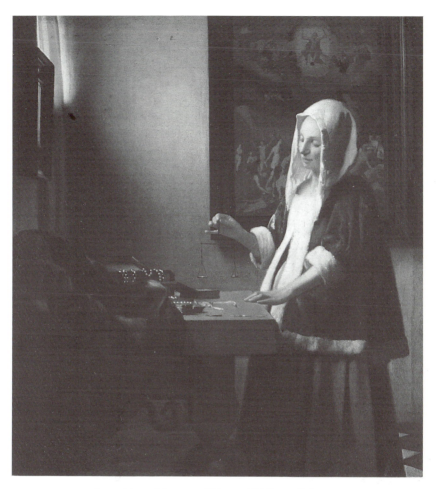

FIG. 20. J. Vermeer, *Woman Holding a Balance*,
Washington, National Gallery of Art, Widener Collection

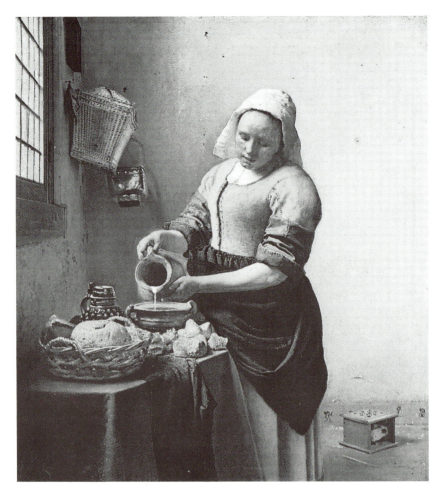

FIG. 21. J. Vermeer, *The Milkmaid*,
Amsterdam, Rijksmuseum

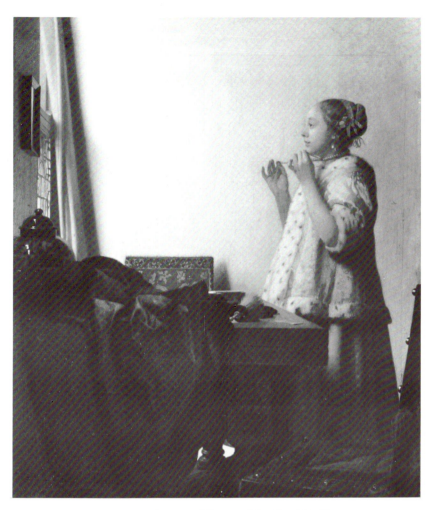

FIG. 22. J. Vermeer, *Woman with a Pearl Necklace,*
Berlin, Staatliche Museen Preussischer Kulturbesitz, Gemäldegalerie

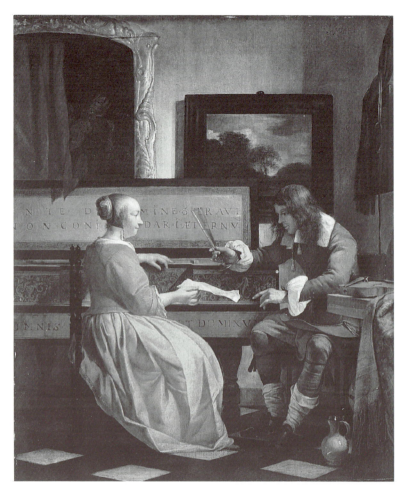

Fig. 23. G. Metsu, *The Duet*, London, National Gallery

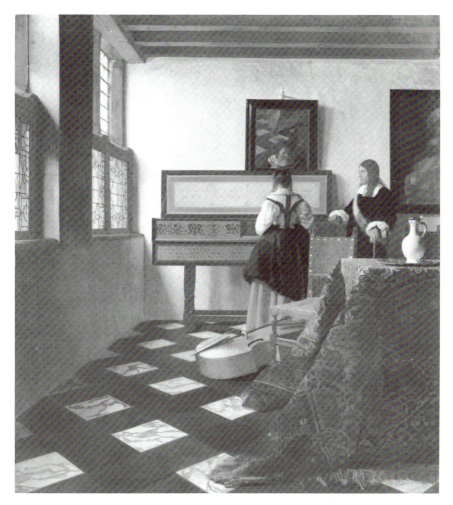

FIG. 24. J. Vermeer, *The Music Lesson*, London,
Buckingham Palace, by permission of H. M. the Queen

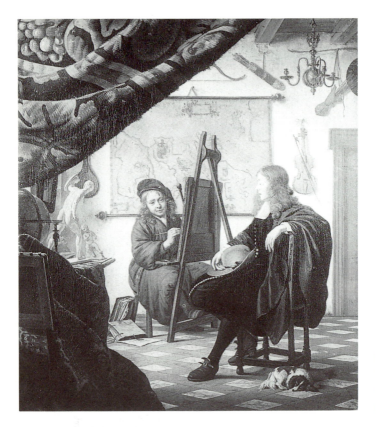

FIG. 25. M. van
Musscher, *The Painter
in His Studio,* Basel,
private collection

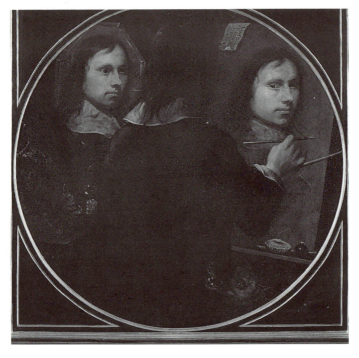

FIG. 26. J. Gumpp, *Self-
Portrait,* Florence, Uffizi

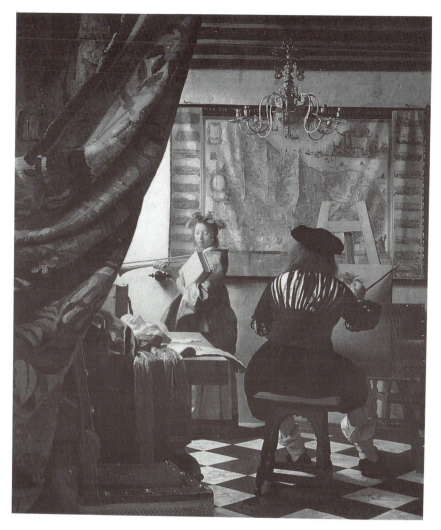

Fig. 27. J. Vermeer, *The Art of Painting,*
Vienna, Kunsthistorisches Museum

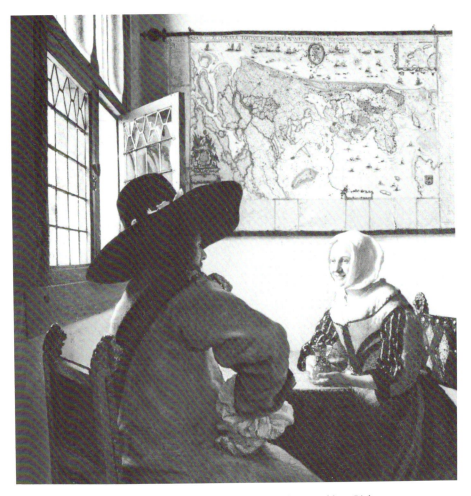

Fig. 28. J. Vermeer, *The Officer and the Laughing Girl*,
New York, Frick Collection

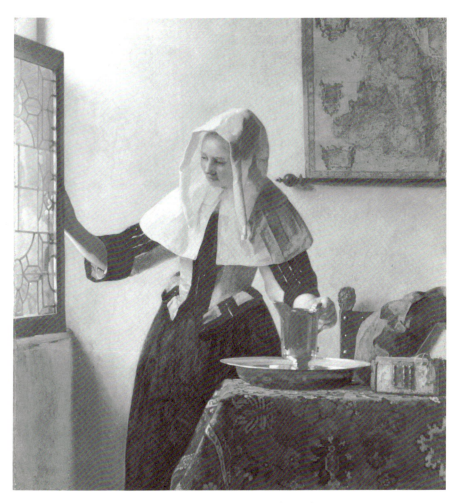

Fig. 29. J. Vermeer, *Woman with a Wine Jug*,
New York, The Metropolitan Museum of Art,
gift of Henry G. Marquand, 1889

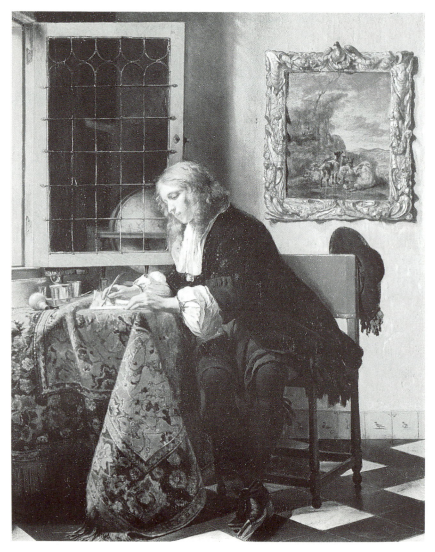

Fig. 32. G. Metsu, *Young Man Writing a Letter*,
Dublin, National Gallery

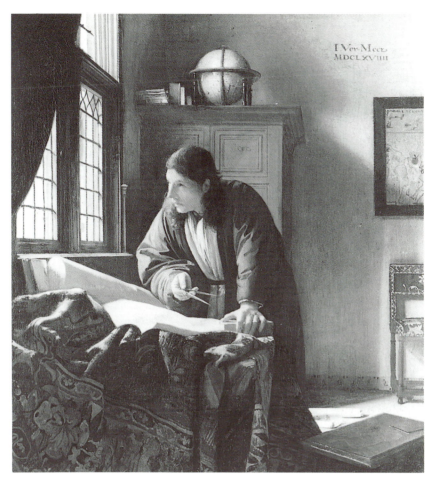

Fig. 31. J. Vermeer, *The Geographer,*
Frankfurt, Städelsches Kunstinstitut

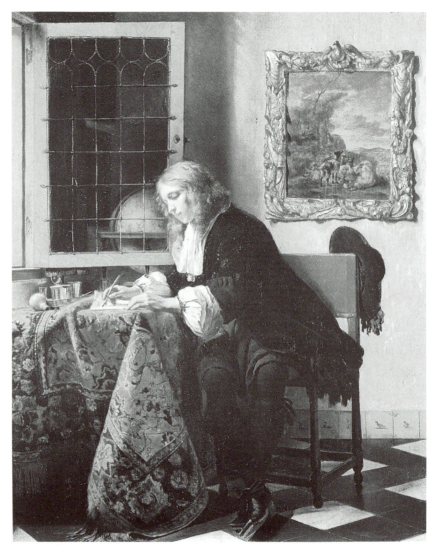

FIG. 32. G. Metsu, *Young Man Writing a Letter,*
Dublin, National Gallery

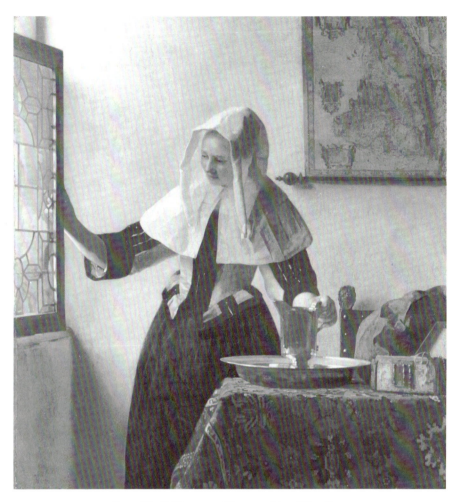

FIG. 29. J. Vermeer, *Woman with a Wine Jug*,
New York, The Metropolitan Museum of Art,
gift of Henry G. Marquand, 1889

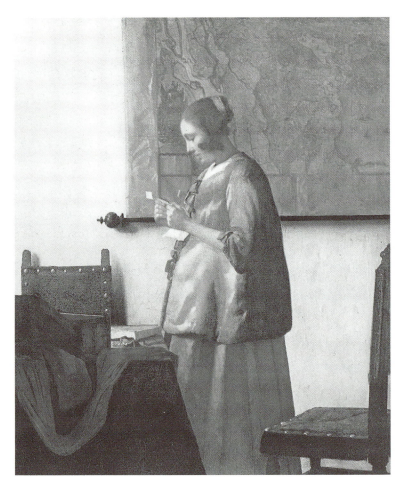

FIG. 30. J. Vermeer, *Woman in Blue Reading a Letter,*
Amsterdam, Rijksmuseum

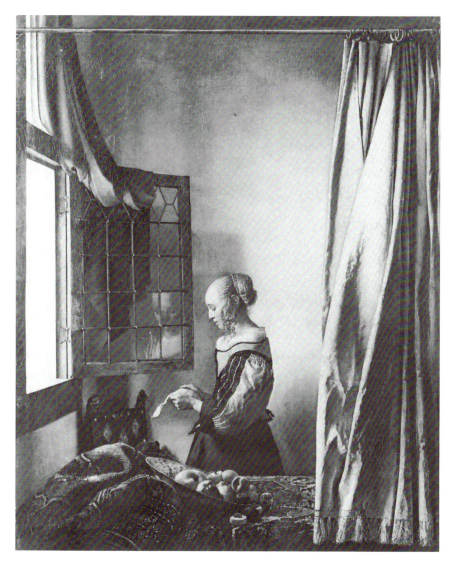

FIG. 33. J. Vermeer, *Girl Reading a Letter at an Open Window,* Dresden,
Staatliche Kunstsammlungen, Gemäldegalerie Alte Meister

FIG. 34. G. Dou, *Self-Portrait*, Amsterdam, Rijksmuseum

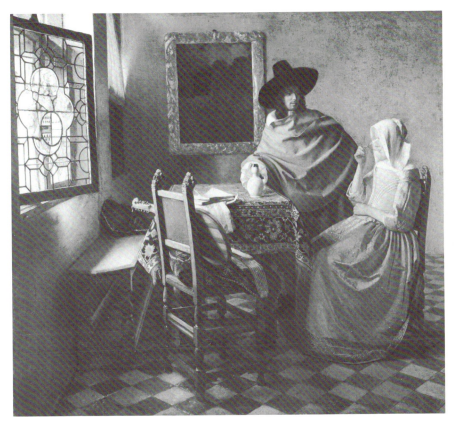

Fig. 35. J. Vermeer, *The Glass of Wine*, Berlin,
Staatliche Museen Preussischer Kulturbesitz, Gemäldegalerie

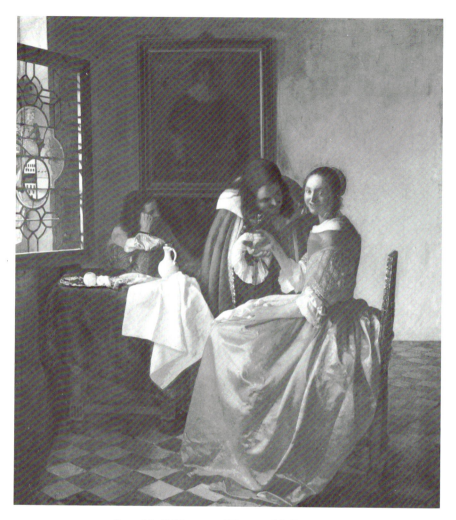

Fig. 36. J. Vermeer, *Woman with Two Men,*
Braunschweig, Herzog Anton Ulrich Museum

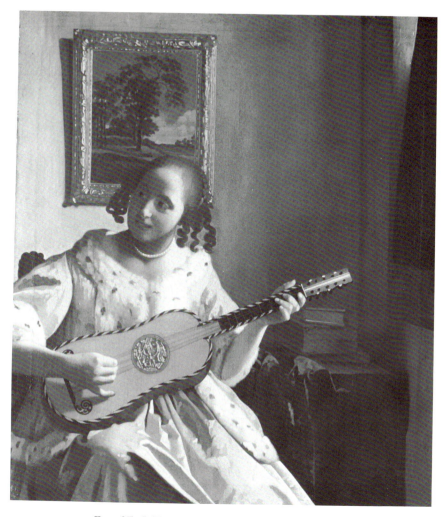

Fig. 37. J. Vermeer, *The Guitar Player,* Kenwood,
English Heritage as Trustees of the Iveagh Bequest

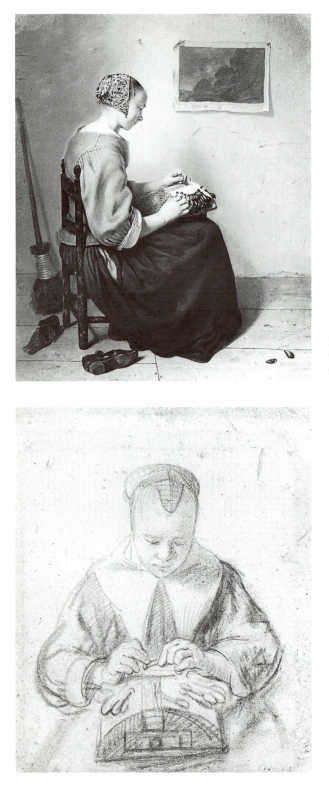

FIG. 38. C. Netscher,
The Lacemaker, London,
Wallace Collection

FIG. 39. N. Maes,
The Lacemaker, drawing,
Rotterdam, Boymans-van
Beuningen Museum

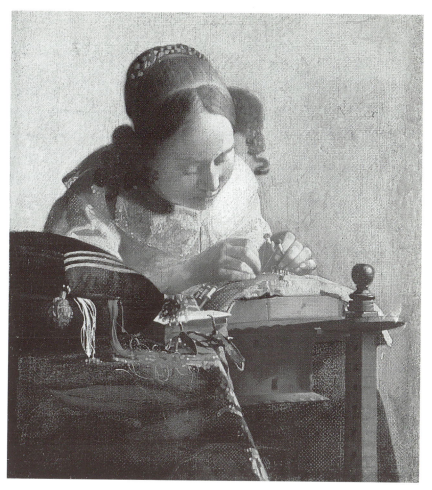

Fig. 40. J. Vermeer, *The Lacemaker*, Paris, Musée du Louvre

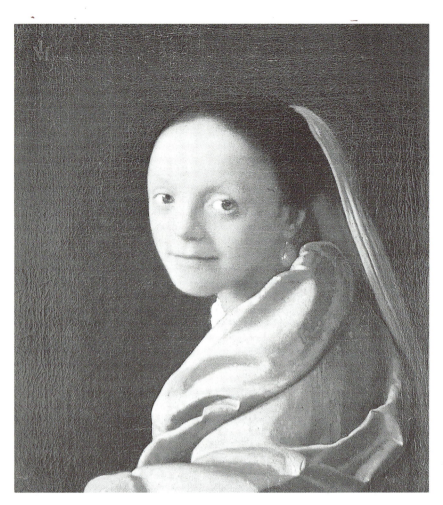

Fig. 41. J. Vermeer, *Head of a Girl*,
New York, The Metropolitan Museum of Art,
gift of Mr. and Mrs. Charles Wrightsman

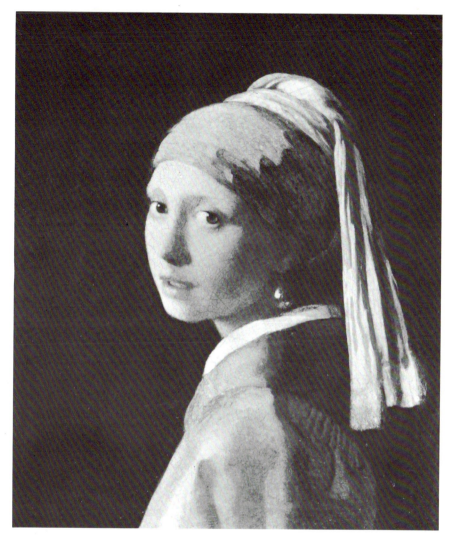

Fig. 42. J. Vermeer, *Girl with the Pearl Earring,*
The Hague, Mauritshuis

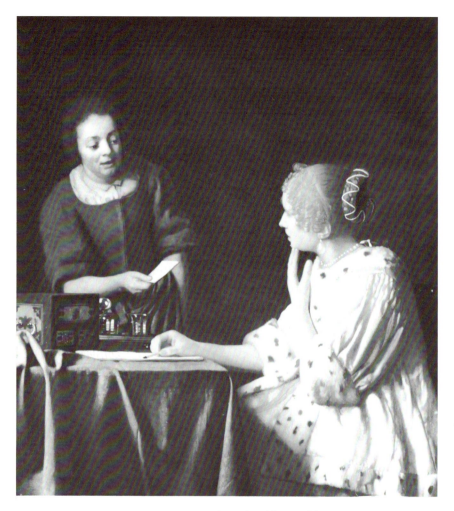

FIG. 43. J. Vermeer, *The Lady with a Maidservant*,
New York, Frick Collection

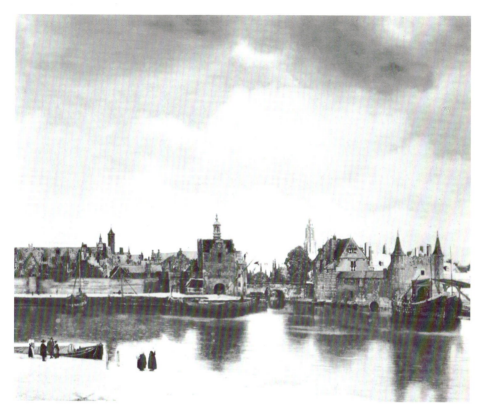

Fɪɢ. 44. J. Vermeer, *View of Delft*, The Hague, Mauritshuis

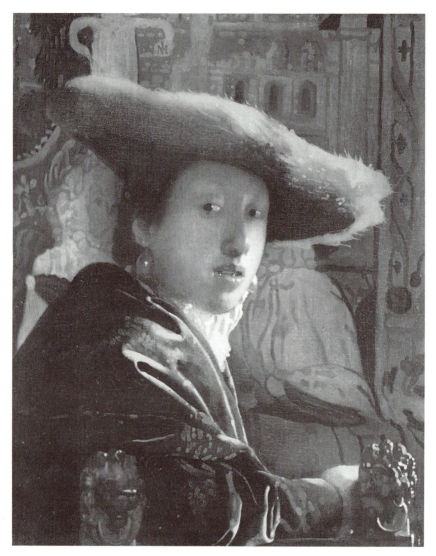

FIG. 45. J. Vermeer (attr.), *Girl in a Red Hat*,
Washington, National Gallery

Catholic in inspiration.[36] The absence of Catholic clients in the ensuing years is no doubt due to Vermeer's adoption, after *The Procuress* (fig. 3), of the interior scene as his genre, a choice that put him in line with the dominant practice of contemporary painting in his country. The main themes of private collections in Delft depended upon the religion of the owner. Among Protestants, we find interiors, landscapes, still lifes, Biblical narratives from the Old Testament—never Christ or the Virgin Mary. But among Catholics, on the other hand, we find few landscapes and many religious images inspired by the New Testament (Ecce Homo, Christ the Savior, the Virgin, the Virgin with Child), as well as a certain number of devotional images.[37] Vermeer's subjects thus are those that would have been favored by Protestants. Questions still remain, however, as to Vermeer's approach to these themes. While these themes are a commonplace aspect of his painting, the part that he shares most obviously with his contemporaries, the treatment that he gives them may not be unrelated to his "Catholic" conception of painting, its uses, and its importance.

As to the *Allegory of Faith:* contrary to assertions of modern commentators on Vermeer, this painting is not an expression of an artistic decadence.[38] Far from it. Instead it constitutes a demonstration of Vermeer's artistic ambition and on examination indicates that, in the eyes of his contemporaries, this ambition was crowned with success.

Modern critics have been bothered by this work because the painter seems to have contradicted himself by inserting an allegory into a seventeenth-century Dutch interior; the presence of the crushed serpent in such an interior would seem to be "jarringly wrong."[39] Such criticism derives from the notion of the coherence necessary for "realistic" plausibility, according to which a certain difference in kind exists between reality and allegory. Vermeer, however, was not the only one in the seventeenth century to mix these levels. The fact that the single implausible object, in this Dutch interior, is the crushed serpent is itself significant, since this motif represents *allegorically* victory over heresy.

In other respects, Vermeer's insertion of elements of an allegorical vocabulary into a realistic Dutch interior was innovative for allegorical painting. Rather than condemning this departure on the grounds of realistic implausibility (which is in any case anachronistic), historians should look for its reasons. Vermeer's "invention" evokes to a certain extent the practice of the "hidden churches" that concealed the place of worship of the Catholics of Delft within secular buildings. This "real allegory" may thus correspond to a particular time in the religious practice of Catholics in Holland. We will return to this notion of "real allegory" with regard to the *Art of Painting*

19

(fig. 27; plates V–VI), whose allegorical intent is weakened when its "real" setting is explained solely on the grounds that we can "imagine an artist painting a model dressed as Clio and we can accept the idea of an artist being inspired by the muse of History."[40] In fact both pictures are based upon "real" actualizations of allegory. To accept one in the name of verisimilitude and reject the other is to fail to see the unity of Vermeer's artistic thought demonstrated by the similarity in their formal arrangements.

As to the artistic quality of the *Allegory of Faith*, the modern historian is free to express his personal opinion, but if we want to judge the quality of a painting historically we must do so in terms of contemporary taste. It is not a question of minimizing anachronisms in the historian's point of view; it should be the very basis of an historian's work. Insofar as the artistic quality of a work of art is concerned, the task of the historian is to recognize what was pleasing formerly and to reconstruct the foundations of this forgotten taste. Indeed the success of the *Allegory of Faith* leaves little room for doubt about the high esteem in which Vermeer's contemporaries held this painting.

In 1699, the *Allegory of Faith* went on sale in Amsterdam, bringing the sum of 400 florins, that is, exactly twice what the *View of Delft* (fig. 44; plate XIII) had sold for three years earlier, also in Amsterdam. The identity of its owner at the time it went on sale is still more significant: he was a controller of the Amsterdam Wisselbank and postmaster of the Hamburger Comptoir in Amsterdam, Herman van Swoll (1632–1698). He was an important collector, the owner of many works by Italian painters and the best contemporary Dutch artists; in the home that he built for himself in 1668 he had the mural decorations done by such important painters as Nicolas Berchem and Gérard de Lairesse.[41] And he was a Protestant, so it is clear that it was the artistic quality of the painting that captured his eye when it came on the market and made him want to buy it (unfortunately we do not know when that was). The appeal is more easily understood if we recognize that the manner adopted by Vermeer in this work was an example of the "fine" and "polished" style popular among certain Dutch artists of the period. As Montias has noted, the cold classicism that Vermeer demonstrates in this work differs from his style in the works most admired today. He had no doubt been inspired by the desire to compete with the "fine painting" then in vogue in Leyden and Amsterdam. Without leaving Delft, Vermeer demonstrated his capacity for *aemulatio* of the work of the most artistically active cities.[42]

Understood in this way, the *Allegory of Faith* confirms Vermeer's artistic ambition and suggests its twin constituents: a historical ambition (to be the

equal of his best-known contemporaries and to participate in the history of contemporary painting) and a theoretical ambition (to develop an allegory within the limits of the timely genre of painting, the interior scene—that is, to re-think the very theory of genres).[43]

The *Allegory of Faith* shows that Vermeer's painting, his structure, and his intentions must be seen in the way that Vermeer doubtless conceived them, in terms of painting. It is not a question of making Vermeer an "art for art's sake" adept, which would be just as anachronistic. Rather, it is that his pictures constitute a response to the situation of painting and the painter in Holland in the third quarter of the seventeenth century. It is a response worked out in terms of painting and by continually posing and resolving artistic problems.

The-Picture-within-the-Picture

THE ENTIRE OEUVRE of Vermeer that has come down to us consists of thirty-four or thirty-five paintings.[1] Interiors form by far the largest group, with twenty-five canvases; the others include three religious paintings (among them the *Allegory of Faith*), two outdoor scenes, one mythological painting, and one allegory (*The Art of Painting*). This count, a meager total, is well known. One is tempted to add to this list the eighteen pictures that appear within his pictures and to consider them as a secondary corpus. This complementary group, Vermeer's eighteen pictures-within-pictures, merits attention in more than one respect.

The composition of this group is quite different from that of the thirty-four "Vermeers": there are six landscapes, one of them a seascape (to which we could add three landscapes painted on the covers of musical instruments), four religious paintings (two examples of The Finding of Moses, one Last Judgment, and one Crucifixion), representations of Cupid appearing in three works, a genre scene appearing twice (a Procuress), one historical painting (a Roman Charity), one portrait, and one still life with musical instruments.

Of this group, two originals that were "copied" by Vermeer have been clearly identified. The *Procuress*, which appears in *The Concert* (fig. 4) and *Lady Seated at the Virginals* (fig. 6), comes from a work painted by Dirck van Baburen in 1622, today in the Museum of Fine Arts, Boston (fig. 5). The Crucifixion that serves as a background for the *Allegory of Faith* was painted by Jacob Jordaens and is today in the Terningh Foundation in Antwerp (fig. 7). These two paintings belonged to the artist's mother-in-law and were in the house where Vermeer went to live soon after his marriage. It is generally thought that this was also the case for the other sixteen pictures that Vermeer represented—that they either belonged to Maria Thins or were part of the artist's personal collection, or at least of his commercial stock.[2]

It is, in fact, more reasonable to see these as representations of paintings that Vermeer had in front of him than to suppose that they were personal inventions of the painter, which would considerably enlarge the number of themes used by Vermeer in his own work.[3] Even so, Vermeer's treatment of

these pictures-within-pictures is interesting for the light it casts on his conception of his art.

Pictures-within-pictures are common in Dutch painting. Although churches were bare of images, Dutch homes were abundantly decorated with pictures. The picture-within-the-picture, whatever its theoretical effect, was first of all evidence of the close relationship of painting to the surroundings in which life was lived.[4] It is not their sole function, however, to evoke the private background within which the painting was done. As Eddy de Jongh showed long ago, they usually helped to establish a moral and "emblematic" commentary on the principal scene.[5] Here again, Vermeer's practice was not radically different from that of his contemporaries. For example, if a seascape (the only one we have by Vermeer's hand) appears in the *Love Letter* (fig. 17), it does so because of the common association at the time between love and the sea, the lover and boat seeking the port of happiness. As Arthur Wheelock has pointed out, *Love Letter* is in this respect very much like an emblem in the collection published by Jan Krul of Amsterdam in 1664. While the picture-within-the-picture may have been copied from one of the two "small seascapes" present in Vermeer's house, it suggests in an obvious way the amorous tone of the letter that the young woman holds.[6] The nature of the picture-within-the-picture is enough to legitimize the modern title given the work.

In this, Vermeer is typically Dutch, the motif of the picture-within-the-picture being so common. A closer examination, however, reveals certain aspects of Vermeer's originality, his own particular "genius." For with Vermeer the representations of these paintings are far from faithful or "realistic." They are also far from a simple demonstration of a moral or emblematic lesson. They resist easy explanation, an end the painter explicitly worked toward.

FALSE CITATIONS

The Procuress of Van Baburen (fig. 5) appears twice in Vermeer's work, in *The Concert* (fig. 4) and in *Lady Seated at the Virginals* (fig. 6). Knowing the original work by the Utrecht painter, we can establish how Vermeer carefully reworked the painting in his representations of it.

Two versions of Van Baburen's canvas have been preserved. The one in the Rijksmuseum in Amsterdam, known for a long time, was thought to be original until the signed and dated canvas that is now in Boston appeared on

the market. The latter is superior in quality and the Amsterdam version is very likely a copy, as is suggested by the fact that in the Amsterdam *Procuress* the right-hand side is reduced, giving the composition a more conventional, symmetrical balance. According to Lawrence Gowing, the way that Vermeer reproduced the painting that he had in front of him, the "fidelity" that he showed, demonstrates that he "copied" the original work of Van Baburen.[7]

But Gowing goes too far in saying that the representations Vermeer made of *The Procuress* "precisely follow" the signed painting. If the twice-repeated appearance of this canvas does indeed constitute two "citations" of one known work—the representation of the frame playing the role of quotation marks around a textual citation—it is all the more important to insist that this citation is, in both cases, inexact, distorted, made to submit to the organization of the painting in which it appears.

In *The Concert*, the picture is completely visible, and Vermeer respects the format and, apparently, the dimensions of the original (101 × 107 cm). In *Lady Seated at the Virginals*, on the other hand, *The Procuress* has expanded considerably in dimension—this impression being reinforced by the fact that Van Baburen's picture is not cited completely but is cut off in height and width by the edges of the canvas, so that its limits are not completely defined. Moreover, in *Lady Seated at the Virginals*, even the format of *The Procuress* seems to have changed. It gives a clearly vertical impression, whereas in fact its appearance is slightly horizontal; in a curious way, this *Procuress* more closely resembles the Amsterdam copy than the Boston original. But the transformation of the format is far from careless or meaningless: thus cut off, the "citation" of Van Baburen occupies a vertical rectangle in the upper right corner that is exactly proportional to the canvas within which it is inscribed. This arrangement reinforces the visual effect of the citation both in the composition of surface and in the emblematic value that the presence of the "bordello scene" has in the context of a lady seated at the virginals.[8]

So, even if Vermeer copied the work faithfully enough for us to recognize it and indicate that his mother-in-law possessed the original, that fidelity is relative. The work was made to submit subtly but strictly to what Vermeer thought necessary for his composition and for the painting's effectiveness.

The liberties Vermeer took with the pictures he copied appear more clearly in the case of Jacob Jordaens' *Christ on the Cross* (fig. 7), cited in the background of *The Allegory of Faith* (fig. 8; plates II–III).

A comparison with the original shows us that Vermeer eliminated the man on the ladder behind the cross and the figure of Mary Magdalene at its

foot. These omissions are not without iconographic consequences. While Jordaens' picture closely depicts the Crucifixion, or possibly evokes the beginning of a Deposition, the image that Vermeer makes of it is less dramatic and is, rather, an immense "devotional image," regrouping St. John and the Virgin at the foot of the Christ on the Cross according to a composition reintroduced by the Catholic Counter-Reformation. However, the fact that Vermeer keeps the melancholy female figure (one of the three Marys at the foot of the cross) between the silhouette of Mary and the body of Christ suggests that the transformation stemmed not from iconographic causes but, more likely, from formal considerations. The presence of Mary Magdalene and the man on the ladder would have obscured and confused the "reading" of the image Vermeer constructed. Appearing beneath the shoulder of the figure of Faith, Mary Magdalene's head would have been difficult to recognize, needlessly complicating this part of the painting; and the bright accent on the body of the man on the ladder would have weakened the luminous effect of the reflections in the glass above, the doctrinal importance of which is in fact essential to *The Allegory of Faith*.[9]

The authority with which Vermeer remade the works that he copied is obvious once one is aware of the originals, but the same authority can be seen when a picture appears several times in different forms (like The Finding of Moses), or when Vermeer deliberately altered the citation within a single example, as with the Last Judgment.

In 1668, Vermeer signed and dated *The Astronomer* (fig. 9). On the back wall in this work he painted a picture whose subject has been recognized as a Finding of Moses, although its original has not been identified positively.[10] The framing of *The Astronomer* obscures what the format of the original Moses may have been, but the canvas represented here was clearly meant to be of moderate or even small dimensions. Two or three years later, in the background of the *Lady Writing a Letter with Her Maid* (fig. 10), Vermeer again painted the "same" Finding of Moses as in *The Astronomer*. This time the citation is cut off at the top and on the right, so that the format of the original still remains unknown, and the picture-within-the-picture is, in other ways, profoundly modified. Not only are its apparent dimensions considerably enlarged but the relationship of the figures to the surface has also changed: the upper part of the landscape has grown higher and the group of personages is farther from the left edge of the picture. (In the preceding version, the side figure of the group is cut off at knee level.) Vermeer specialists have observed the expansion of the Moses from one picture to the other, but without additional comment. It is, however, a striking demonstration of the way that Vermeer adapts the paintings he

represents to the purposes of his own compositions, rather than faithfully representing them.[11]

The treatment of the Last Judgment that serves as a background element in *A Woman Holding a Balance* (fig. 20) is particularly instructive. We will see later how this picture-within-the-picture plays a decisive role in the emblematic and moral interpretation of the canvas. Its geometric position is strongly accentuated, with an obviousness unusual in Vermeer; it takes up almost the entire upper right quarter of the canvas. Iconographically and formally, this Last Judgment is the most prominent picture-within-the-picture in Vermeer's work. Subtly but purposefully, Vermeer has distorted the lower part of its ebony frame; as Arthur Wheelock has noted, the frame of the Last Judgment is wider and descends lower to the right of the female figure than to the left.[12] Serving to free up a light neutral background for the pair of scales and to allow them to be set off at the geometric center of the image, this manipulation says a good deal about Vermeer's "fidelity" to the objective reality of what the eye sees.

Only naive or mistaken ideas of how painters work could cause surprise at Vermeer's manipulations, either obvious or surreptitious, of his pictures-within-pictures. Equally important distortions in the work of his contemporaries could be found if we studied their works with the same minute attention that we devote to the thirty-four canvases of the "sphinx" of Delft. However, the scrupulousness of his work and the quality of reflection implied by his slow production give his manipulations a resonance lacking in the case of a painter who worked rapidly and produced many canvases. In any event, these manipulations challenge the idea that his painting is "realistic" and the idea that his canvases have a "descriptive vocation," that their essential aim is to transcribe the appearance of objects, or as Goldscheider believed, that his art is "an art of painting, not of composition."[13] We should keep this in mind when considering the various geographic maps that we meet in his work. A scholarly approach allows us to identify and date each map reproduced by Vermeer. Considering, however, what has just been said about the "realism" of his transcriptions, prudence and appreciation of subtlety are needed in analyzing the ways in which these maps are introduced and reproduced, are "cited," in his pictures.

THE SUSPENSION OF MEANING

It has already been noted that in Dutch paintings of the seventeenth century pictures-within-pictures customarily have an emblematic function, and that

Vermeer's do not differ fundamentally from those of his contemporaries. Careful attention allows us, however, to discern the "deviations" his art makes within the apparently commonplace. Just as he carefully worked out the formal presentation of his pictures-within-pictures, Vermeer manipulated their symbolic functions. The extreme economy with which he represented them reinforces their visual effect within the painting. His pictures-within-pictures have a manifest presence, sometimes more insistently than do the works of his contemporaries and the force of this presence accentuates the symbolic content he invests his paintings with—a meaning, however, that often remains uncertain, eluding our grasp. It is as though Vermeer were playing with the common motif of the picture-within-the-picture in such a way as to alert us that there is a meaning, and at the same time to prevent a grasp of that meaning.

A Woman Holding a Balance (fig. 20) presents the clearest example of this paradox. The imposing presence of a Last Judgment in the background shows that the action of the young woman carries moral and religious connotations. But a precise definition of these connotations is impossible: the picture defies all unambiguous interpretation and has sparked five very different hypotheses, all equally plausible.

Albert Blankert first proposed that we understand the painting as opposing the young woman's action to the image of the Last Judgment. Busy weighing precious material, attached to worldly goods without thinking of the final judgment, the young woman personified Vanity.

A later microscopic examination revealed that the weighing pans of the balance were empty. Arthur Wheelock thus identifies in the young woman's concentration on the scales and her apparent indifference to the jewels lying on the table a woman responsible for her own actions, which she weighs and balances. The mirror on the wall facing her would indicate her willingness to know herself: "In her acceptance of the responsibility of maintaining the balance and equilibrium of her life, she is aware, although not in fear, of the final judgment that awaits her."

For Nanette Salomon, the Last Judgment, a theme that was rarely treated by Protestant painters, should be seen in relation to the fact that the young woman is apparently pregnant and that the two pans of the scale are in balance. The religious meaning would then be expressly Catholic. In relation to the Last Judgment, the equilibrium of the balance would belie the Protestant doctrine of predestination.

Following this, Ivan Gaskell related the mirror on the wall to the scale at the center of the image, interpreting the meaning of the canvas in terms of Cesare Ripa's *Iconologia*, widely known at the time: a woman of noble

appearance, holding a mirror in her right hand and a gold balance in her left, is the allegorical figure of Truth. Combined with the Last Judgment and the pearls on the table, this Truth becomes "divine truth and revealed religion."

Coming back to the problem, Blankert then proposed that the moral sense of *A Woman Holding a Balance* is the "triumph of Time over material forces." His interpretation relies in particular on an engraving from the beginning of the century where the figure of a young woman with a balance is associated with a background representation of a Last Judgment while six lines of text explain the meaning of the image.[14]

Iconographic and scientific investigation, marvelous as they are, make the uncertainty insurmountable (which interpretation shall we choose?). But they also arouse the suspicion that the answers are somehow peripheral, that the question of the moral meaning of the Last Judgment has been badly posed. In attempting to interpret unequivocally a painting whose allegorical meaning is deliberately uncertain, the iconographic approach complicates in the extreme with possible allusions an apparently simple picture. The iconographer is not wrong to look for a moral meaning, but before drawing final conclusions it is imperative to look at this apparent simplicity, to ask how the meaning is articulated and made manifest within the picture itself.[15]

For example, to demonstrate that the balance pans are empty and eliminate the idea (suggested at first glance) that this is a representation of Vanitas, microscopic examination was necessary. It is very unlikely, however, that a contemporary viewer would have looked at the painting with such an instrument. Iconographic hypotheses are doubtless meant to rediscover the meaning that Vermeer himself intended; but they fail to note that Vermeer himself did not try to make this meaning immediately perceptible. To the naked eye, it is not certain that the balance pans are empty.

Thus while the presence of the Last Judgment puts the young woman's act in a religious context, Vermeer does not define this context; thus the meaning is both undeniable and uncertain. It is revealing that when Pieter de Hooch made use of Vermeer's arrangement he eliminated this ambiguity: he chose the traditional treatment of the theme and removed the picture-within-the-picture entirely (fig. 18).

As Gaskell himself notes, the perception of the moral meaning of *A Woman Holding a Balance* is at the same time imposed by the presence of the picture-within-the-picture and confused by the way that Vermeer uses his allegorical material. If *A Woman Holding a Balance* is typical of Vermeer, it is, Gaskell says, because the allegory is "contemplative" rather than "expository." The observation is just. If we define his terms and their implications it

is even compelling: the "allegorical" meaning of *A Woman Holding a Balance* is not explicit ("transitive") but implicit ("reflexive").[16] In the context of the interpretation that Gaskell proposes, the term "reflexive" has the advantage of recalling that the implicit character of the allegory is tied to Vermeer's use of the reflective object par excellence, the mirror. Instead of being hand-held, as Cesare Ripa suggests, it is hung against the wall, as is common and ordinary. Instead of being turned toward the spectator, as in the work of Nicolas Tournier representing *Truth Holding a Mirror to the Vanities of the World* (fig. 19), it is turned toward the interior of the picture. It reflects nothing—neither for the woman, who is not looking at herself, nor for the viewer looking at the picture. The "mirror of truth" reflects the interior of the picture itself. Vermeer's picture is more than "contemplative," it is "reflexive": its meaning is played out within itself and it is there, if anywhere, that it is to be revealed.[17]

The imposing formal and iconographic presence of the Last Judgment makes *A Woman Holding a Balance* somewhat unusual among Vermeer's works, almost an object lesson. One is confronted, however, with uncertainty when the iconography of the picture-within-the-picture, while suggesting an emblematic elaboration of the principal scene, does not allow us to draw any clear moral.

According to conventions of the time, the presence of Dirck Van Baburen's *The Procuress* provides erotic overtones to the two pictures of Vermeer where it is cited: *The Concert* and *Lady Seated at the Virginals*.[18] But the presentation of the principal figures seems to contradict this erotic reading and to move it decisively away from the evocations that contemporary painters introduced with this theme. One could even suspect that the whole canvas deliberately sets itself against the idea of venal love that the picture-within-the-picture evokes, thus playing both with and against the iconographic reference.

In other cases, the lack of iconographic transmission precludes any definitive interpretation while it simultaneously reduces the possible association of ideas. Thus we can establish that the picture of which a part appears in the upper left corner of the *Girl Asleep at a Table* (fig. 12) is the same Cupid that appears in *Girl Interrupted at Her Music* (fig. 13) and *Lady Standing at the Virginals* (fig. 14). In the *Girl Asleep* Vermeer makes the figure of Cupid barely identifiable and at the same time gives it a mask that disappears in the later "citations." This detail is the only clearly iconographic element of the picture-within-the-picture. He thus hints at a moral reading, but one that cannot lead to any certain result. *Girl Asleep* has given rise to a number of interpretations, both diverse and seductive.

29

Swillens sees it as an evocation of amorous disillusionment, since the mask has fallen off; the young girl is not asleep but rather prostrated.[19]

For Madlyn Kahr, the picture has a precisely articulated moral meaning. The young girl symbolizes Sloth, the vice that paves the way for all others (evoked by the objects surrounding the principal figure). The message of the painting is clear: one must be active in avoiding the traps of sensual pleasures; worldly enjoyments are nothing but vanity.[20]

Gowing sees the canvas as an image of Sleep, the moment when masks fall, uncovering the fantasy that is the sleeper's secret, which one may suppose is "a fantasy . . . of love."[21]

Blankert sensibly observes that the visible portion of the picture-within-the-picture is too little to permit its identification as a Cupid—once again, erudite knowledge would have falsified the perceptual circumstances in which the picture was seen and for which it was painted. Blankert thus sees the *Girl Asleep* as just a variation on the popular theme of the Sleeping Servant and possibly an allegory of Sloth.[22]

But Montias thinks that, even in this context, one cannot ignore the mask, which is in fact quite visible. If the somnolence of the servant is nothing but a mask, he asks, why is she pretending to be asleep?[23]

Aside from some excessive interpretations, omitted here, the imaginative fertility that interpreters have shown with regard to this painting in fact corresponds to a plurality of possible meanings that Vermeer intentionally offers the viewer. The way that he used, on two occasions, a Finding of Moses confirms this "polysemic" usage of pictorial representation. In *The Astronomer*, the Finding of Moses is the middle term, and whatever the exact emblematic significance, whether in a complementary or oppositional relationship with the principal figure,[24] it brings a religious and spiritual connotation to the canvas as a whole. In *Lady Writing a Letter with Her Maid* (fig. 10), where the same Finding of Moses has grown to immense proportions, it carries hardly any religious resonance but only a free thematic association with the epistolary activity of the principal figure.[25] From *The Astronomer* to the *Lady Writing a Letter with Her Maid*, the transformation of the picture-within-the-picture thus affects not only its apparent dimensions but even the meaning that it is thought to transmit: depending on the gaze that is turned on it, the Finding of Moses changes meaning. It is, in itself, polysemic.

It is time to draw some conclusions, at least provisionally, from these first observations.

With few exceptions, the divergent interpretations of the historian-iconographers are not arbitrary. They are justified by the fact that the

picture-within-the-picture, in Dutch painting of the seventeenth century, raises what I would call an "impulse toward meaning": the picture invites the viewer to draw a moral or spiritual lesson that is presumed to spring from the confrontation of the principal and secondary subjects within a single canvas. It would reduce the intention and meaning of these secondary pictures to see them only as insignificant and ordinary household decoration.

Furthermore, the care that Vermeer took in arranging these pictures in his work and the frequently laconic economy of his iconography further condense this effect of an "impulse toward meaning." In the first work where Vermeer used this device, the *Girl Asleep*, even though the allegorical meaning of the mask is uncertain (all the more uncertain because the figure of the Cupid is not shown), the visible part of the picture-within-the-picture is proportional to the format of the canvas itself. Reinforcing the presence of the secondary image, making it in fact intrinsic to the articulation of the principal image,[26] the strictness of the geometric construction emphasizes the "impulse toward meaning" of the picture-within-the-picture.

The divergences and aporias to which iconographic interpretations lead are thus due not to a lack of information or knowledge on the part of scholars but rather to Vermeer's plan, to his manner of using material to elude interpretation, to hold meaning in suspense, to make the "reading" of what is visible indeterminate.

Love Letter confirms this. It is enough to compare it with the apparently similar version of the same theme by Gabriel Metsu.

Metsu's *Young Woman Reading a Letter* (fig. 15) and Vermeer's *Love Letter* (fig. 17) treat the same basic iconographic material: a young woman (who wears the same type of clothing, of the same color), her servant, a letter, a seascape hanging on the wall, a laundry basket, a sewing cushion, a shoe (or a pair of shoes). The "subject" is the same, made explicit in the modern title of the Vermeer: the arrival of a love letter brought by the servant interrupts the young woman's activity (sewing in Metsu; music in Vermeer). The similarities end there. Systematically, Metsu "narrativizes" the incident, while Vermeer suspends its progression. Not only has Metsu's young woman plunged into the reading of the letter that she holds toward the window so as to see better, but she has dropped her thimble so suddenly that it has rolled up to the foreground of the picture.[27] In Vermeer, this narrative-making is almost absent, reduced to an exchange of glances (questioning or complicit?) between the servant and the woman. She has not opened the letter, the seal of which remains unbroken.

The treatment of the picture-within-the-picture in each heightens this difference. Metsu's servant raises the curtain that protects it. Her gesture draws attention to the seascape and helps to make the letter's contents explicit, while at the same time dramatizing the anecdote, as does the movement of the dog that turns its attention to the servant, suggesting simultaneously the theme of conjugal fidelity.[28] In Vermeer, the absence of the dog abolishes any reference to conjugal fidelity, whether maintained or betrayed; the seascape (emblematically "amorous") is there but takes no part in the action except to serve as a background to the two principal figures. These two pay it no attention that would confirm its meaning. And the existence of an additional landscape, dispersing the presence of a picture on the wall, somewhat dilutes the amorous reference of the seascape. It could be simply hanging there, its inclusion in the work not requiring that we attribute to it a meaning other than the literal.[29]

One can agree with Eddy de Jongh that Vermeer is particularly inexplicit: "The representations of Steen are generally clearer than those of Metsu. Metsu is usually more comprehensible than Dou. Dou in his turn is more easily grasped than Vermeer."[30] The uncertainty of meaning is deliberate in Vermeer, a principle that affects many aspects of his compositions. The motif of the picture-within-the-picture acts as a condensation of this uncertainty, the principle of which can be summarized as follows.

Representations of paintings in Vermeer's work belong to the contemporary emblematic system, but their primary function is not exposition of the moral of a scene that would otherwise be trivial. They thus do not really play the role of "citations." It seems that, as Gowing notes, Vermeer's pictures-within-pictures do not appear in the form of miniature or "conceptual replicas" of what the work represents, but rather are "purely visual phenomena, flat, toned, surfaces."[31]

This definition, which is accurate from a formal point of view, is worth considering on the theoretical level formerly proposed by André Chastel, according to which the picture-within-the-picture generally constitutes, within the painting where it appears, "a reduced model of its structure or a scenario of its production."[32] This formulation is particularly useful for bringing into the open the implicit theory that Vermeer developed for his art. As Chastel says in the same passage, his "intentions" are "complex, if not concealed."[33] His pictures-within-pictures not only show the importance of "tonality" or the role of surface effect in Vermeer's painting, but also, within the paintings themselves, reflect the "structure" and the "scenario" according to which Vermeer conceived his art.

From this point of view, *The Music Lesson* is worth special attention.

THE MIRROR OF ART

In his thirty-four pictures, Vermeer painted only five mirrors. Four of them reflect nothing at all; only that in *The Music Lesson* (fig. 24; plate IV) contains a visible reflection. As one might expect, what we see there is rich in significance.

In *A Woman Holding a Balance* (fig. 20), *The Milkmaid* (fig. 21), and *Woman with a Pearl Necklace* (fig. 22), the position of the mirror precludes any hope that the viewer may glimpse a reflection—for example, that of the young woman who gazes at herself in *Woman with a Pearl Necklace*. The *Girl Asleep at a Table* (fig. 12) shows that this absence of reflection was a choice made by Vermeer. On the back wall, which is seen through an open door, a mirror hangs beside a window, facing the viewer. But one sees no reflection, and this is all the more remarkable since Vermeer painted the blank mirror over the silhouette of a man that was originally in this place on the canvas.[34]

Only the mirror of *The Music Lesson* reflects something. And what we see there reveals how carefully Vermeer considered the use of this motif. Above the young woman playing the virginals, the inclined mirror reflects her face and bust; it also reflects the corner of the table painted in the foreground of the picture. Finally, in the upper section, the reflection continues, going beyond the space represented in the picture, showing the base of the easel of the painter who is at work painting the scene that we see (plate IV).

At first glance, this "invention" is only a variation on the theme of the painter at his easel reflected in the picture. In locating this reflection in a framed mirror, however, Vermeer subtly undercuts the use and function of the motif. The easel cannot be seen as an "accidental" reflection, such as one caught on a polished surface, convex or concave. The mirror's ebony frame, echoing the frame of the Roman Charity next to it, gives it the status of picture-within-the-picture.[35] It gathers together visible elements of the picture and, beyond the field of the picture, the very instrument of its production, the painter's easel. It thus incontestably displays the "scenario of the production" of *The Music Lesson*. But it does more; it displaces the reality of what is represented. What we see (*The Music Lesson*) is not a simple interior scene; it is the representation of this scene being turned into a picture. In other words, the mirror of *The Music Lesson* presents the representation as representation: these people are the models. They are posing, or, rather, they have posed. This interior view with figures is an artificial construct, the representation of a representation. For Vermeer, painting was indeed a "cosa mentale."

The construction worked out by Vermeer has a second, more complex

effect, which involves the viewer's own relationship with the picture. We must examine it closely, and enter into the fine adjustment of this reflection—Vermeer's arrangement transformed into a veritable device. This second effect depends first of all on the perspectival construction of the painting, which is worked out with particular care.

The position of the easel in the mirror suggests that the spectator shares the point of view of the painter. The perspective in fact puts the vanishing point of the orthogonals—that is, the point of the assumed projection of the spectator's line of vision—on the body of the young woman, on a plumb line with the easel. The mirror thus implies that the view of the painter and that of the viewer overlap. But at the same time, Vermeer has carefully excluded the spectator from the painter's point of view. This exclusion hinges first on the simple fact that the painter is absent from the mirror: nothing there indicates that he is seated in front of the reflected easel. The easel is not the painter, and his absence confirms that Vermeer's mirror is not a simple reiteration of the traditional motif of the "painter's reflection." It is a variation, working at another level, a more unobtrusive, more theoretical one.

And further, the height of the vanishing point shows that the spectator's point of view is not what the mirror implies for the painter. The vanishing point is indeed on a plumb line with the easel; the painter and the viewer are thus on the same perpendicular axis in relation to the canvas. But the vanishing point is placed very low in the space represented. The horizon line determined by it comes at the bottom of the windows.[36] This position might seem natural if we imagine that the painter is seated at the easel. But, if you look closely, the vanishing point is too low to correspond even to the view of the seated painter: midway, the height of the blue chair confirms that this line of vision would be higher than the vanishing point. The calculated nature of this arrangement is attested by the fact that it reappears in *The Art of Painting* (fig. 27; plates V–VI). Since the painter there is shown seated, his point of view is made explicit in the image, and the geometric vanishing point of the image is placed much lower, to the left of the young woman and at the height of the painter's wrist. In *The Music Lesson*, the viewer's position is closer to the painter than it is in *The Art of Painting*, but still does not share the same point of view; the viewer is, however, subtly excluded from a presence within the painting itself.

The framing of the image that Vermeer adopts confirms and reinforces this exclusion. The figures are distant, and the apparent depth of the field is considerable. However, the framing is tight—both in the upper part (the ceiling is cut off at the half-way point of the double window at the back) and

on the sides. On the right, the Roman Charity is only partially visible; on the left, the wall is cut off at about mid-point of the first half of the nearest window, with the floor continuing forward, ahead of the visible wall. By this framing, Vermeer creates a double and paradoxical impression: the proximity of the locale, the distance of the figures.

The pattern of the floor tiles allows us to conclude that the cutting off of both edges has been carefully calculated so as to correspond in depth to three clearly differentiated spaces:

—the visible part of the ceiling corresponds to the zone occupied by the virginals and the two personages;

—the visible area of the side wall corresponds to the chair and the viola da gamba;

—in front of that, closest to the picture plane, the ultimate band of space corresponds to the floor and the table covered with its carpet.

This framing, unusual in Vermeer,[37] slants like the mirror, making the flooring in front of the table move forward beyond the visible wall, without anything supervening to obscure the geometric evidence. It also emphasizes an apparently secondary element of the decoration: the table covered with its carpet, which, in the lower right quarter of the image, blocks and eclipses the spatial continuity. This spatial construction, the division of objects and figures within the depth of the represented space, reinforces the effect of distance between the viewer and the two painted figures. Reinforced by the chair and the viola da gamba, the table not only interposes a visual obstacle between the viewer and the figures, it accentuates the distancing of these figures by emphasizing how small they are in relation to the mass of the carpet, to the importance of its motifs, and to the size of the luminous pitcher.

The mirror reinforces this distancing. For if it suggests in itself a continuity and sharing of space between the figures and the viewer, the floor that shows in it is not otherwise represented in the picture. In its internal coherence, *The Music Lesson* becomes an inaccessible sphere. Its mirror does more than show the other aspect of objects or figures, as it usually does, it shows the internal inaccessibility of the picture; it makes clear that we do not see what is supposed to be shown, the presence of the living painter. This presence is evoked by the easel, but only refers to an absence, a past. Hidden in the canvas, the co-presence of the painter in the painting is forbidden to the spectator; the only place where it is indefinitely repeated is in the picture itself. In the intimacy of the picture, the mirror introduces a gap, infinitesimal but insurmountable, between the painter (who is painting) and the beholder (who is watching). This gap establishes the *present tense* of the

35

painting, an effect of presence that we can only acknowledge, that we can only witness without entering into its intimacy.

By displacing the traditional motif of the reflected painter and representing the absence of the painter in the mirror, Vermeer gives the composition of *The Music Lesson* a truly theoretical value. Without treating it anecdotally, he lets us see the process of the production of the painting: while he brings the spectator into close intimacy with the painter and with what is going on (and will continue), the painted representation excludes the spectator from it.

A final point must be underscored: this theoretical effect is not shown by iconographic means. It is not made explicit in the picture, but is allusive, evading our immediate grasp: it is the very structure of the work that produces the meaning. Nonetheless, theory is at work in the representation, and two factors indicate that this painting has, for Vermeer, a special place in his oeuvre.

Vermeer repeated, under various guises, the table in the foreground, already present in *The Procuress* (fig. 3), the *Girl Asleep at a Table* (fig. 12), and the *Girl Reading a Letter at an Open Window* (fig. 33; plates VII–VIII), but the reflection in the mirror appears as an exception in his work. Reflecting the painter's easel, it has a definite "reflexive" value: it displays Vermeer's thought about his art.

Furthermore, a careful analysis of the effects of the framing in *The Music Lesson* indicates that these effects have been meticulously thought out; Vermeer has clearly marked this framing: on the left side wall, the floor, and the ceiling.

Of Vermeer's other interior scenes, only two show both the floor and the ceiling of the room where figures are placed. They are the two allegories: *The Art of Painting* and the *Allegory of Faith*. One should not infer from this that *The Music Lesson* is a "disguised allegory." The formula inscribed on the virginals, however, suggests that the idea is not unreasonable.

The virginals of *The Music Lesson*, of all the keyboard instruments represented by Vermeer, is the only one whose raised cover has a text rather than a landscape, a true "titulus" of an allegory of music: MUSICA LETITIAE CO(ME)S MEDICINA DOLOR(UM)—music, companion of joy, remedy for pain. This inscription is also not particularly original. Benedict Nicholson has discovered that it was inscribed on two instruments made by Andries Ruckers in 1624 and 1640 and it is found on the virginals of the *Portrait of a Young Woman* painted in the 1640s by Karel van Slabbaert.[38] From a strictly musical point of view, the allegorical echoes of the text are

commonplace. The theme of the painting (a love theme) is, again, common: a young woman at the virginals, "assisted" by a young man. It is enough, however, to compare Vermeer's treatment with, for example, Gabriel Metsu's, to appreciate the originality of *The Music Lesson*.

In Metsu's *The Duet* (fig. 23), a religious text appears on the virginals. It is drawn from the Psalms,[39] and clearly contradicts the attitudes of the figures. On the other hand, the two pictures-within-the-picture (the landscape and, especially, the Feast of Kings painted above the young girl) are consistent with the pleasure suggested by the gestures of the two figures. The allegorical or moral meaning of the scene is both obvious and vague. Obvious because the opposition between the erotic posture of the figures and the Biblical text is evident; vague because the text inscribed on the virginals gives no solid key to interpretation. One cannot read it for what it is (a spiritual exhortation in the midst of a scene that contradicts it) without forcing the effect of the picture. As Svetlana Alpers observes, the text written on the virginals is one element of the representation among others, "all of this interlocked, even overlapping, but without any clear hierarchy or ordering."[40]

The allegorical meaning of *The Music Lesson* works in exactly the opposite way: it is not obvious but it is precise. Considered separately, the text and the posture of the figures are too neutral—the text too general, the attitude of the figures insufficiently explicit—for their mere juxtaposition to establish a clear moral meaning. Once the ensemble of elements is put in order, however, the moral meaning and the web of relationships can be perceived.

Gowing proposed the most careful reading. The Roman Charity of the picture-within-the-picture, his starting point, indicates that the emblematic theme is captivity and also suggests a remedy: in the Roman Charity, Pero suckles her imprisoned father Cimon. In *The Music Lesson*, the virginals tells us that music is the "medicina dolorum." In keeping with the love theme usually associated with the musical theme, the partially visible Roman Charity suggests the idea that the young man is a "prisoner of love," his love for the young woman at whom he gazes.[41] Gowing adds that the ancient origin of the theme of the Roman Charity is not irrelevant to Vermeer's introduction of this image into *The Music Lesson*. The story of the imprisoned Cimon nursed by his daughter Pero is found in Book 5 of the *Memorable Facts and Stories* of Valerius Maximus. But Valerius Maximus gives us neither a "fact" nor a "story"; his account is presented as a description of painting leading to a eulogy of that art.[42] If we add to that, Gowing continues, that the name of the protagonist of the Roman Charity, Cimon, is also the name of the Greek

painter who invented perspective, we can conceive perhaps a "distant and private analogy between the man of *The Music Lesson*, held prisoner by the woman before him, and the artist himself."[43]

Gowing's argument is brilliant but somewhat shaky, in particular because it must appeal to the mythological figure of the Greek painter to support the idea of an analogy between Vermeer and the masculine figure of *The Music Lesson*. Gowing relies on erudite information to formulate what is fundamental to the picture: the analogy that it makes between the painter (both present and absent) of the mirror and the man absorbed in gazing at the young woman.

Some scholars have recognized in this figure a self-portrait of Vermeer. The hypothesis is reasonable, but turns the interpretation in an anecdotal or autobiographical direction that is not in keeping with Vermeer's general attitude. It is on a theoretical level that the analogy between the painter of the mirror and the male figure of the picture works.

The very organization of the picture makes the figure of the young man, rotated by ninety degrees, relay the gaze the painter directs at the young woman, which is, in the picture, relayed "in person" by the mirror that dominates her. From the young man to the mirror (and to the painter) Vermeer has constructed a complex relationship of the gaze (doubled, rotated, lateralized: delegated) that is worth exploring,[44] since the way the male figure regards the young woman allows us to formulate the meaning of the gaze that the painter brings to his picture.

As the contemporary theme of *The Concert* (fig. 4) or *The Duet* (fig. 23) commonly assumed, the gaze of the young man, seen in profile, is a look of love. By analogy, the gaze of the painter is also a look of love, but a love that has less to do with the female personage who is represented than with painting itself.

Here we find a popular theme of the day, according to which the highest degree of artistic fulfillment is reached when the painter paints "for love of" his art. Originating in Aristotle's *Ethics*, transmitted by Seneca's *De Beneficiis*, the theme became fashionable in the Renaissance,[45] and at the moment when Vermeer painted *The Music Lesson* it was current in Holland. We find it in Samuel van Hoogstraten in a form close to Seneca's. On the outer sides of the perspective box that he made between 1654 and 1662, he represented the painter's three sources of inspiration: Fame, Wealth, and the Love of Art. This last is represented by a painter at his easel, painting the muse Urania who points to a winged putto leaning on a cloud and holding a banderole with the inscription, "Amoris causa."[46]

Thus, in a genre scene with a popular theme (a young couple together at a

musical instrument), the two pictures-within-the-picture suggest two levels of emblematic reading. The clearer, public level concerns the art of music ("letitiae comes, medicina dolorum"); the latent, hidden level concerns the art of painting, done "amoris causa." What is unique here is that Vermeer has slipped this intimate pictorial reference into the midst of an apparently ordinary, public, musical theme.[47]

One last remark on the relationship that *The Music Lesson* enjoys, in Vermeer's oeuvre, with *The Art of Painting*.

No matter what chronological order specialists adopt for arranging Vermeer's works *The Music Lesson* is the last in which a man and woman are seen together, with the exception of *The Art of Painting*. And it is, without exception, the last in which the man's face is visible in such a grouping. *The Art of Painting* reverses what is visible in this relationship: the woman shows her face to the viewer while the painter is seen from behind, concealing his face and his gaze even as he is shown busy painting. Between the two canvases, a relationship exists that makes *The Music Lesson* a turning point in Vermeer's evolution and makes its mirror the "mirror of art" towards which the painter would henceforth work. Several years later, *The Art of Painting* made explicit on the allegorical level the conception of painting that already informed the musical theme of *The Music Lesson*. And in his genre scenes, Vermeer would concentrate on what the mirror of *The Music Lesson* shows: a woman, under the gaze of the (absent) painter, in an interior. In this premonitory reflection, Vermeer has pruned away all superfluous, supplementary iconography. Through a musical theme caught in the mirror of art, he has declared painting to be a "cosa mentale," done "amoris causa."[48]

The Art of Painting

Despite the abundance and diversity of commentaries provoked by Vermeer's *The Art of Painting* (fig. 27; plates V–VI), there has been unanimity on one point: it is an allegory in which Vermeer has given form to what was for him the "Idea of Painting."

Still today, however, the question remains open as to what meaning Vermeer could have intended for this image. The attributes of the model (laurel crown, trumpet, book) make her incontestably a composite of Fame (Fama) and History (Clio); at the same time, the meaning of the various objects that embellish the picture, particularly those that are shown on the table, is still under discussion. With the assumption that they refine the allegory and make its meaning more specific, they sometimes evoke attributes of different muses, sisters of Clio—allusions to Euterpe as well as to Thalia, Polyhymnia, Erato, or Calliope have been suggested—and sometimes they suggest the three Arts of Design (painting, architecture, and sculpture), painting being the most privileged of this classic trinity.[1]

None of these interpretations is preferable to any other; none excludes the others; and none of them is decisive. The relative lack of iconographic differentiation, typically Vermeerian, even allows us to think that the picture implies all of them. Analysis could come to rest here.

If one is nevertheless prompted to take it up again, it is because the different readings of *The Art of Painting* suffer from the same weakness: they treat the elements of the image as independent motifs, each endowed with its own univocal meaning, which, when assembled, together form a "phrase" that gives us the "content" of the work. They "spell out" the picture to get at its meaning. This approach, a typically iconographic one, is far from arbitrary or anachronistic. It corresponds to rules laid out in the basic allegorical manual of the seventeenth century, the *Iconologia* of Cesare Ripa, which makes each element of an image a separate "attribute" of the allegorical figure that contributes to the definition of the "parts" or "qualities" of the notion represented. Applied to *The Art of Painting*, however, this way of reading is deceptive: it produces a commonplace interpretation for a highly original painting.[2]

To escape this commonplace, to avoid recognizing only the accepted and

conventional meaning for the elements articulated, one must not spell out this picture; one must rather focus on how the manipulation of these known elements in the work produces a signification particular to the work and to its maker. *The Art of Painting* presents a painter at work; while identifying the iconography implied by the furnishings of the painter's allegorical studio, we must also look at the way that Vermeer manipulates the various elements and the relationships he introduces between them. And we must further consider how this allegory of painting is *painted*, how the pictorial treatment shapes the representation and gives to otherwise well-known "iconographic" motifs their particular meaning.

A Personal Allegory

That *The Art of Painting* is an original and personal work is certain. This is true whether it is considered in relation to the body of Vermeer's work or in relation to the treatment that Vermeer's contemporaries would have given such a theme.

The dimensions of the canvas (120 × 100 cm) are enough to distinguish it from his other works. For Vermeer, it is a large format; it is bigger than the *Allegory of Faith* (114 × 89 cm) and is exceeded by only two "youthful" works, *Christ at the House of Martha and Mary* (160 × 141 cm) and *The Procuress* (143 × 130 cm). In choosing such a size, Vermeer returned to the dimensions he had used for his first religious or mythological paintings,[3] a return that shows the intellectual ambition *The Art of Painting* expresses. Of course the allegorical genre could have dictated the use of such dimensions but, in contrast to the *Allegory of Faith*, which was done on commission, it was his own initiative that prompted Vermeer to paint *The Art of Painting* around 1665–1666. At this time his professional career was at its height, between the two nominations as syndic of the Guild of St. Luke and shortly before Pieter van Berckhout called him "the celebrated painter named Vermeer."[4] This has led to the surmise that the painting was done either in response to a request by the Guild or at least for it, by way of homage. Archival documents have shown, however, that this was not the case: *The Art of Painting* did not leave the painter's home until his death. It is hard to imagine that the Guild would have refused such a gift, if offered.

The Art of Painting may be the only work that Vermeer deliberately kept for himself; he, thus, very probably attached particular importance to it. The efforts that his widow and his mother-in-law made to keep it from

leaving the family home and being seized or sold for payment of the painter's posthumous debts were pushed to the legal limits and speak eloquently to its importance.[5]

The choice of the allegorical genre is significant. The title of the canvas, *The Art of Painting*, was given personally by Vermeer, quite exceptionally. In the negotiations of the years 1675–1677, this was the name that his widow and his mother-in-law used to designate the work, and there is every reason to think that the picture was so called during the lifetime of the artist, in his own home. Some historians, however, give it another title, calling it *The Studio*. This title not only violated (posthumously) Vermeer's intentions; it erases an essential fact of the work, its allegorical import in the eyes of Vermeer himself, which testifies to the intellectual content with which it was imbued.

The Art of Painting is highly personal, unlike what Vermeer's contemporaries would have done. The themes of "allegory of painting" and "painter's studio" were well known during the period, but were separate. The allegory was developed according to the rules of the genre and utilizing its tools, while the image of the studio gave the opportunity to show, in painting, the actual circumstances of the painter's work. In mixing genres and blurring established distinctions, Vermeer embarked on an operation that is both original and precise in its elaboration.

The figure of Clio, muse of history, is not presented as a companion of Apollo; she is a real person, a model whom the painter has posed in order to turn her, in painting, into a composite figure of History and Fame. By contrast (and as a corollary), the painter and his studio are not presented in real circumstances. Compared with various Studios painted in that period, the studio of *The Art of Painting* is manifestly "unreal," or, more accurately, allegorical. The drapery in the foreground presents a remarkable decor, comparable to the *Allegory of Faith* (fig. 8; plates II–III), and the luxurious flooring with its impressive crosses of black marble is equally exceptional. As for the painter, seen from behind in luxurious clothing, he obviously does not demonstrate the actual circumstances of his work. Neither are his expected tools visible (palette, a variety of brushes, box of colors, prints, and so forth); one can see only the brush (but cannot distinguish its tip) and the maulstick (the use of which is, incidentally, incongruous at this preparatory stage of the work).[6] Vermeer has embarked on a double game: he has "de-realized," or allegorized, the painter and his studio while "de-allegorizing" the allegorical figure, shown with the features of a real painter's model.

One is tempted to call *The Art of Painting* a "real allegory," and to see its inspiration as parallel to Courbet's *The Painter's Studio*, to which he gave

the long title *Real Allegory Determining a Phase of Seven Years in My Artistic Life*. The parallel, however, stops short. The two works are too different. *The Art of Painting* is not at all "realistic" in the sense that Courbet used the term, and it would be reductive to interpret its conception as auto-biographical.[7] *The Art of Painting* and *The Painter's Studio* in fact have nothing in common—except perhaps that both canvases deliberately introduce a confusion to the "hierarchy of genres" already traditional in the seventeenth century. In Courbet, however, this confusion amounted to transgression; it is a tool of combat, ideological as well as pictorial. Vermeer's work contains in itself nothing of transgression. The double game that he plays is surreptitious; it marks, at the very most, his personal distance from the hierarchy of genres that then characterized professional activity and governed the art market.[8]

In this context, Hermann Ulrich Asemissen has recently proposed an interesting hypothesis for reading the painting. Relying on the statutes of the Delft Guild of St. Luke as reaffirmed in 1661, he sees in the different objects surrounding the painter the "symbols of the crafts to which painting was allied within the Guild of St. Luke." *The Art of Painting* would then be an allegory of the "arts and crafts existing within the Guild and associated with painting."[9]

Though this interpretation relates Vermeer's picture to the actual circumstances in which he practiced it is not satisfactory. Not only does it lead its author back to the erroneous supposition that the canvas was painted for the St. Luke's Guild,[10] but it too greatly reduces the theoretical and intellectual range of the allegory. As Asemissen himself emphasizes, the picture associates Painting with History and, indirectly, with Poetry. If Vermeer did not personally subscribe either to the doctrine of the hierarchy of genres or to the "metaphysic linked to this hierarchy,"[11] it is still true that in constructing for himself this allegory of "the noble art," he assigned the painter not an artisanal but a "liberal" role—"liberal" in the sense that contemporary Dutch theoreticians, following the Italians, used the term. Here Vermeer clearly distanced himself from the official, traditional attitude of the Delft guild, which it had just displayed in 1661—an artisanal and conservative one.[12]

In any event, a "professional" reading of the allegory would lead to two conclusions:

First, Vermeer exalted his art in relation to the crafts of the guild. In presenting the "symbols" of these crafts as so many attributes and instruments of the painter, he subordinated them to his art, putting them on a lower level, thus sufficiently marking the incomparable prestige of painting.

And second, Vermeer affirmed his personal position in an implicit and private manner. While just named syndic of the guild, he confided his ambitious conception of painting to a picture that was not intended for the public eye. It was for his home that Vermeer reserved this allegory, where painter and painting take themselves as subject.

THE PAINTER'S DOUBLE HORIZON

Whatever the iconographic value of its secondary accoutrements, *The Art of Painting* makes the young girl and the geographic map the dual principal subject of the painter's vision. It is in the interplay between these two that Vermeer finds the objective of painting, its incomparable prestige and its glory.

The young girl is the painter's model, upon whom he has turned his gaze, and whom he is in the act of painting in the guise of Clio. Like the Christ on the Cross in the *Allegory of Faith*, the map is emphasized by its dimensions and by the place that it occupies on the back wall. Among other things it fixes the *horizon* of the painter very exactly: between its cartographic representation proper and its lower band carrying a long explanatory text, the map includes an inner border that the composition of the painting puts at the height of the painter's eyes—as though it forms an image of the course the painter's gaze takes as though it inscribes the trace of that gaze on the surface of the painting.[13]

It is along this trace that Vermeer chose to sign his name, as close as possible to the figure of Clio. This signature is astonishing on two counts: Vermeer rarely signed his work, and this painting was reserved for private purposes. By signing *The Art of Painting* in this place, Vermeer thus intimately signaled his investment in the work. He ties the young girl and the map tightly together in the design of the picture by continuing the border pictorially into the darker edge of the blue cape thrown over her shoulders.

If the allegorical meaning of the young girl has been elucidated (she poses as the model for Clio-History and Fama-Fame), the meaning of the map is much less certain. It is crucial to clarify its function and signification if we are to get to the core of Vermeer's thought.

The original that Vermeer "reproduced" was identified some time ago. It is a map of the entire territory of the Netherlands, grouping together, to the north (found on the right), the Protestant Seven United Provinces and, to the south, the ten provinces that remained under the domination of the Spanish Hapsburgs after the Treaty of Westphalia in 1648. The map was

made by Claes Jansz. Vischer and was edited by his son Nicolaes, no doubt after 1652, the date of the death of Claes Jansz.[14] In keeping with the allegorical luxury of the studio, Vermeer proposes a luxurious version of the map, framed by a series of twenty city views.

This map was rather frequently represented in contemporary Dutch painting, its relative commonness making interpretation a delicate matter. It would be incorrect, for example, to jump to the conclusion that it is a sign of Vermeer's preoccupation with history or politics. Some scholars have indeed emphasized the fact that Claes Jansz. Vischer's map, in continuing to group together the Catholic and Protestant provinces, was out of date at the time that Vermeer represented it. They have linked the "dated" character of the map to two other elements of *The Art of Painting*, both of them also apparently "dated" by 1665–1666: the costume of the painter and the central chandelier that dominates the representation. The type of slashed doublet that the painter wears was indeed out of style in 1665; and the chandelier, with its two-headed Hapsburg eagle on top, would have alluded to a bygone epoch of Dutch history. It has been thought that the map, the chandelier, and the painter's costume constitute a cluster of "backward-looking" allusions, an idea fully justified by the figure of Clio-History set against the map of a vanished historical reality. And since Clio furthermore holds the trumpet of Fame, *The Art of Painting* has thus been understood as imbued with a double nostalgia, nostalgia for the lost unity of the Catholic Netherlands, and nostalgia for the glory that painting then enjoyed— before Protestant domination profoundly changed the social and intellectual circumstances of its practice.[15]

The hypothesis is seductive: it fits both the Catholicism of Vermeer and the character of his artistic ambition, an ambition that did not seek commercial or social success in contemporary society but instead impelled the artist toward the meditative, inner expression of a *cosa mentale*, in the tradition of the "noble art."

The interpretation of *The Art of Painting* as nostalgia is, however, exceedingly weak. In order for the "backward-looking cluster" to furnish an indication of Vermeer's choices, each element would have had to be incontestably out of date in the 1660s. But this is not so clear. As Asemissen insists, the chandelier has the Hapsburg eagle but this does not necessarily imply an allusion only to the Spanish Hapsburgs, and thus to the recent division of the Seventeen Provinces; it may be a general reference to the history of the Netherlands. And again, the slashed doublet was without doubt an old-fashioned article of clothing at the date of the painting, but it was not out of date in painting. It is found in a number of pictures painted by Vermeer's

contemporaries.[16] Finally, and especially, the map of the Seventeen Provinces was indeed politically out of date in 1665 but, as James Welu has shown, this type of map continued to be issued well after the Treaty of Westphalia.[17] Thus it does not necessarily constitute a reference (planned and covert) to the lost unity of the Netherlands. One cannot base an interpretation of the allegory on the nostalgia that may have been implied by the prominence of this map.

Still worse, in tying the presence of this map too forcefully to the political history of the Netherlands, one runs the risk of specific iconographic overinterpretation with regard to a detail that is indeed significant: the large craquelure that runs vertically down the map above the painter's left shoulder.

Clearly accentuated by Vermeer, this detail has been the subject of rash commentary. After Tolnay and Sedelmayr had correctly pointed out its importance in the construction and effect of the canvas, Welu saw in it an explicit allusion to the division of the Netherlands. The location of this craquelure does not, however, correspond to the frontier separating the Catholic and Protestant provinces since it leaves Zealand, the second of the United Provinces, from an economic and political point of view, to the left, that is, in the south. But since the craquelure passes directly through the city of Breda, a city that played a crucial role in the wars that led to the division of the Netherlands, Welu thinks of it as a "dividing point" between the northern and southern provinces.[18] Asemissen rightly rejects this "overinterpretation," only to affirm once again that the craquelure marks the frontier of the Province of Holland. Vermeer, he thinks, here expressed "an identification with the historical role and importance of the province."[19]

Based on a "reading" of the map, these interpretations force the meaning that Vermeer gave to its presence and that he deliberately left in a state of "iconographic suspense." But, especially, they lessen the import of its presence. In a painting explicitly conceived and presented as an allegory, an object that occupies so prominent a place and on which the painter left his signature in such a decisive spot, necessarily has a signification that was well thought out, cerebral. Rather than resort to an iconographic approach that turns content into anecdote—and before considering the painting's overall scheme—we should ask about the values associated with cartography in seventeenth-century Holland. They cast some light on the reasons for the presence of this map in the picture and on its appearance.

Cartographic representation, the fruit of an ancient artisanal collaboration between a team of surveyors and a painter,[20] has a practical function that can be social or political. Plotting and recording serve, for one thing, to

demarcate the extent of territorial possessions, individual or collective, and potentially, to settle legal conflicts about limits and properties. It is not enough, however, to look at a map; it is necessary to know how to read it in order to interpret it, to make use of it. Its prestige is intrinsically tied to the cognitive procedure that directs its use. The map represents a type of knowledge. It is a "description" of the territory it represents (Vermeer uses the term in the title of the map in *The Art of Painting*); it appropriates real space into the order of knowledge—scientific knowledge whose "power expresses and affirms itself in the map as an effect of a representation, an effect of the representation."[21]

Texts exist that tell us how the prestige of geographic maps in the seventeenth century depended on the fact that, by putting a representation "before one's eyes," they acquainted those who viewed them with faraway places or countries unknown to them.[22] This conception has a dual consequence, with an influence on *The Art of Painting* that has not been sufficiently recognized.

In the first place, the knowledge particular to the geographic map, its means of "demonstration," associates it closely with the art of painting. Painting, also, "puts before one's eyes," "makes the absent present," "demonstrates" its knowledge of the world. It is not a matter of a vague connection: on both the practical and theoretical level the relationship between geography and painting had been recognized and precisely formulated since antiquity. Ptolemy's *Geografia*, after having proposed that "geography is an imitation of the painting of the whole known earth," distinguishes "geography" (which deals with the world as a whole and depends on mathematics and geometry) and "chorography" (which deals with the representation in detail of particular places, that is, topographical views).[23] It was not without good reason that Vermeer presented Vischer's map framed by twenty topographical views: in the traditional dual articulation (geographical and chorographical) and in the allegorical context of the picture, what is represented is the whole of the "demonstrated knowledge" of geography as an "imitation of painting."[24]

There is more. For the seventeenth century, cartography was in league with history. In 1663, Joan Blaeu dedicated his twelve volume *Atlas* to Louis XIV with the explicit words: "geography is the eye and the light of history." As Svetlana Alpers emphasizes, the idea that geography "makes us see" what history tells us is not new; it had been raised more than a century earlier and was current in the seventeenth century.[25] Again, it was not without good reasons that Vermeer placed Clio in front of a grand and luxurious map of the Seventeen Provinces. In its ideational content and

form, the map is associated with the history of the Netherlands; it puts it "before our eyes."

One detail of the lateral placement of city views constitutes a strong indication of this conception. At the bottom of the left hand column, appearing between the trumpet of Fame and the book of History, Vermeer put a view of the "House of Holland," in The Hague; corresponding to it on the right and pointed out by the red knob of the maulstick, is a view of the "House of Brabant" in Brussels. We do not know what the arrangement of topographic views may have been in the example that Vermeer had before him, but whether it was present in the original map or introduced by Vermeer, this deliberate balancing, in the painting, of two political residences is not fortuitous; it makes an undeniable reference to the modern history of the Seventeen Provinces and their division between Protestants and Catholics.[26]

In the allegorical field specific to *The Art of Painting*, Clio and the map of the Seventeen Provinces present painting as "demonstrated knowledge" under its triple form of history, geography, and chorography. In terms that were those of the seventeenth century, Vermeer constructed an allegory of painting in which that art sees itself confirmed in its noblest aims.

"Nova Descriptio"

One may of course ask whether this is not attributing excessive importance to an object whose presence is, after all, a commonplace in painting. The four maps represented in Vermeer's works are known,[27] and the precision with which he "reproduced" them shows that he had them in front of him when he painted them. The meticulousness of his rendering even constitutes, for some, an argument in favor of the "realism" that he demonstrates in painting.[28] In short, common sense suggests that we should not "theorize" too much.

However, we must not forget that *The Art of Painting* is an allegory, explicitly conceived as such, and that the choice of its various elements has thus been the subject of intellectual reflection, in which these elements constitute the "attributes" of Painting. Furthermore, the very "picturality" of Vermeer's paintings ought to prevent our trivializing the image of his "maps-within-the-picture" by an excess of down-to-earth prudence. The meticulous care with which he treated the cartographic object differs from the rapid sketches of his contemporaries. With Vermeer, the maps acquire a "weight of painting" that we fail to account for by simply evoking his

"descriptive realism." The pictorial elaboration that he expended on them invites a second look.

For example, the maps that appear in the *The Officer and the Laughing Girl* (fig. 28) and *Woman in Blue Reading a Letter* (fig. 30) at first glance look completely different from each other in their apparent dimensions and their tonality. In fact both represent the same map of Holland and West Friesland, published in 1620 by Willem Jansz. Blaeu.[29] Where then is the "realism" of Vermeer? In the first use that he made of this map (*Officer and Laughing Girl*), he clearly manipulated its "real" appearance: the land areas are colored blue while the water areas seem to keep the color of the vellum on which the map was printed.[30]

This kind of manipulation shows that Vermeer's maps, far from being simple reproductions of existing maps, are "images of maps," conceived and executed as a function of the pictures in which they appear. This is the same phenomenon that we observed with regard to the pictures-within-the-pictures and, to use Gowing's terms Vermeer's maps are not "conceptual replicas" but "visual phenomena."[31]

But a map is not a painting. In the seventeenth century it was the carrier of a prestigious representational knowledge. Its submission in the order of painting thus touches what is, in painting, the knowledge of representation. In an allegory, the pictorial treatment of the map engages the painter's conception of knowledge in painting and of the relationship in painting between seeing and knowing.

Of course, in painting, maps are not meant to transmit knowledge, to be "read." They are there to be "seen." However, the attention that Vermeer brought to their rendering exceeds what a simple visible presence would require. Vermeer was, furthermore, the only one of his contemporaries to bring such "pictorial" attention to maps. The map of the Seventeen Provinces has been meticulously painted, without being "depicted." The learned meticulousness of the painter has displaced the domain and objective of representation: what Vermeer "depicts" are the circumstances under which the map is visible in the painting. More visible than maps usually are in Dutch painting, promoted to the rank of a major attribute of Painting, the map remains still an unreadable "painted map." The truth that it bears and transmits is a truth of painting, the truth of its pictorial presence and appearance.

The minute care with which Vermeer treated the "accidents" that affect the surface of the map in *The Art of Painting* is significant. The deliberate blisters, the oblique waves caused by the hanging and the weight of the object, create various luminous configurations within the representation of

the map, zones of shadow that obscure the visibility of an object pains-takingly represented. This particular paradox is deliberate: this is what the great vertical craquelure above the painter's left shoulder demonstrates.

Doubtless too preoccupied with assigning the craquelure an icono-graphic and political meaning, critics have neglected to mention the ex-treme linear precision with which its spine is "depicted," in clear opposition to the relative haziness of the adjacent areas of the map. This contrast corresponds to a pictorial choice that Vermeer had slowly refined. In the *Officer and Laughing Girl* (c. 1658; fig. 28) and the *Woman with a Wine Jug* (1662–1665; fig. 29), the surface of the maps are perfectly flat; no folds, blisters, or craquelures leave their mark. In the two other maps painted before *The Art of Painting* (*Woman in Blue Reading a Letter*, fig. 30, 1662–1665, and the *Woman Playing a Lute*, 1662–1664), surface accidents are present but, in terms of rendering, their representation is approximate; it is more a modulation of the pictorial material than a scrupulous and precise representation of a fold or blister.[32] It is only in the *Art of Painting* that these accidents are "depicted," that they become the subject of a "description" in the seventeenth-century meaning of this term.

Since *The Art of Painting* is an allegory, one should not neglect the theoretical import of the brilliant meticulousness with which Vermeer care-fully represented accidental damage to the surface of the map. If there is "demonstrated knowledge" in the map of the Seventeen Provinces as Ver-meer painted it it concerns the incidence of light and how it affects the appearance of the map, and how one becomes aware of it in painting. Several years later, *The Geographer* (fig. 31) peremptorily confirmed this idea. On the ground and on the table, the strongest light accents of the picture correspond to the presence of maps. But these maps have become decidedly unreadable. The ones on the floor are rolled up; on the table, the map on which the geographer is working is spread wide open, perfectly visible, but irremediably unreadable. The dazzling light has consumed the representation.[33]

If we admit with Svetana Alpers that cartography was an "impulse" of Dutch painting in the seventeenth century,[34] we must admit that few paint-ings demonstrate it so strongly as *The Art of Painting*. In this sense, Vermeer was once again "commonplace." It is critical, however, to recognize that the term "descriptive impulse" applied to his painting must not be understood only in the meaning that Alpers gives it. Vermeer does not describe or depict the map as a "descriptive object"; he depicts the presence of the map in light and, to adopt again an expression of Gowing, used with regard to *The Milkmaid* (fig. 21), the "cartography" to which Vermeer becomes attached is "the incidence of light."[35]

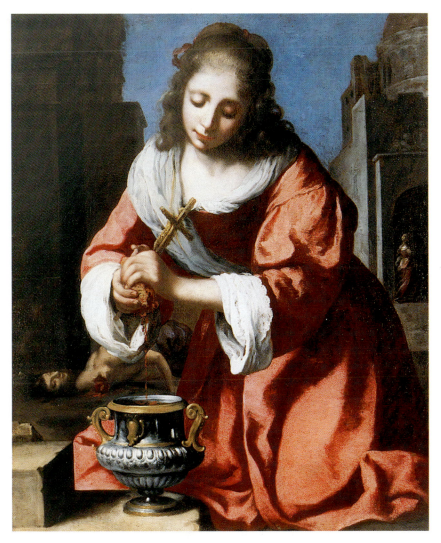

PLATE I. J. Vermeer, *St. Praxedes*,
Princeton, The Barbara Piasecka Johnson Collection

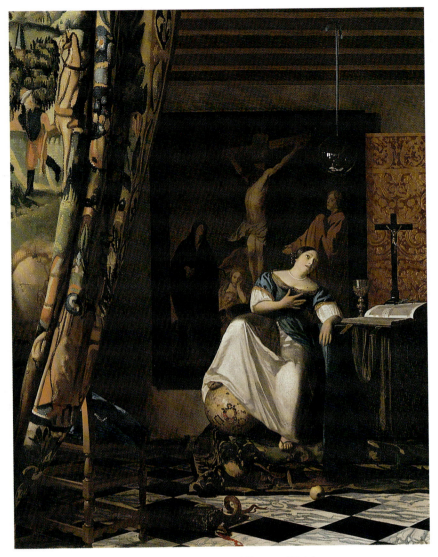

PLATE II. J. Vermeer, *Allegory of Faith,*
New York, The Metropolitan Museum of Art,
Michael Friedsam Collection, 1931

PLATE III. J. Vermeer, *Allegory of Faith,* detail

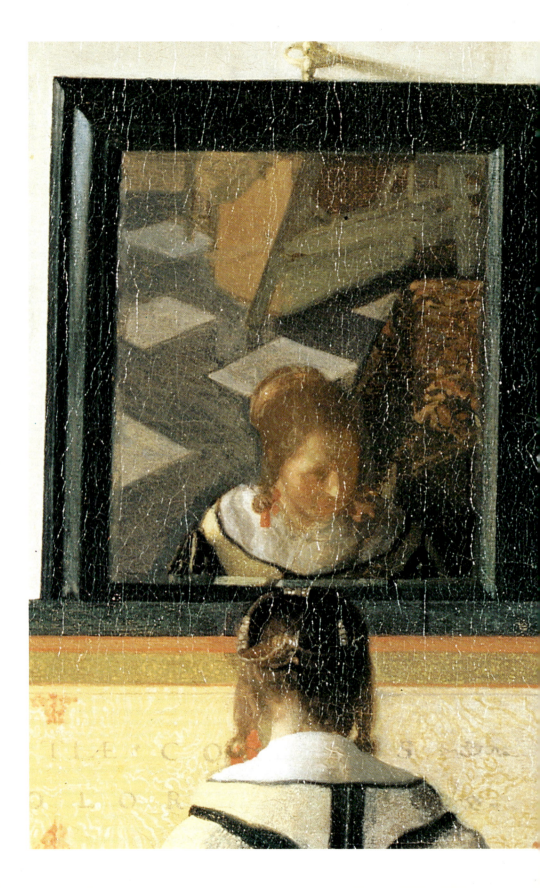

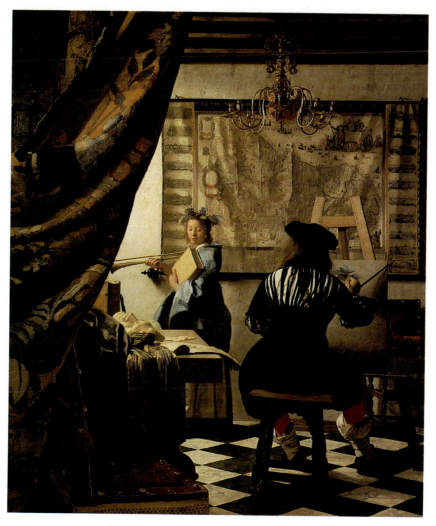

PLATE V. J. Vermeer, *The Art of Painting*,
Vienna, Kunsthistorisches Museum

PLATE IV. J. Vermeer, *The Music Lesson*, detail, London,
Buckingham Palace, by permission of H. M. the Queen

Following pages:

PLATE VI. J. Vermeer, *The Art of Painting*, detail

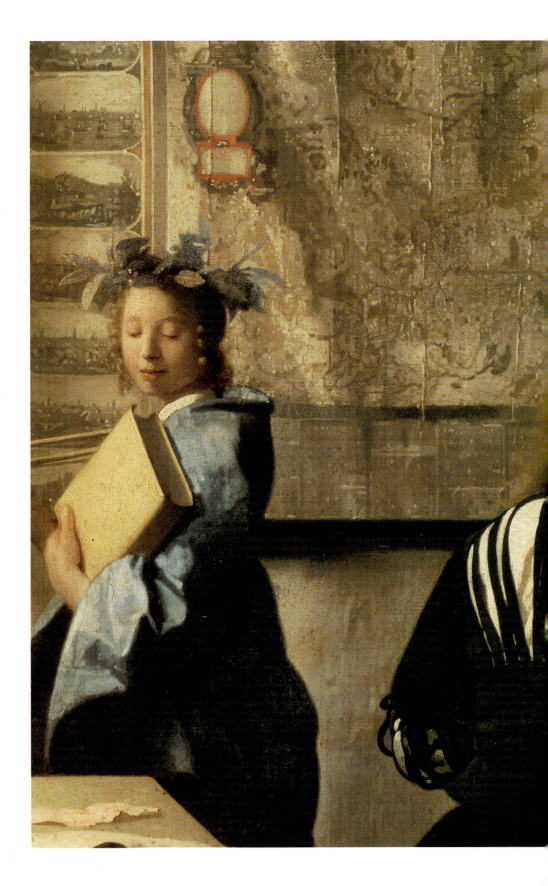

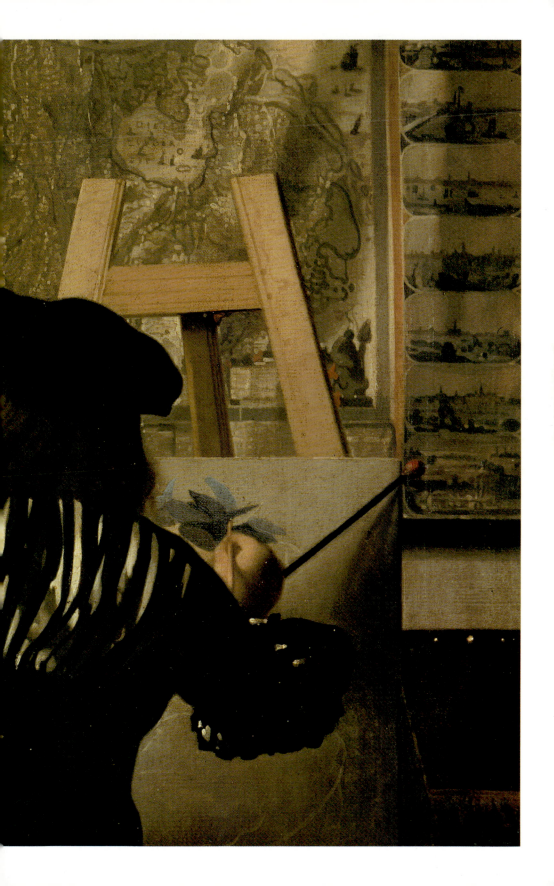

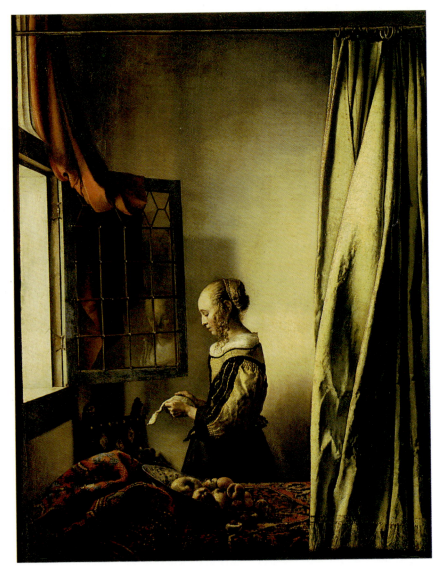

PLATE VII. J. Vermeer, *Girl Reading a Letter at an Open Window,*
Dresden, Staatliche Kunstsammlungen, Gemäldegalerie

PLATE VIII. J. Vermeer, *Girl Reading a Letter at an Open Window,* detail

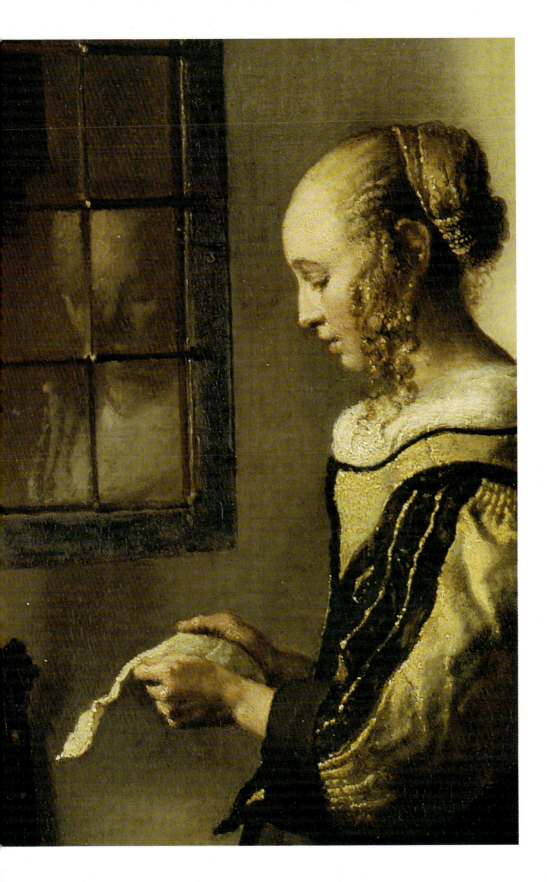

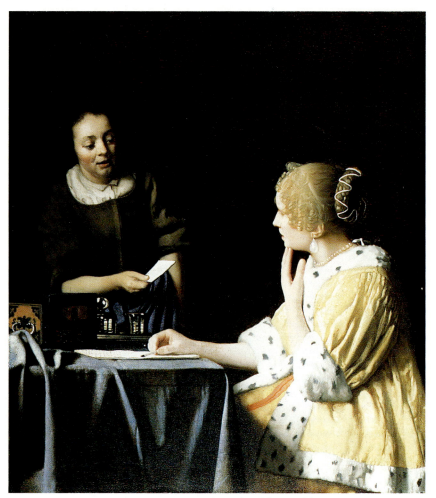

PLATE IX. J. Vermeer, *The Lady with a Maidservant*,
New York, Frick Collection

PLATE X. J. Vermeer, *The Lady with a Maidservant*, detail

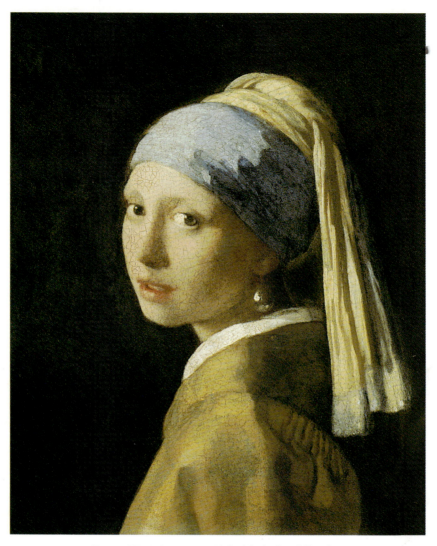

PLATE XI. J. Vermeer, *Girl with the Pearl Earring,*
The Hague, Mauritshuis

PLATE XII. J. Vermeer, *Girl with the Pearl Earring,* detail

Following pages:

PLATE XIII. J. Vermeer, *View of Delft,* detail,
The Hague, Mauritshuis

PLATE XIV. J. Vermeer, *The Lacemaker,* detail,
Paris, Musée du Louvre

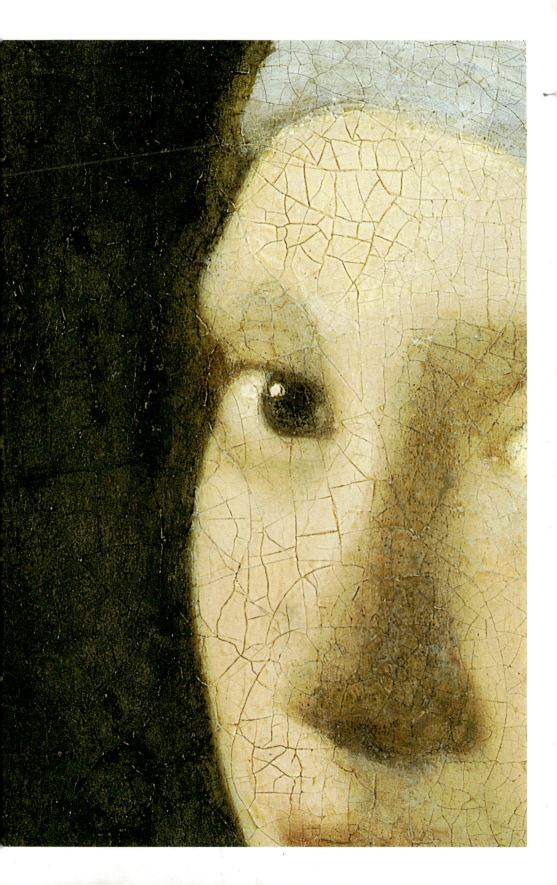

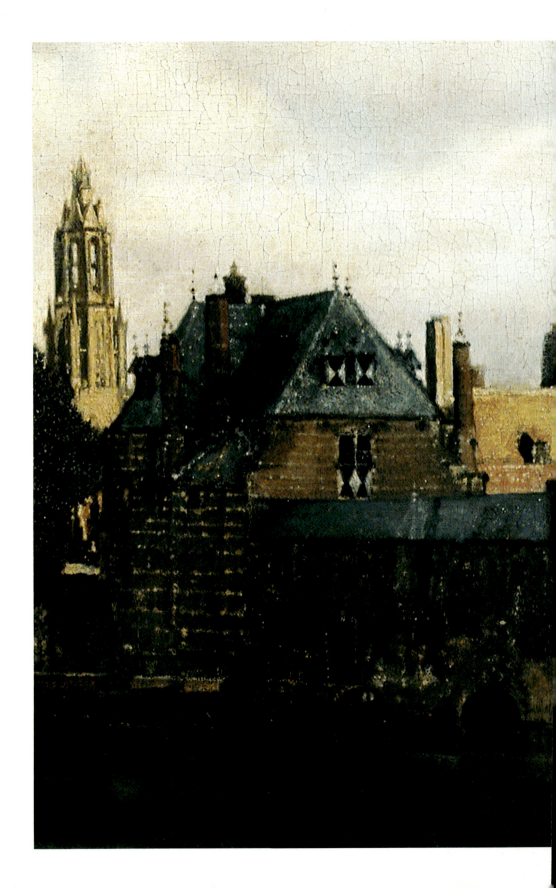

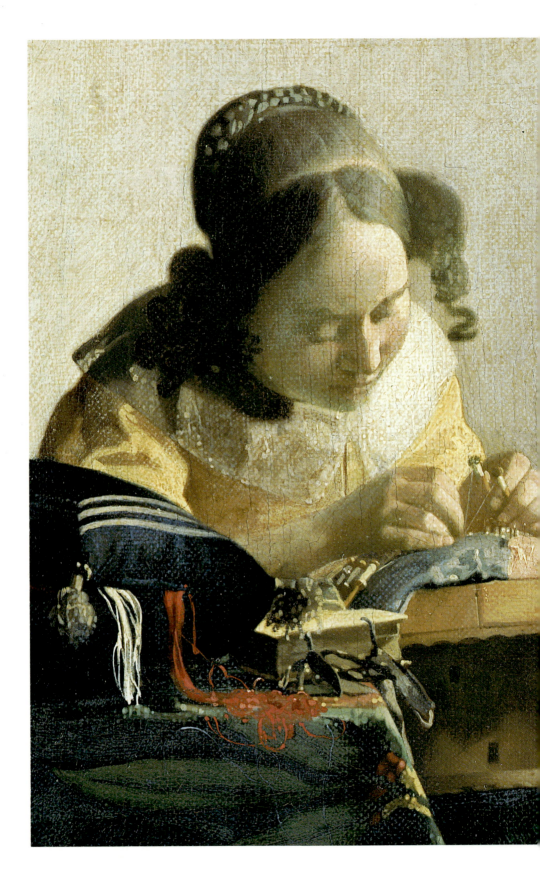

We are once again on the verge of the customary: Vermeer, "painter of light." From the seventeenth century on, connoisseurs have seen this as characteristic of his art.[36] But once again, we must not confine ourselves to the banal: the "description" of light and its effects on the representation of objects is not without consequence for the body of knowledge that painting aims to depict and make us see.

At the same time that he concentrates his attention on the luminous appearance of objects, Vermeer in effect abandons the linear conventions that lie at the base of all "description" in painting.[37] This abandonment was one trait that constituted the originality of the painter in his time; he shows an "almost solitary indifference to the whole linear convention and its historic function of describing, enclosing, embracing the form it limits": "nothing concerns him but what is visible. . . . The conceptual world of names and knowledge is forgotten."[38]

With regard to *The Art of Painting*, Gowing's observations are important for two reasons:

First, as to the contrast between the precision with which the accidents are depicted on the map and the looseness of the cartographic drawing itself, the rejection of linear conventions and their cognitive authority applies to the object that above all relays descriptive information, the map.

Then, of all the painted writing that adorns *The Art of Painting*, Vermeer makes two words stand out, painting them so that they are easily and completely readable. They are in the title of the map, at the two ends of the upper border: "NOVA [. . .] DESCRIPTIO." In the allegorical context of the work, these two words resound like a subtitle, the "motto" or "titulus" of a new conception of painting whose expression could be formulated thus: just as the painter is not present to be known, so painting does not exist to let us know the object that it represents, whose presence is "depicted" in light. And just as what is most precisely seen of the map is its folds and faults revealed by the low-angled light, so in painting the knowledge of the object is bedazzled by the very light that allows it to be seen—as would be confirmed several years later by the dazzling map spread out on the table of *The Geographer*.

The map of *The Art of Painting* could thus very well celebrate an ancient and glorious unity, now lost. This unity is not the political and religious unity of the Seventeen Provinces but the unity of the Art of Painting, which for the learned painter, the "doctus pictor," established the double horizon of history painting and painting as "demonstrated knowledge."[39]

This celebration of the lost unity of painting is not an occasion for nostalgia. As Vermeer sets it down on his canvas, the allegory "demonstrates" a new knowledge, of which painting is the bearer: this "nova de-

scriptio" of Vermeer constitutes a new way to what was formerly the glory of the Art of Painting. Like the "Phoenix of Delft," the painter's art was reborn from its ashes.

A paradoxical detail, seldom noticed but incontestable, confirms this idea. In this allegory where Painting takes itself as the subject, the painter who is represented paints neither what Vermeer painted nor as he painted. It is not only that he is busy painting an allegorical figure, whereas Vermeer, ever since *The Procuress*, had taken the interior scene as his pictorial domain, but also that the allegory the painter is painting (a bust of Clio) is not what Vermeer is painting (the painter in his studio), and, especially, the *technique* of this painter is not Vermeer's. In other words, this representation of Painting as an idea of the art of painting does not depict the practice of the painter who painted it. Let us consider this paradox.

Vermeer chose to represent his painter in the initial stages of work and, clearly visible on the canvas under the painter's right arm, he represented the preparatory drawing that fixes the underlying contour of the allegorical bust to come. By revealing what underlies the painter's art, Vermeer states discreetly—or rather, secretly, since he alone knows how his underpainting is done—that the technique of this allegorical painter is not his own. In his canvases, as X-rays have shown, Vermeer did not do a preparatory drawing to be filled in by color. The first stage of his paintings consists of a structure of clearly contrasting light and shade where forms emerge *without drawing.*[40]

Between the practice of the figured painter and that used by Vermeer to represent him, a breech secretly appears, an unexpected dialectic establishes itself, that shows itself—or betrays itself[41] —in the bulbous hand resting on the maulstick. One cannot doubt that this shapeless hand is significant; Vermeer has put it on the geometric horizon line of his canvas, that is, at the theoretical height of his own gaze as painter of this picture. And, as the hand is style (maniera), what is at stake here is nothing other than the position that Vermeer, in his allegory, gives to his own style, to his own hand.[42] The matter can be summarized in the following way:

By means of the dual image—that is, of Clio (History carrying the trumpet of Fame) and the map (painting as demonstrated knowledge and an image of knowledge as "effect of representation")—Vermeer establishes the double horizon of painting, that of classical theory from Alberti and Leonardo to Karel van Mander and Samuel van Hoogstraten. In painting this allegory on his own initiative, in reserving it for the privacy of his home, and in signing it on the horizon line of the painter with his complete name (I. VER MEER) Vermeer personally acknowledges this conception as his

own. In other words, his own ambition as a painter, the fame that he expects for his art, and the horizon that he establishes for himself, place him in the realm of painting as a *cosa mentale*. The painting of Vermeer is "classical."

But its classicism is paradoxical, showing this "irreplaceable deviation" that, according to Merleau-Ponty, characterizes the "Vermeer structure." As is pointed out by the double reference of the map and the clearly visible preparatory drawing on the painter's canvas the practical and theoretical basis of this classical painting is drawing. But Vermeer does not practice this kind of drawing. In this allegory whose theoretical principle he accepts, he thus calls upon a theory of painting from which his own practice deviates. To this deviation the allegorical context of the picture gives a properly theoretical value.

The knowledge that the painting of Vermeer masters and depicts has to do with the visibility of objects, the ways that the incidence of light and the conditions of vision give an appearance to objects and allow us to apprehend them visually. There is nothing new about this: all specialists agree in emphasizing the extreme attention that Vermeer gives to "transcribing" the visual appearance of the visible world. But, in putting this understanding of visibility in the theoretical context of classical painting, Vermeer implies that his own practice maintains a complex relationship with the theory of knowledge that painting is supposed to "demonstrate." What enables us to understand *The Art of Painting* is that, in viewing pictures, we know the visible aspect of what is represented without having to know, in itself, the object that is subjected to our gaze. We can become aware of the visual phenomenon in the guise of which the object is brought before us; it is not the object itself.

The nuance may appear to be slight; the consequences are not.

Within the classical conception, *The Art of Painting* presents itself as a "critical" picture, one that compromises its cognitive foundation by reflecting on the circumstances of representation. It is enough to recall here the terms that Poussin used about seeing objects to grasp the extent to which *The Art of Painting* perverts the classical conception from within: "It is necessary to know that there are two ways of seeing objects, one simply seeing them, and the other, considering them attentively. To simply see is nothing more than to receive naturally in the eye the form and resemblance of the things seen. But to see an object by considering it, is to search with particular care beyond the simple and natural perception of form by the eye, the means of thoroughly knowing that same object: thus one can say that the simple aspect is a natural operation, and what I call the *Prospect* is an office of reason."[43] In making the "simple aspect" into the *prospect* of the

painter, Vermeer turns upside down the "office of reason" to which learned painting brings witness of its "truth" and its "demonstrated knowledge."

This perversion of the classical categories helped to establish the modernity of Vermeer and his rediscovery in the last third of the nineteenth century. It would, however, diminish his art to consider it only with regard to modern or contemporary categories. Its richness, its intensity, and its oddness depend on the expression of his pictorial position, by means of the classical categories, within the common themes of Dutch painting and in reference to that learned, "descriptive" impulse to which his closest colleagues responded.

A Painter's Position

A painter at work is shown from behind, his face invisible. As one would expect, his position was the object of a particularly thoughtful elaboration on Vermeer's part. In fashioning the allegory, he made his most personal invention, almost an emblem of his pictorial conception.

This painter is not the first to be seen from behind in images presenting the artist at work. According to Charles de Tolnay, it was a usual mode of presentation. However, in the various cases where the painter is seen from behind, in front of his canvas, his face remains visible, whether in three-quarter view or in profile.[44] We must be careful not to rob Vermeer's idea of its originality; this presentation from behind, the face invisible, is so original that it was not even repeated in works that were directly inspired by *The Art of Painting*, such as *The Painter in His Studio* that Michael van Musscher painted about 1690 (fig. 25), in which Welu sees a "pastiche" of Vermeer.[45]

The view of the back of the head is a choice all the more striking since this representation of the painter at work irresistibly suggests that we are, one might say, facing a self-portrait. Not only do the clothes, the beret, and the hair recall those of the self-portrait of Vermeer in *The Procuress*, (fig. 3)[46] but the image of a painter in his studio is the ordinary occasion for a self-portrait. In Vermeer's household, the question no doubt did not even come up. Even so, these arguments should not obscure the evidence: Vermeer does not let us see the face of his painter; and if he lets us think that the silhouette is his own, he does not affirm it.

There have been attempts to reconstruct what Vermeer might have done to paint himself in this way, inventing an arrangement of mirrors that would have permitted him to see himself from behind.[47] The attempt is pointless, since nothing would have prevented Vermeer from putting "his" costume

on a model and painting him in the position he wanted. This would have made it a singular piece of business: a false (or pseudo-) self-portrait, a "figure of Vermeer" without being "Vermeer in person"—a hypothesis all the more seductive since this painter does not paint like Vermeer.

In fact, the identification of the person represented in this costume is a secondary question. What matters is Vermeer's decision, which conceals the face of the painter, preventing the viewer from recognizing his features and knowing his identity. His choice was very different from the one that Johannes Gumpp made some twenty years earlier in his *Self-Portrait* now in the Uffizi (fig. 26). Gumpp's image is equally exceptional, but his face is doubly visible and recognizable, in the mirror at the left and on the canvas in progress at the right.[48] What is at stake in Vermeer is different but just as forceful; the suspended identification is calculated and the deliberate uncertainty makes sense.

Vermeer concentrates the indeterminate iconography we have seen in his interior scenes on the figure of his painter. Asemissen is right in not seeing his turned back as an expression of Vermeer's "modesty" (as Hulten does); but despite that it is inaccurate to speak of the "anonymity" of the painter. His situation is more complex. It certainly expresses a "desire to reduce the individual dimension of the artist," but it is neither "for the purpose of generalizing" nor to make this silhouette that of "any painter appearing in the middle of an allegory of painting."[49] This is in effect to forget that this figure remains "Vermeer"—even though his individual identity is indecipherable.

It is this "uncertainty" that matters, and whose function we must try to clarify.

The painter is thus "Vermeer," but also someone "other" than Vermeer. It is striking, furthermore, that none of the objects present in his studio can be found in other Vermeer interiors. The relationship between Vermeer and this figure is on the order of a "projection." Asemissen notes in this regard that "Vermeer painted himself in the position that he probably occupied in front of his canvas. The representation of the painter in the picture is a projection of the painter as he was, in front of the picture."[50] No doubt; but on condition that one gives the term "projection" its full resonance and does not confuse projection and identification. For, contrary to what Asemissen says, Vermeer does not identify himself with this painter. If, as we have seen, he placed his own theoretical ambition on the same level at which this painter works, he does not paint like him and he does not paint the same thing as he does. We have already seen the importance, from this point of view, of the bulbous hand that holds the brush at the height of the geometric

horizon of the picture. It is time to note that it is distinct also from the carefully "drawn" manner of rendering the costume of the painter, the drawing of its slashes, the outline of his beret, the folds of his stockings. Moreover, along with the accidents to the map, the clothed silhouette of the painter, his stool, and the painting in progress are the only precisely drawn elements of the picture.[51] The remarkable treatment of the hand that paints is not fortuitous. It repeats and punctiliously concentrates Vermeer's complex artistic position mentioned earlier. To put it simply, Vermeer "resembles" this painter; but resemblance, of course, is not identity.

The eclipse of the face leads to another series of meaningful consequences.

In concealing the painter's gaze, Vermeer makes another odd choice in the context of the self-portrait. The gaze of the represented figure, when directed straight at the picture's viewer, in effect identifies a portrait as a "portrait of the painter, by himself." This direct gaze, perpendicular to the surface of the picture, bears witness to and recalls the intimate gaze that the painter directs at his reflection in a mirror; that becomes, in the self-portrait, a public gaze addressed to all who come across it. "Publicly intimate," this gaze is a privileged transmitter of the act of representing oneself that constitutes all self-portraiture (and of the demand to be "taken into consideration," socially recognized, that it often expresses). This is precisely what Vermeer does not do. He even avoids showing that the painter's gaze is directed toward his model. He does not make a personal representation of himself, a decision that is in line with his attitude of retreat from the social world, to which reference was made earlier.[52]

However, it is not possible to leave the matter here, for if the painter's gaze is hidden in *The Art of Painting*, it is also put on show, "paraded," in a complex and roundabout way.

It is, first of all, shown to be invisible. The position of the painter, seen from behind, results in the painter's gaze being "out of the field but in it." As we have seen, the inner border of the map indicates the trace that his gaze, turned toward the model, marks on the surface of the canvas. And in deliberately placing his signature on this border, Vermeer suggests that this trace relays his own gaze.

It is more than a duplication, however; it is a true *delegation* of that gaze. For the gaze of Vermeer does not identify itself with that of the represented painter. The perfect horizontal of the inner border fixes the horizon of the represented painter—his mathematical horizon, according to perspective theory, his "mental" horizon in relation to the content of the allegory. Vermeer signs his work on this mental horizon but, as constructed, the perspective of the image places its horizon at a lower point on the canvas

than that of the painter who is represented.[53] This difference is enough to indicate the distance that separates Vermeer's own position from that which is embodied in the practice of that painter.

Furthermore, the painter's gaze is not only "shown to be invisible"; when we "consider" it, as Poussin would have said, its direction is, in fact, indeterminable for at least two reasons.

First, the inner border of the map does not correspond to the supposed direction of that gaze: the painter is working on the model's laurel crown. His gaze ought thus to move slightly upwards, following a direction that would be marked obliquely on the map.

Secondly, the painter's face seems to be turned slightly toward the model, but the brush seems to be in the process of touching the canvas. Such simultaneity is inconceivable: no "representational" painter can at the same time paint and look at the model, "see and make seen." Classical thought, when it deals with this innermost process of representation, says expressly: "The draftsman, although he has Nature at hand, still can draw it only from memory; it is not properly Nature that he copies, since he no longer sees it when he looks at his paper: it is the image that he has retained." As Jacques Guillerme writes, citing this passage of 1759 from the *Mercure de France*: "Representation implies an active recollection, it is the very revelation of memory."[54] Pointing to the "House of Holland" and the "House of Brabant," the two directions indicated by the inner border and the maulstick suggest a divergence of gazes by which an allusion to the recent history of the Netherlands is sketched out. This allusion is concentrated and actualized on the pictorial level in the figure of the painter, whose gaze is caught between his model and his canvas.[55] Even though the viewer may feel as close as possible to the intimacy of this creative moment, the painter's activity cannot be known, exactly.

The knowledge that we have of Vermeer, "delegated" in *The Art of Painting*, is thus uncertain, indeterminate. His presence leads to his being, in the picture, the "figure" of the "mental" activity of looking, of which the picture is the "manual" memory. This duality shows itself in the Vermeerian double mark of the *signature*, graphically inscribed on the mental horizon within the picture and of the bulbous *hand* that is painting the attribute of Fame. The position of the painter does not make him the representation of a Vermeer individually identifiable and recognizable. Vermeer lets himself be seen only second hand, as a gaze that sees and a hand that paints to let us see. The representation resembles him, but one cannot know either the person wearing this painter's clothing, or what this figure is doing, what he has in mind.

The echo of this calculated incertitude will be heard later, when analysis

of the interior scenes will once again bring out the evidence of an ungraspable presence deliberately constructed by the painter. Within Vermeer's oeuvre, *The Art of Painting* constitutes a theoretical reference to which it is legitimate to relate his other paintings. It sets forth the "Idea" of painting that informs the interior scenes. This private allegory suggests that in those scenes the human figure is presented in the fullness of visible appearance, meticulously and knowledgeably "depicted"; but, to go back to Poussin, even by "considering attentively," the viewer cannot "thoroughly know" it.

The Place Within

Vᴇʀᴍᴇᴇʀ placed the vanishing point of *The Art of Painting* on the left side of the image, near the figure of Clio, under the knob at the end of the map's lower rod. It is thus lower than the eyes of the two figures, the standing model and even the seated painter.[1] Since the vanishing point determines the theoretical position of the viewer's eye, the situation of viewing is from slightly below the painted figures. Even though subtle, the effect is incontestable: the view from below causes a slight monumentalization of the represented figures. Its function is clear: in line with the allegorical intention of the image, the perspective implicitly, almost surreptitiously, helps to exalt the figures.

It would be a mistake, however, to reduce this treatment of the vanishing point to this single tactical function. The view from slightly below the figures is in fact a basic and typical element of Vermeer's paintings. It is found in very different subjects; it does not depend on the nature of the subject, but tends a priori to organize their representation. It affects the very content that Vermeer gives to these subjects.

This view from below of course exists along with other elements which Vermeer associates with it, all of which contribute to defining the structure of his paintings. I will attempt to delineate the coherence of this structure, to follow the reciprocal transformations of the different elements, hoping to get at what it is that determines the specifically "Vermeerian" originality.

SURFACE SPACE

Of the twenty-four interiors where the geometric construction can be reconstituted,[2] twenty put the viewer in a position slightly below the figure represented. This recurrence is too regular not to be meaningful, but the explanations advanced so far are hardly satisfactory.

It has been thought that this point of view may reflect that of the painter at work. Like his colleagues when they represented themselves in the studio—and like the painter of *The Art of Painting*—Vermeer very probably painted while seated. This explanation, however, is not adequate, for the "view from below" occurs in paintings where the principal figure is also

seated. This is the case in the *Allegory of Faith* (where, it is true, the figure is on a dais) and in *The Astronomer*, fig. 9 (who, to be sure, has raised himself slightly from his chair), the *Woman with Two Men*, fig. 36 (where she is actually seated on her chair), and, especially, in *The Art of Painting*.

This regularly lowered vanishing point prompted Charles Seymour to see in it the trace of the use of a camera obscura placed on a table, which would determine a geometric horizon located about eight inches from the surface of that table.[3] The argument is not convincing. First of all, as Arthur Wheelock has shown, the camera obscura is poorly adapted to the painting of interiors; it requires a complicated manipulation, and, everything considered, is hardly justified when the representation requires a focus on objects or bodies situated on planes clearly differentiated in depth.[4] Moreover, as we will see later, even when Vermeer had recourse to a camera obscura, he never faithfully transcribed the specific effects created by that tool. Finally, Seymour's hypothesis is unconvincing for the simple reason that nothing would have prevented Vermeer from raising his camera obscura if he had wanted to, to make it coincide with the visual angle of the painter seated in front of his canvas. So if he generally lowered the geometric horizon of his canvases, it was because he chose to do so, a choice that raises the question of the construction of his pictures and, at the same time, their effect on the viewer.

Moreover, Vermeer arrived at this arrangement by a slow progression, between 1656 and 1661. In the first interior scene that has come down to us (*Girl Asleep*), the horizon is very high, the vanishing point being situated on the door, slightly above the frame of the mirror that is visible in the background; the effect is of a pronounced view from above on the seated figure. Vermeer then renounces this type of scene setting. In *Girl Reading a Letter at an Open Window*, fig. 33 (about 1657), the horizon remains slightly more elevated than the gaze of the standing young woman. From then on the horizon goes down regularly. In *The Glass of Wine*, fig. 36 (1658–1660), the horizon is higher than the seated young woman but lower than the standing man; in the *Officer and Laughing Girl*, fig. 28 (about 1658) and *Girl Interrupted at Her Music*, fig. 13 (1660–1661), it is again lower than the man's gaze but is found now just about at the height of the line of vision of the seated young woman. In *Woman with Two Men*, fig. 36 (1659–1660), it is lower than the gaze of the seated young woman, at the height of the gaze the bending man bestows on her. This evolution, whether linear or not, is not accidental.[5]

The lowering of the geometric horizon is in fact associated with another fundamental element that is equally dominant in the construction of Ver-

meer's canvases. In fourteen of the twenty-four canvases that have come down to us and whose perspective we can reconstitute, the horizon is in the upper half of the canvas.[6] Vermeer thus tends to combine a (slight) view from below with regard to his figures and a (slight) raising of the horizon on the surface of the canvas. Such an arrangement is of interest in that it is paradoxical: to monumentalize figures, the view from below is generally combined with a lowering of the horizon on the picture's surface. Vermeer occasionally does make use of this: in *A Lady Standing at the Virginals* (fig. 14), the horizon is located lower than the center of the canvas and confirms the monumentality of the figure (which the framing places "in front of" the floor that is represented).

By lowering his horizon in relation to the figures while raising it on the surface of the canvas, Vermeer is thus playing a double game and trying for a specific effect: seen from a little below, the figure is slightly monumentalized but, equally, the horizon's being raised a little on the canvas brings the viewer closer to the canvas, in two ways:

First, the visual angle of the figure is less dominant than it would be if the theoretical line of sight of the viewer were situated lower on the canvas; the monumentalization that goes with all views from below is attenuated by the relative proximity of two points of view.

Second, in raising his geometric horizon, Vermeer at the same time raises the floor and, especially, brings the wall that serves as background of the picture visually closer.

The frequency of this combination makes it a characteristic of Vermeer's pictorial space and determines the *effect* he aims at: even as he slightly monumentalizes his figures by a slight "view from below," Vermeer brings them, and the whole picture, closer to the viewer. He invites the viewer into a proximity that eludes by a minute distancing.

The Milkmaid (fig. 21) is one of the first works where this arrangement is fully exploited. The geometric horizon is located in the upper half of the canvas but is clearly lower than the young woman's face. Vermeer has carefully located his vanishing point below the wrist of the young woman, exactly on the perpendicular of the stream of milk that pours from the pitcher—just where the (concealed) gaze of the young woman is concentrated. In the *Lady Writing a Letter with Her Maid* in the Beit Collection (fig. 10), the horizon is also placed in the upper half of the picture; clearly lower than the face of the standing servant, it corresponds to that of the mistress writing, with the vanishing point being placed almost exactly in her left eye. The viewer this time is closer to the point of vision of the principal figure, but the latter's gaze is inaccessible. We will see later how the *Girl*

61

Reading a Letter at an Open Window (fig. 33; plates VII–VIII) and *The Lacemaker* (fig. 40; plate XIV) play with this arrangement, with extraordinary precision, to put the viewer into an intimate but inaccessible relationship with the figure represented.

In this arrangement, the walls play a decisive role in the effect that the pictures produce and even the content with which Vermeer invests them. By bringing them visually closer to the viewer, Vermeer achieves a pictorial emphasis on the surface that is more pronounced than in the works of most of his contemporaries. *The Milkmaid*, again, is a good example of this. Vermeer had initially painted an object hanging on the wall, maybe a map.[7] By leaving the wall bare except for the carefully depicted traces of something hung (a nail hammered in, the hole of an extracted nail), Vermeer empties it of specific information. To balance the way that light plays over the still life on the table in the foreground, Vermeer only lets us see the representation of a wall surface that appears as a painted surface.[8]

The surface of a painting can serve as the basis of a careful geometric elaboration that constructs the implicit meaning of the work. *Woman Holding a Balance* (fig. 20) gives a particularly successful example of this. The vanishing point is higher than the middle of the picture, lower than the eye of the figure, located exactly on the axis of the balance at the vertical center of the painting. It establishes the (theoretical) gaze of the viewer at the same point as the (concealed) gaze of the young woman. But more importantly, this placement embodies the "spiritual" content of the scene. Placed in the center of the picture and framing that center, the balance is, for the viewer, suspended at the vanishing point while the gaze of the young woman follows a diagonal across the canvas that passes exactly across the lower left corner of the "Last Judgment." Vermeer tightly ties together the perspective construction, the placement of the figure, and the geometric elaboration of the surface. This organization contributes to the religious meaning of the canvas: placed on either side of the median axis of the picture and in perfect equilibrium, the empty balance pans symmetrically frame the center of the whole picture, this geometric centering of the equilibrium of the scale confirming the non-Calvinist meaning of the painting.[9]

Woman Holding a Balance, however, is a somewhat exceptional case, since the presence of the Last Judgment in the background clearly implies a spiritual meaning for the image, as the geometric composition functions as a support for a moral signification. The importance of the walls and of their particular surface effect is more profound; it works, in general, at a more fundamental level than does the iconographical.

By allowing no opening in these walls that serve as a background, Ver-

meer reduces the articulated depth of the representation; he concentrates attention on the principal figure and prevents the eye from traveling over complementary spaces and stopping at details. Vermeer's walls do not tell stories; they neither develop nor comment on the principal scene, and do not in themselves constitute an iconographic fact. They do, however, contribute forcefully to defining the Vermeerian "locus" of the figure and at the same time they demonstrate a decisive aspect of the spirit in which Vermeer approaches the genre of the interior scene. By their surface effect, and by what they represent within the space represented (that is, a wall), these walls of Vermeer emphasize what one can call the "closing of a private space"; and they do this much more specifically than in the work of his contemporaries. It is this that we must consider now; it is essential to the definition of the "Vermeer space."

THE FIGURE AND ITS LOCUS

From *Girl Asleep at a Table* (fig. 12)—the first interior scene in the full sense of that term and the only canvas developed in depth behind the principal figure—to the last works of Vermeer (the two young women playing virginals), we see a growing tendency to close off the represented space so as to install an isolated female figure within it. This is a characteristic element of the discreet "deviation" that Vermeer makes from the common practice of his time.

Unlike his contemporaries, Vermeer excluded from his representations any presence of the exterior world. Aside from *The Little Street* and the *View of Delft* (fig. 44)—which belong to an established genre of painting while being set apart within this genre by the enclosing of their spaces—the canvases of Vermeer never give a direct view of nature. One does find in them many windows whose irradiating light lets us see what is offered to the view. These windows are often open, but, despite their transparency, never let us perceive the town or landscape: the angle at which they are shown makes them veritable walls of light that exclude from our field of vision all exterior presence.[10] Regularly closed off at the back by walls void of any opening and fully exploiting their surface effect, the space of the representation is decidedly limited laterally to the interior world of the private circle.

Moreover, within this private world, Vermeer progressively reduced the number of his personages and finally showed only female figures, in couples or alone. This feminine presence has been abundantly glossed; but it has certainly not been sufficiently emphasized that the reduction of the number

of figures and the progressive exclusion of male personages[11] eliminate what Gowing, in referring to the iconographical themes of the time, called "the intruding figure."[12] Present in pictures like the *Officer and Laughing Girl*, *Woman with Two Men*, *Girl Interrupted at Her Music*, and *The Glass of Wine*, the male personages offer variations on a double theme with erotic overtones: the gallant offering, or receiving, a drink; the gallant interrupting a woman at her music. Within this general theme, the allusion to venal love could be made explicit by a secondary motif; it could also remain more discreet while still being no doubt easily identifiable by the viewer of the time. With Vermeer, the erotic allusion that goes with the "intruding figure" is discreet sometimes to the point of being deliberately uncertain.

While Vermeer excludes the male figure, he still evokes the "intruding figure" in vestigial form, a trace introduced into the picture by what is thought to be outside the frame, outside the field of representation, and toward which the attention of the young woman is turned. It may be the imagined presence of someone (male?) in the room (*The Guitar Player*) or of the exterior world at which the young woman gazes through a window (*Woman with a Wine Jug*, *Woman Playing a Lute*).

The representational structure of the private world of Vermeer is distinguished in this way from that of Ter Borch (to whom he is close in other respects). In the latter, the interior cell is given no relation to the exterior world. As Germain Bazin has pointed out, one sees no windows in the interiors of Ter Borch, and sometimes even the domestic decor itself has disappeared. The figure stands alone, surrounded by half-light.[13] In Vermeer, on the contrary, the private world is related to an exterior one, invisible but suggested in the field of the representation. To be more precise, in Vermeer, the outer world and the "intruding figure" (excluded from direct visibility) return to the pictorial field under two "symbolic figures" of the natural and social world, the map and the letter.[14]

Here again, Vermeer is not innovative. These two motifs belong to the common repertory of contemporary Dutch painting.[15] Values attached to the geographic map have been pointed out earlier. Alpers has shown how the presentation of a missive, in the interior scenes where it appears, helps to heighten the idea of an inaccessible reserve, of "privacy." As the center of attention for the personages, and thus of the presumed message of the painting, the letter does not reveal its contents. With exceptions, and setting aside the generic allusions that can be furnished by other objects invested with precise iconographic signification, the painter generally does not give a means of identifying the letter's contents through the gestures or facial expression of the personages. It appears as the center of visual attention in

the picture, but, for the viewer, this center remains empty: "the letter stands for or represents invisible facts and states of the soul."[16]

Vermeer does not neglect this use of the letter; on the contrary, he reinforces it by reducing the number of personages and suppressing all direct reference to the outer world. He thus centers the emphasis on the intimate relationship with the contents of the letter. In *Girl Reading a Letter at an Open Window* (fig. 33; plates VII–VIII), the reflection of the young woman's face in the window is an example. In a parallel treatment of the same theme, a young man writing a letter beside an open window (fig. 32), Gabriel Metsu puts a terrestrial globe in that same place, visible through the transparent glass. Vermeer, on the contrary, by using the pane for reflection, doubles the attention given to the letter and thus underlines the intimate, inward-looking character of the relationship to the missive that has come from outside.

The precision with which Vermeer simultaneously organizes the exclusion of the outside world and its return in an allusive form is shown by the fact that none of his paintings gives us all three objects that mark the transfer of the exterior world into the interior world—the window, the map, and the letter, but he does associate them in pairs: map and window (*Officer and Laughing Girl*, *Woman with a Wine Jug*), map and letter (*Woman in Blue Reading a Letter*, *Love Letter*), letter and window (*Girl Reading a Letter at an Open Window*, *Lady Writing a Letter with Her Maid*).

These choices affect the meaning that Vermeer gives to the "subject" of his interior scenes and, more specifically, the perception that the viewer of the painting can have. In gradually excluding the male figure and rigorously economizing allusions to the exterior world transmitted through objects, Vermeer obscures the anecdote, makes the meaning of the action of the principal figure less explicit; and as he reduces his interior scene to the presentation of a young woman alone, the relative obscurity of the work's meaning concentrates in the female figure the reserve of the image, the relative incommunicability of its contents.

This attitude is heightened through the closing off of space in the direction of the viewer. Vermeer does not limit himself to luminously blinding the open window and eliminating space behind his figures or doors to fix and define the depth of his canvas. In addition, he elaborates the foreground of his pictures so as to erect a visual barrier to the viewer's approach.

Lawrence Gowing has made the count: of the twenty-six interiors that we know, only three leave open the space that fictively separates the viewer from the model who is the subject of the painting. In five others, the "passage" to the interior is encumbered with objects; in eight more, these objects be-

come imposing and raise something like a barrier; and in the last ten, these objects are transformed into "veritable fortifications."[17] Light curtains or heavy hangings, tables covered with carpets, these in turn covered with diverse objects arranged in learned still lifes, chairs, musical instruments— one of the most constant features of the "Vermeer structure" is to obstruct access to the interior space represented, to interfere to a greater or lesser degree with the free visual movement in depth by imposing in the immediate or near foreground objects that create an obstacle, sometimes a screen extending the whole width of the surface offered to view.

This practice was not Vermeer's alone; it was rather common at the time. But Vermeer took up this mode of presentation and gradually elaborated it to the point that it became a specific characteristic of his manner. Particularly accentuated in his first interior scenes (*The Procuress*, *Girl Asleep*), this device of the obstacle later became more flexible, and its variations multiple; these variations in their richness and invention make the picture a "reserved" space, a place where the human figure is present, even close, but protected, as it were, from all approach to discovery, all direct communication. *Girl Reading a Letter at an Open Window* and *The Lacemaker* are the two poles, soberly set down, between which the variations developed.

In the foreground of the *Girl Reading a Letter* (fig. 33), a table transversely bars the whole surface. It is covered with a carpet that swells and masses on the left while a half-overturned plate spreads its still life directly beneath the silhouette of the profile. Upon reflection, Vermeer painted a curtain on the right-hand side that takes up almost a third of the total surface of the image. X-ray examination has revealed that this curtain replaced a very large glass placed at the extreme right of the canvas. The curtain is common in contemporary painting and its shape in the *Girl Reading a Letter* suggests that Vermeer took his inspiration from Gérard Dou; the form of the folds is in fact rather close to that of the curtain of the *Self-Portrait* that Dou painted about 1640 (fig. 34).[18]

Thus there is nothing especially original in this transformation. Two details, however, show that Vermeer, in introducing this curtain, was not content to reproduce a trite idea: he made use of it in a complex operation of concealment.

At the same time that he covered up the big glass by adding the curtain, Vermeer erased all trace of an intended picture of large format representing the same Cupid that is found three other times in his work. This latter made explicit the tenor of the missive being read by the window. But was it really necessary? In contemporary genre painting, the letter is usually taken to be a love letter. In excluding the Cupid, Vermeer did not necessarily exclude the

amorous theme;[19] in his usual manner, he makes the allusion to it less obvious and the suggestion more discreet.

The curtain was substituted for the Cupid. Of course nothing would have prevented Vermeer from leaving the picture partially visible. But just as the effacement of the picture-within-the- picture indicates the intention not to make the contents of the letter explicit, the use of the curtain in the painting deliberately enunciates the fact that the viewer "does not see everything." It is to the viewer's eyes that this curtain speaks, and to which it acts as an obstacle. At the time that he added this curtain, Vermeer made it come exactly to the point where the sight lines of the window converge, thus to the point that marks the theoretical position of the viewer's eye. Inscribed in the geometric and spatial structure of the picture, this point establishes the paradox of a visibility simultaneously offered and partially withheld. In fact, at the same time that the curtain, being drawn back, shows us the *Girl Reading a Letter*, it also makes us see that there is something that we do not see; more, its presence suggests that this relative invisibility is the very thing that is offered to our view.[20]

This concealment within the scene complements the exclusion of the exterior world. In *Girl Reading a Letter*, Vermeer began the articulation of interior space that was his own. He sets aside an interior within the interior, an inner interior; he shows the privacy of the private, or, more exactly, an intimacy within privacy, which is, as a realm of reciprocal knowledge, inaccessible.

At the other pole this structure was carried to its extreme, and to perfection in its economy of means (fig. 39; plate XIV).

The theme of the lacemaker was common at the time, and Vermeer doubtless followed the close-up presentation and the hand position that one can see in the drawings of Nicolas Maes from the 1660s (fig. 38).[21] But Vermeer again deviated from his likely model and from the painters who treated the same subject. In his version of the theme, everything is organized so that the viewer does not see anything of what the lacemaker is doing. Unlike Maes, and as often in Vermeer, the point of view is oblique. Since the model is not shown facing front, her right hand hides the work she is doing even while attention is concentrated there. Moreover, in contrast to the view from above usually adopted, the view from slightly below reinforces the impossibility of seeing. The intentional character of this lowered point of view is confirmed by the fact that Vermeer, unlike his colleagues, does not show the young woman working on her lap, as was doubtless the usual practice of lacemakers. She is seated at a table, and, beside what looks like a book (what is it doing there?), the sewing cushion (*naaikussen*) is

positioned near her on another table covered with a rug. In a condensed form, adapted to the format of the painting and to the extreme closeness of the point of view, the arrangement as a whole is again a version of that distancing by screens and interposed obstacles that Vermeer used elsewhere. The naaikussen and the rug constitute a mass that obstructs the foreground at the very place where the viewer is supposed to be.

The path of the gaze completes and confirms this arrangement: Vermeer invites us to share the view that the lacemaker has of her work, to participate in her inner concentration, but then excludes us from any glimpse of this work, from any share of this view.

The white thread with which the lace is being worked is painted with extreme linear precision, and the exactitude in this rendering of detail is shown up by the contrasting mode of presentation that Vermeer adopts for the red and white threads coming from the cushion. In *The Lacemaker*, what is even more remarkable about this contrast, and what distinguishes it the most from Vermeer's usual practice, is not the inexactness of the red and white threads, treated as spots and colors, but the linear precision of the white thread with which she is working.[22] The very choice of theme doubtless led Vermeer to such precision in the rendering: how can one paint a thread of the lace except as a thread, at least without losing the subject one has chosen to represent? But the dual treatment of threads in *The Lacemaker* marks, of itself, the precisely regulated effect of the "Vermeer structure." From one thread to the others, the viewer seems in effect to see like the young woman, to share the critical task of her gaze: precise and concentrated on the point of the pin, it is imprecise and inattentive at the edges of the visual field. However, it is not possible to suppose that we are seeing like the lacemaker: not only do we not see what she is looking at, but, even more important, the red and white threads coming out of the naaikussen, which are visible to us as positioned by the painter, are invisible to her. They are presented exclusively for our view. The difference of visual precision and definition that distinguishes the one working white thread from the mass of resting threads suggests that we are looking at what the lacemaker is looking at, and that we even look at it as she does; at the same time, the painter shows us that we are not seeing either what she perceives nor what she is looking at. As close as possible to sharing her gaze, we find this also hidden from us by her lowered eyelids and the concealment of the very point where her glance falls. And at the same time two masses of red and white make us feel that we are not seeing what we are looking at, although everything seems to show it to us.[23]

Thus, in a manner like that of the curtain of *Girl Reading a Letter at an*

Open Window, but still more subtly—functioning within the painting's interior and without recourse to that intermediary, indeterminate space that the curtain belongs to—the threads of *The Lacemaker* show that there is something hidden in what is shown, an "inner interior": the intimacy of the person, a presence visibly invisible.

Precision and Blur

The Lacemaker, at 24 by 21 cm, is the smallest of the paintings attributed with certainty to Vermeer.[24] The very intimacy of contact implied by this format is not irrelevant to the minuteness with which Vermeer here controls the effect of his structure. In a compressed form, the canvas reveals another dominant characteristic of his work, a fundamental that also contributes to determining its originality: Vermeer's painting is *blurred*. He does not linearly define the object that he depicts. We have already evoked the theoretical importance of this choice with regard to *The Art of Painting*, and we have just seen the contrast that *The Lacemaker* raises between the threads coming out of the naaikussen and the linear quality of the working thread; but it is in the whole silhouette of the young woman that Vermeer shows a singular absence of drawing, an indifference to any "linear legitimation" of the form.[25] The left hand sums up the contrast between "descriptive" sharpness and painterly blur: to the extent that the working thread is depicted linearly, so it is impossible to identify the slightest "descriptive" drawing, the slightest differentiated form in the area that serves as background for this thread—that is, the thumb and the palm of the hand. From this point of view, Gowing brings together *The Lacemaker*, *The Guitar Player* (fig. 37), and the *Lady Writing a Letter* of the Beit Collection. For him, the absence of linear drawing in the shadow constitutes the "most palpably personal feature of Vermeer's method," and he insists on the exceptional character of such a practice at that time.[26]

This method is in fact all the more remarkable in that Vermeer, according to the categories of the time, was a "fine painter," a *fijnschilder*, an artist whose works were appreciated for the quality of their "finish."[27] In a format as much reduced as that of *The Lacemaker*, in a painting that draws attention to an activity that is itself based on fineness of work, the haziness of the rendering and the declared indifference to the linear precision of drawing acquires an illustrative value.

According to some scholars, who have turned to photographic technique to support their thesis, this blurred effect comes from Vermeer's having

systematically used a badly adjusted camera obscura, one whose focus was defective.[28] I have already emphasized the limitations of this type of "positive" explication with regard to the lowering of the horizon in Vermeer's work. We must pause to consider this thesis, however, since, for its supporters, the use of a poorly focused camera obscura would account not only for the linear imprecision of Vermeer's drawing but also for his famous pointillism, for the importance that he gives in some of his canvases to these little drops of color, the luminous globules marking the play of light on various textures. These do indeed resemble the "circles of confusion" that one observes on the image of a badly adjusted camera obscura. Must one, then, suppose that Vermeer faithfully transcribed this effect? Obviously not, and here we touch on an effect that belongs to Vermeer's style, to his manner of painting and, we will see, to the content of his art.

There is no cause for surprise that Vermeer should have used a camera obscura; it would be more surprising, in that period, if he had not. Like his contemporaries, he knew the camera obscura and he could have had recourse to it at any moment of the creative process. The problem is to understand how he used it and for what ends.

In Holland of the seventeenth century, Vermeer was neither the first nor the only painter to use globules of color to represent the reflection of light on a texture as it appears in a camera obscura.[29] The first use that he made of it was limited (in *The Procuress*, fig. 3), but he later utilized the procedure in a much more emphatic way than his contemporaries, for example in the pointillism of the bread of *The Milkmaid* (fig. 21) or the draperies of *The Art of Painting* (fig. 27) and the *Allegory of Faith* (fig. 8). And the use that he made of it is both original and paradoxical.

First, he had recourse to the camera obscura for the very specific blurred effect that can be observed there. A. Wheelock notes that in *The Lacemaker*, "the visual effects are . . . comparable to the unfocused image of a camera obscura."[30] But it is hardly reasonable to suppose, as Charles Seymour does, that he used an archaic instrument or one that could not be regulated.[31] Apart from its astonishing positivist naivete, this hypothesis rests on a false conception of the "realism" of Vermeer—as is confirmed by the second paradox that appears in his use of the camera obscura.

Vermeer puts his luminous drops on surfaces where the material textures preclude their being "circles of confusion." These circles in fact appear on brilliant surfaces, wet or metallic, struck by very bright light[32] —which is not the case in Vermeer's paintings. The *View of Delft* (fig. 44) is instructive in this respect. Vermeer very probably used a camera obscura in the preparation of the picture. The instrument was used especially for landscape and

exterior views,[33] and in several places the canvas shows the globules of color that call attention to the characteristic effect of a defective focus. But the location of these globules also indicates that they do not reflect an observed reality. In painting them on the side of the boat found on the right of the canvas and along the buildings bordering the canal, Vermeer deliberately put them where technically they could not appear. As Wheelock points out, "it seems unlikely that Vermeer's *View of Delft* is an exact visual record of an image of a camera obscura."[34]

The same is true in most other cases: Vermeer's pointillism does indeed have reference to the camera obscura, but the reference is displaced. Thus in *The Lacemaker*, the blurred appearance of the threads or the face corresponds perhaps to an observed phenomenon, but the luminous drops on the rug or the collar could not have appeared in a camera obscura.

Far from transcribing the effect produced by an unfocused camera obscura, Vermeer uses the phenomenon freely, even arbitrarily, from a "realist" point of view. He evidently did so because this technically based, objective sign of a poorly defined vision satisfied a search for an *effect* in painting. The displaced use of a phenomenon specific to the camera obscura was an integral part of Vermeer's artistic choices. It even casts some light on the subject, since, in making an obvious reference to this instrument, Vermeer situates his paintings in relation to the prestige that it enjoyed at the time. For, contrary to what one might gather from too rapid a reading of the witnesses, that prestige was complex: considerable among scientists and intellectuals, more measured among artists.

From the sixteenth century on, the camera obscura was not known primarily as a convenient mechanical expedient for the artistic representation of the external world. In the sixteenth century, it had attracted the attention of such different individuals as Leonardo da Vinci, Jerome Cardan, Giovanni Battista della Porta, and Daniele Barbaro; in the seventeenth, Kepler and Constantin Huygens. Its prestige depended on its being an instrument for the scientific observation of natural phenomena. Even more important, its impersonal mechanism registered and demonstrated something about the laws of vision and of Nature itself: the person who looks at the reflected image of the camera obscura is the viewer and witness of hidden natural truths, "secrets" of nature that he could not observe with the naked eye.[35]

In a letter to his parents of 13 April 1622, the young Constantin Huygens speaks of his enthusiasm for "the admirable effects in painting of the reflection in a camera obscura." He finds it impossible "to reveal the beauty to you in words: all painting is dead by comparison, for here is life itself or something more elevated if one could articulate it."[36] This is the enthusiasm

of a young intellectual; the artists themselves are much more discreet. If they use the camera obscura, they do not make a display of it; and they scarcely speak of it. Furthermore, in the autobiography that he wrote between 1629 and 1631, Constantin Huygens expresses his wonder that painters could have neglected or "been unaware of such a pleasant and useful aid."[37] Huygens was wrong; painters knew about this "aid," but they did not brag about it. Following the tradition of artisanal secrecy, Dutch painters were perhaps not anxious to reveal a technique that permitted them to achieve an incomparable truth to life, especially in landscapes. But there were also other reasons for their silence. A letter that Sir Thomas Wotton addressed to Bacon in December 1620, where he describes the use that Kepler made of a camera obscura, also indicates that the use of this mechanical instrument was unworthy of a painter: it is as a "mathematicus" and not as a "pictor" that Kepler says he has made drawings with the aid of this instrument. According to Wotton, the camera obscura can be useful for topographic views but, as to landscapes, it is not worthy of a "liberal" art—even though "surely no painter can do them so exactly."[38] The discretion of artists no doubt had still another and simpler cause: the camera obscura was useful for learning to paint but the established master hardly needed it. His skill was enough. We know, for example, that Samuel van Hoogstraten installed a camera obscura twice (in Vienna and in London). However, in his *Treatise* published in 1678, he abstained from recommending to the painter the use of a mechanism that was useful primarily for beginners: "These reflections in the dark can give no small light to the sight of the young artists; because, besides gaining knowledge of nature, so one sees here what main or general (characteristics) should belong to a truly natural painting." But he immediately adds that one can see the same thing in "diminishing glasses and mirrors, which, although they distort the drawing somewhat, clearly show the main colouring and harmony."[39]

We will doubtless never know whether the attitude of painters in this matter was on the order of an artisanal secret, whether it had to do with a concern not to tarnish the glory of the "liberal" artist—at the very time when painters were separating themselves from the traditional system of the guilds—or whether the painter, having attained a certain degree of professionalism, no longer needed this mechanism, which was as complex as it was elementary in its pictorial result—since a "diminishing mirror" did the same thing just as well. But, to come back to Vermeer, one thing is certain: much more than his contemporaries, he painted an *effect* that can only be observed in the camera obscura; comparatively, he even made a display of it. This attitude could only have been justified by the scientific prestige of the instru-

ment that was directed toward making visible a natural phenomenon inaccessible to the naked eye and uncovering, as it were, a secret of Nature. However, in displacing what he observed, in painting the phenomenon where it could not appear, in thus falsifying its truth, Vermeer also shows that he was not concerned with the properly scientific dimension of the camera obscura. If, as a painter, he plays with this mechanical aspect revealed by the camera obscura, it is because it corresponds to his own artistic search, his "prospect" as a painter. What he kept of it was, in painting, a painterly effect, a selective blurring that evoked "scientifically," and manifested pictorially, the *invisible in the visible*.

Vermeer's predilection for a "blurred manner" shows itself radically in the way he treats the modeling and outline of his figures. With extreme precision, Vermeer worked in certain places to blur or prevent the identification of what he depicts. He can then distort the appearance of the object and, even while manifestly "depicting" it make the object become strangely disquieting or, as Gowing puts it, "grotesquely unlike itself."[40] If his painting sometimes and selectively "puts at risk" what Panofsky would have called a pre-iconographical description,[41] it is, according to Gowing, because the "method" of Vermeer leads him in general to determine the modeling of his figures "optically, almost mechanically, not conceptually or in the interests of comprehensibility."[42]

The Girl with the Pearl Earring (fig. 42), the *Head of a Girl* (fig. 41), and the *Lady with a Maidservant* (fig. 43) permit us to clarify what is at stake, artistically and theoretically, in this method.

These three paintings are alike in presenting the figure against a background that is almost uniformly somber, thus proposing a maximum luminous contrast, completely detaching the figure from the background. All three also share the same complete absence of any outlining.[43] The result is a kind of localized interpenetration of the background and the figure, a blurring of the line of demarcation. One can observe this particularly in those places where the contour ought to form a clear linear edge. Vermeer makes the background flow into the figure: in *Girl with the Pearl Earring*, he uses the line of the lashes of the right eye; in the profile of *The Lady with a Maidservant*, he puts a spot at the top of the nose, anatomically inexplicable.

As odd as they are, these subtly handled "passages" between the edges of the figure and the background, the fusion that an indistinct shadow creates between the edges of the figure and the surface it occupies, constitute a personal version of sfumato, the shading of contours whose principle was proposed by Leonardo da Vinci. By establishing that shadows are more important than contours in painting, that they demand greater knowledge

and involve greater difficulty, Leonardo made the "ungraspable character of their limits" one of the privileged points of the painter's work. According to the formula of André Chastel, Leonardesque sfumato "contradicts the clear outline of the drawing by effacing its contour and produces, instead of a formal statement, a diffuse state of emerging."[44]

It would be difficult to describe the effect of Vermeer's faces better than that. Leonardo's texts provide the theoretical loss of Vermeer's work; a theory, however, that extends over the entire history of mimesis in painting. The "question of contour" is of supreme difficulty for the painter who wants to give his figures the appearance of life. This was at the heart of Vermeer's search.

Leonardo, in fact, had only declared what Alberti had implied as early as 1435: the contour (*orlo*) of forms ought not be made with "too apparent a line"; far from representing the "limits of a surface," this makes the contour appear like a "break." One should "desire in circumscribing the figure only the movement of the contour."[45] But Alberti himself was formulating, differently, what Pliny the Elder had already proposed in Book 35 of his *Natural History*: "The execution of contours" is the "supreme subtlety of painting (*picturae summa subtilitas*)"; to "make the edges of bodies and close up the ends of the disappearing planes of the object" rarely succeeds in painting, for "the contour line must veil itself and end in such a way as to promise something else behind it, and even to show what it hides."[46] It is a matter of some importance that, for Pliny, the supreme master of this extremely difficult art was the Greek, Parrhasios, the painter of the celebrated curtain that deceived Zeuxis himself. From subtle contour to trompe l'oeil, painting "promises" what it hides and makes us hope for what it does not show. In the middle of the sixteenth century, Vasari took up and summarized this theme in a definitive formula: the contribution of the "bella manièra," the essential quality of the "beautiful style" of the cinquecento, that Leonardo initiated, is "grace" exceeding measure; and it appears "between the seen and the unseen."[47] Vasari was not thinking here of Leonardesque sfumato, but something of much the same order: this effect of the living presence, equally ungraspable and irrefutable, that painting reaches when it "promises something else behind it and even shows what it hides."

Allegorically, *The Art of Painting* indicated how, "between the seen and the unseen," the "aspect" could shatter the classical "prospect" and establish a new art of painting. In Vermeer's eyes, the aim of painting was not to make its object known but to make the viewer witness to a presence. This is one of the continuing searches of his art—for him, an "end of painting."

The "Vermeer method" accounts for the odd effect that his painting

produces: his pictures do not allow resolution by the viewer. The term resolution here must be understood in two senses, optical and logical: the painting resists both visual and conceptual resolution. It inserts a screen to preclude discriminated vision; nor can it be resolved on the level of its contents. It does not permit elucidation, nor transformation into something other than a surface of colors present and representing something. This double barrier to "resolution" assures Vermeer's painting its effect of presence, "between the seen and the unseen," to cite Vasari again, the fiction of living. At this point Vermeer reaches what traditionally constitutes the ultimate objective of painting, its essential need and its aim, the "divine force" (Alberti): to re-present, to make the absent present, to make the image live. But his paintings are constructed in such a way as to render this life equally present and inaccessible, near and impenetrable. What is seen is not the *secret* of nature observed, but really a *mystery* within the painting itself and about the visibility of its figures.

Vermeer's Religion

ACCORDING TO Aloïs Riegl, the most profound characteristic of Dutch painting, its specific *kunstwollen*, is related to its being intended as an "art of interiority." In the specific genre of the group portrait, to which Riegl devoted his fundamental study of 1902, the concentrated attention of the figures, turned toward the viewer (their *Aufmerksamkeit*), constitutes "the most subjective expression of inner life," exemplary of painting that has as its objective the presentation to the viewer of the immaterial presence of the individual character. A work like Rembrandt's *The Syndics* is the culmination of a tradition inaugurated in the first half of the sixteenth century, for in it the Aufmerksamkeit of the figures is joined in a particularly dramatic way with its aesthetic corollary: the involvement of viewers and their subjectivity in the spiritual interiority of the picture, which demands an intimate gaze unique in northern art, a gaze that, according to Joseph Koerner, is capable of being "attentive to something not visibly present in the picture."[1]

Despite the personal bias of an aesthetic and moral order that runs though the thesis of *Das holländische Gruppenporträt* and dates the work,[2] the text remains current, for it is based on an eminently modern conception of art history as the history of the relation between the viewer and the work of art. It is a history distinct from esthetics by virtue of the attention it gives to the evolution and transformation of the relationships of the gaze.[3]

If Riegl's text comes into the present context, it is because the associated ideas of the Aufmerksamkeit of the figures and the subjective involvement of the viewer strikingly echo some of the *effects* in which we have just recognized a dimension specific to Vermeer's art: the suggestion of the invisible in the visible, of the intimacy of a figure simultaneously close and inaccessible. For Riegl, one of the specifics of Dutch painting is that "the objective, outward coherence of the scene transforms itself into the inner experience of the person who regards it."[4] This idea seems to adapt well to the aesthetic experience proposed by Vermeer's canvases: think only of Proust's Bergotte in front of the *View of Delft*. So, after all, Vermeer only *seems* to be original; his "inscrutable delicacy," which so amazed Lawrence Gowing, is, on further consideration, only a given of the period, an aim common to Dutch painters at the time, an historically determined expression of the kunstwollen of Dutch painting. Just when we think we have

grasped the truth, the "irreplaceable deviation" that would characterize the "Vermeer structure," Riegl's text leads us to recognize in it a general truth of Dutch painting of the seventeenth century, a commonplace.

The affinity between Riegl and Vermeer remains, however, paradoxical. Not only did Vermeer paint no group portraits—and his painting seems far removed from what is implied by the genre—but Riegl's hero was Rembrandt. And even though Vermeer and Rembrandt were both "Dutch," the difference between their conceptions and practice of painting are surely more significant than their (very improbable) similarities.

In fact, Riegl's analyses lead us to put the question of Vermeer's originality in a new light—specifically, that of the particular form taken, in Vermeer's work, by this "fine manner" wherein painting works, as Pliny the Elder put it, to "promise what it does not show."

In his works on the evolution of portraits and interior scenes in Holland, David Smith has clearly shown how the development of introspection and of respect for privacy was associated with a desire for elegance, this dual phenomenon being explicable by the success and progressive diffusion of models of civility previously specific to courtly society. In 1603, when the manual of Stefano Guazzo on "Civil Conversation" was translated into Flemish, this rather elementary manual became available to the public. Its limitations made it particularly attractive to the Dutch middle class, who were still "struggling to master the outward forms of the gentlemanly ideal." In 1662, Baldassare Castiglione's *The Courtier* in turn was translated, to serve the needs of those milieus with insufficient culture to read it in Italian or French.[5] This translation alone attests that a larger social group felt the need for a more subtle elegance: what they sought were beautiful manners colored by nonchalance, the *sprezzatura* exalted by Castiglione, where a perfect education hides the constraint on which it is based, to the point of seeming natural, of becoming an "art that hides art." But the dissimulation particular to sprezzatura also implied an opposition between what one revealed and what one concealed. Moving from the limited circle of the court milieu to bourgeois social groups, the success of the Italian model developed a dialectic (decisive for the makeup of modern subjectivity) between interior world and exterior world, private and public, subjective interiority and social role (or persona).[6]

The context of these practices (where the social and the artistic are intimately mingled) allows us to situate the originality of Vermeer in a more precise manner.[7] For if his painting is clearly different from Rembrandt's, it is also different, more subtly so, from that of other "fine painters" and in particular from Pieter de Hooch, who, in the 1650s, introduced and devel-

oped, at Delft, an original conception of the portrait and of interior scenes which displayed an elegant social awareness along with the consciousness of a sharp delineation between public world and private sphere.[8]

First, Vermeer's "fine manner" was practiced, as has already been said, in a particular way, a "blurred manner," especially perceptible in the traditional matter of contour. We must return to that briefly. In a letter that he wrote to Pieter Spierincx on 17 November 1635, the art merchant Leblon paid tribute to Torrentius and justified the worth of his works by affirming that they were of such fineness that "one cannot see the least unevenness in his colors or distinguish a beginning or an end in the whole picture."[9] This praise could apply to Vermeer as well, but his "fine manner" is quite different. In Torrentius, Dou, and the other fijnschilders, the height of technical competence is to make all traces of the painter's labor, all material presence, the "painterliness" of the painting, disappear from the work. The drawing, and hence the contour line, remains the basis of the work and of the fascinating effect that results. If we seek an ancient tradition for this practice, we find it in Pliny the Elder, who tells the story of the friendly rivalry that pit Apelles against Protogenes on their ability to trace the finest line with a drop of color on a brush.[10]

When it has to do with contour, Vermeer's "fineness" also plays on the visible and invisible limits of the figure, the indeterminate character of its beginning and end. But the invisibility that he proposes is of another order. More than invisible, the line of contour is abandoned. If the edge of the body or the face can no longer be located, it is because his blurred treatment makes the border of the figure not so much indiscernible as transitional, an uncertain zone where "passages" back and forth result, in a fusion of figure and background. The attitude of Dou and the "fine painters" saw drawing as the ultimate value; Vermeer's choice, and the "irreplaceable deviation" that it implies, was that of a *colorist* working with light.[11]

Moreover, in Rembrandt, Fabritius, and De Hooch, the manifestation of interiority as "reserved intimacy" came by way of the portrait and from a complex play on the motif of the threshold. Vermeer himself did no portraits,[12] and his paintings do not include thresholds presented as an articulation between public and private worlds. Aside from *The Little Street,* where the threshold lets nothing be seen of the interior to which it leads, the only painting that explicitly includes an image of a threshold is *Love Letter*; the threshold, however, is within the private space itself. The two allegorical paintings do give the notion of threshold by means of the foreground tapestries; but again, the threshold is situated within the interior of the private space of the representation. It is to the viewer that it addresses itself:

these tapestries, by being shown drawn back, turn what is shown into an unveiled or revealed interior.[13] The allegories establish the theoretical principle of obstacles that, in his interiors, Vermeer puts at the visual entrance to his space. It is the painting that affirms its interior as a reserved interiority, and it is exclusively between the painting and its viewer that the threshold of that intimacy is marked off.

The dialectic of the threshold between public and private thus does not occur in Vermeer. Elsewhere it evoked a growing affirmation of a right to privacy.[14] With Vermeer, privacy is like an "acquired right"; it is presented as such, like a subjective inwardness within the objective interior that we see. From this point of view, Vermeer seems close to Ter Borch, who never shows windows and rarely shows thresholds. But the principle behind their effects is different. The most typical figure of Ter Borch, the one most often taken up by his contemporaries, is a young woman seen from behind, her expression necessarily undecipherable.[15] Simply by the pose, the interiority of the figure is presented to the viewer as a *secret* of the picture pointedly withheld from the viewer, that is, precisely intended for the viewer.[16] By contrast, the figures of Vermeer do not address any secrets to us: what we see of them, in full light, manifests the mystery of what is present, but not visible.

The originality of Vermeer lies in the relation that his very conception and practice of painting creates between the picture and its viewer. Whatever the subject represented and whatever the apparent poverty of its content, his pictures are *reflexive*. We have thus to return to what constituted Vermeer's "prospect": that simple "aspect" of things, their presence in a dazzling light that forbids us to "thoroughly know" them. We have, decidedly, to go back to light, and the meaning it might have had for Vermeer.

"The light seems to come from the painting itself"; such was the feeling of Thoré-Bürger beholding the particularly strong effect of light in the painting entitled *Officer and Laughing Girl* (fig. 28).[17] As early as the eighteenth century, some of Vermeer's paintings were noted for their quality of light. Thoré-Bürger followed this line of thought when he said that "the most prodigious quality of Vermeer . . . is the quality of the light"; when trying to "specify the faculty particular to Vermeer in lighting his painting differently from Rembrandt and the most sun-struck masters," he judges that, for Vermeer, "light is everywhere, on the back of a chair, a table, or a harpsichord, just as it is beside the window. Only each object has its half-light and its reflections mix with the surrounding rays."[18] For Thoré-Bürger, "it is to this exactness of the light that Vermeer owed the harmony of his colors."

When he further specifies the faculty of Vermeer in this regard, he says that Vermeer's light, far from being "artificial" like Rembrandt's, is "all that a careful physicist could desire."[19]

This "realistic" conception was to have a long history; one finds such statements in a number of later commentators. It is, however, too much of the period that produced it (corresponding to the general interests of Thoré-Bürger and to the fact that he dedicated his articles in the *Gazette des Beaux-Arts* to Champfleury) to apply without nuance to the objectives of Vermeer or to account for the meaning that light had for him. Indeed, a century later, scholars do not hesitate to believe that the "preeminence" of Vermeer over his colleagues in the use of light has a "special significance": we should understand it as the light of Revelation, "once we recognize that Vermeer's goal was the communication of Christian truth."[20]

This last affirmation doubtless corresponds to a dated approach to painting and shows, in particular, how heavily iconography weighs in the interpretation of works, with especially prejudicial results in the case of Vermeer.[21] However, it is less arbitrary than it may seem. The idea of light as "form" and "symbol" of the divine is traditional in European thought; it is also narrowly associated with the supposed "realism" that, in the fifteenth century, Dutch painting attempted.[22] This religious and mystical conception remained present and diffuse in the seventeenth century: not only did emblematic literature make use of it,[23] but, more significantly in the present context, Kepler personally developed, along with his objective and scientific research, a veritable "metaphysics of light." As David Lindberg has demonstrated, numerous philosophic and theological observations run through the works of Kepler, from which it appears that "light is [in Kepler] not only the image of the triune God; it is also the origin of the soul's faculties, the bond that connects the spiritual world with that of corporeal matter, and a mirror of the laws of nature"; better yet, created by God "ex nihilo, in his image," light "imitates its Creator."[24]

We do not need, here, to demonstrate that a precise relationship existed between Kepler's metaphysics of light and the light that animates Vermeer's painting.[25] It is enough to note that the Christian metaphysics of light remained current and basic in the seventeenth century. We can, in turn, try to specify the spiritual content of what was one of Vermeer's most fundamental and personal searches: the refining of a light that would be "everywhere" in the painting.

Unlike the emphatic chiaroscuro that equally characterizes Rembrandt and the Caravaggists of Utrecht, light is for Vermeer a principle of classical coherence. While animating the surface and giving body to the painting (conceiving color as the refraction of light), it contributes to the stable

equilibrium of the whole. In this Vermeer's light differs radically from that of Rembrandt—the Dutch painter who has gone deepest into the artistic and spiritual function of chiaroscuro. Vermeer's paintings, we have seen, do not include thresholds that create a passageway between opposed spheres of public and private; equally, they do not construct a luminous opposition between interior and exterior, spiritual and material, as is the case with Rembrandt—and, to a lesser degree, with Pieter de Hooch, where the opposition between public and private is played out more exclusively on the social level.[26]

These differences are profound. Rembrandt's chiaroscuro has a precise religious meaning, as David Smith has demonstrated: it expresses a Protestant ethic based on a formal contrast that embodies the irreconcilable opposition between heaven and earth, the spiritual and the material.[27] For Vermeer, on the other hand, the harmony, balance, and fusion of light and shade, equally distributed throughout, constituted an aesthetic foundation. In the religious context of the time, with the spiritual conceptions and metaphysics associated with light, we could be led to think that Vermeer succeeded in reconciling the opposites that Rembrandt dramatically contrasts.

Can we see in this harmony, however, the manifestation of a spiritually optimistic attitude with which Catholics confronted the Calvinists?

One must beware of facile or peremptory responses. It is not a question of seeing Vermeer as a "Catholic" painter. He could be considered such only in reference to paintings done on commission whose iconography is specifically Catholic (the *St. Praxedes*, plate I, and *The Allegory of Faith*, fig. 8),[28] and even there, in general the work of Dutch painters who were Catholic does not differ from the "usual" production of their colleagues.[29] But this last point itself leads to reflection. Vermeer's paintings, even of ordinary and clearly trite subjects, remain remarkable; the Vermeer structure does constitute a subtle but irrefutable "deviation." Is it inconceivable that this was tied, in a very general way, to a Christian esthetic tradition, or, in seventeenth-century Holland, a Catholic esthetic: the dogma of the mystical union of the visible and the invisible, along with a faith in the power of the image to incorporate a mysterious presence that is both living and indefinable?[30]

The hypothesis is heavily laden, but nonetheless merits consideration. Knowing that Vermeer converted to Catholicism before entering the Guild of St. Luke at Delft, one may well think, like Swillens (himself a Catholic), that this conversion "reveals something of his way of thinking and way of life."[31] And, one should add, his way of *painting*.

We do not know (and will never know) the personal reasons that led

Vermeer to convert to Catholicism at age twenty. But the circumstances of this conversion are not so obscure. Coming between his engagement to Catharina Bolnes and their marriage, it was no doubt a condition to the realization of that marriage; as we have seen earlier, however, there is no reason to doubt the sincerity and depth of his conversion. It is the conditions under which it occurred that are of interest here. The very fact that the marriage was possible leads us to think that Vermeer must have completed his artistic education under a Catholic painter (maybe Abraham Bloemaert of Utrecht). Among all the hypotheses about the identity of the masters of Vermeer, this is the most likely—not so much for stylistic reasons but because it allows us to explain how an apprentice painter from a middle-class, Calvinist milieu could have met and courted a young Catholic girl of good family.[32]

In all likelihood the education received in the studio of a Catholic painter at the end of his apprenticeship—that is to say, at the time when reflection on and discussion of the theory of painting came to crown technical lessons—must have left traces on at least one very specific point, the well-known opposition between Calvinists and Catholics with regard to images. Beyond iconoclasm, already out of date at this time in Holland, the religious disagreement about images is specifically linked to the question of their use (or non-use) in the domain of spiritual meditation. As in the exclusion of images from public places of worship, it is here that we find a firmly rooted Calvinist rejection of the faith that Catholics have in the spiritual power of images. Protestant techniques of spiritual meditation have as their source earlier Catholic practices; in their sequence one cannot help recalling the successive phases of Ignatian meditation. But they differentiated themselves more and more clearly in the seventeenth century, as Protestants developed their own conception of spiritual meditation. We must consider this a moment.

In the first quarter of the century, the Catholic Father Richeome advised the pilgrim to have with him always an image that could help him in his prayers. The advice is traditional, but when the good father "invites his reader to meditate by relying on a material representation that in fact plays the role that St. Ignatius gave to inward representations, . . . the concrete palpable image is substituted for the inward image, again emphasizing the affective, not to say sensual, inclination of this method of prayer."[33] The Protestant, on the other hand, makes the text and letter of Scripture the guide and model to follow in the phases of meditation. More specifically, Protestant meditation is distinguished from Catholic in the kind of "application" that the faithful make of the themes on which they meditate. Catho-

lics seek to put themselves into the religious scene that they have before their eyes (or that they imagine in precise detail); they want to "apply" themselves to it and participate in it so as to attain "vision." Protestants do the opposite. Instead of applying themselves to the image and becoming a part of it, they apply the theme and text of their meditation to themselves and to their own experiences of life. Protestants who meditate can utilize the same subjects as the Catholic but, rather than having to consider them in themselves and imagine them in their sensuous detail, they must limit themselves to the Word, to apprehend there the paradigm of Salvation and put it inwardly to work.[34] This attitude is in accord with the moral hierarchy of meanings as the Calvinists define it: hearing is superior to sight, which is the source of illusions and transmitter of diabolical seduction that can lead to the idolatrous cult of painted images. On the other hand, the Catholic can believe, like Father Richeome, that there is "nothing that delights more and makes a thing glide more softly into the soul than painting, nor that engraves it more deeply on the memory, nor that more effectively rouses the will and sets it energetically in motion."[35] Undoubtedly, the Catholic approach to the painted image endows it with spiritual prestige and the certainty of a "real presence" that Calvinists rejected. In countering the latter both liturgically and aesthetically,[36] Catholics used miracles, of which images are the transmitters and which attest to the truth of their confidence in the image.

This conception of the virtual power of the painted image to become truly present could well be the spiritual frame that aroused and empowered the choices and artistic ambitions of Vermeer.

If it were for love, *amoris causa*, that Vermeer converted, it was a particularly complex love, which combined love of the charitable indulgence of the Catholic God, love for the desirable Catharina Bolnes, and, just as profoundly, love for painting, which for the Catholic church was not surrounded with suspicion, which was, on the contrary, invested with an exceptional and mysterious aura. Perhaps it was his own religion of painting that had also intimately led Vermeer to conversion.

It is unlikely that a historical document will turn up that would transform these conjectures into certitude. It is, nevertheless, worth making them, if only to clarify what there is of Vermeer in one of his apparently least "Vermeerian" paintings, the *Allegory of Faith* (fig. 8; plates II–III). The canvas reveals the complex relationship between Vermeer's Catholicism as such and his religion of painting.

The canvas should not be considered as an indication of artistic decadence, as we have already seen. On the contrary, for the period, it was a theoretically ambitious and aesthetically successful work. It is still true that,

for a modern viewer, this canvas stands apart, that it has a different effect from other works by Vermeer. Edward Snow sees in the *Allegory of Faith* a failure of what had succeeded in *The Art of Painting* and recognizes in it the trace of an essentially "anti-Christian" vision, one in conflict with its allegorical theme.[37] This is a serious misinterpretation. One can understand the peculiar character of the *Allegory of Faith* better by recognizing it as "applied painting," in two meanings of the term. It is a painting to which the artist applied himself, with great care, to make it overly finished, thus less alive, colder; and it is a painting put to the service of an end outside itself, no longer "reflexive" but decidedly "transitive," seeking to deliver a clear ideological message. A work done on commission, this canvas ought to be more exactly titled *Allegory of the Catholic Faith*.[38] It was not intended primarily to explain a religion of painting: its primary function was to be a painting of religion, of a religion precisely defined as Roman Catholic. The reception that this canvas requires is not the same as for other works of Vermeer; the difference arises from the response (successful in terms of the period, boring for us) that Vermeer addressed to the commission he had been given.

One attribute of the allegory, from this point of view, acquires a specific value—the glass sphere hanging from the ceiling by a blue ribbon, which is the object of contemplation by the principal figure in the painting (plate III). It summarizes, in effect, the twin forces at work in the representation. The commission and its iconographic program gave it an exact meaning within the framework of allegorical attributes; but Vermeer, by the pictorial response that he brought to the commission, has gone beyond the iconographic message—to the point that this allegorical sphere becomes, as it were, an emblem of his art and of his relationship to the act of painting.

This sphere is not present in Ripa's *Iconologia*, the source of a certain number of attributes of the allegory. Even so, it was not Vermeer's invention. He took it from the book of emblems *Emblemata sacra de fide, spe, charitate*, published at Antwerp in 1636 by the Jesuit Father Hesius, where this attribute signifies the immensity of the human soul when it has faith. The accompanying poem says that as "a little globe encloses the immensity and contains what it does not understand," so the human soul that believes in God "is greater than the greatest world."[39] The attribute fulfilled the iconographic function for the person who commissioned it, who established the program of the image, and who knew its implications. It delivers a message that is all the clearer for finding its source in the work of a Jesuit who was known for his predictions, but was also a professor of philosophy, a writer, and an architect.[40]

The pictorial configuration of the sphere (its painterly aspect), however,

produces another level of meaning, one that no longer has to do with the allegorical message but rather with the presence of the painter in the very enunciation of the message. In carefully placing the luminous touches of reflection that show "the greatest in the smallest,"[41] Vermeer excluded two expected motifs. He omitted, first of all, the reflection of the painter in his studio, which is present in this type of globe when the motif has its usual signification of Vanitas.[42] This exclusion is easily explained; such a reflection would not have corresponded with the theme of the painting and would have introduced a confusion contrary to Vermeer's practice and to his patron's wishes. It is less easy to explain the omission of the reflection of the cross, called for by the emblem of Father Hesius. The deliberateness of this exclusion is all the more obvious since Vermeer painted on the sphere the reflection of a mullioned window. The intersecting framework of this window offered a means of representing the cross that would have been all the more discreet and effective since the cruciform reflection of a window in a globe was a traditional symbol of Christ *Salvator Mundi*.[43]

This omission may have occurred for formal reasons (a cruciform reflection might have excessively accentuated a burst of light at this spot in the work). This hypothesis, however, suggests that concern for pictorial effect has an impact on the allegorical dimension of a painting, with regard to a detail that is important to the message of the painting. Equally, one should be especially careful not to reduce to a commonplace the meaning of what appears, upon reflection, to be a personal and carefully meditated invention.[44]

By obscuring one of the four openings of the casement crossing, Vermeer has prevented our recognizing the Cross; he does, however, expose something else. This reflection shows a window, part open and part closed, one of the windows in the painter's studio, which regulated the intensity of light as the painter wished. Vermeer thus made a subtle, yet precise reference to the lighting conditions that he organized to work out the luminous contrast on which his picture is built and which contributes to its religious context.[45] The chiaroscuro of the *Allegory of Faith* is the most highly contrasted of Vermeer's works; the light that strikes the tapestry (with greater intensity than in *The Art of Painting*) is not the same as that which lights the figure of Faith. The message of the image suggests that, beyond the area of tapestry, a spiritual light illuminates a spiritual space, a space in which obscurity is not necessarily negative.[46] However, in effacing the globe's reflection of the cross, Vermeer was not satisfied, as he usually was, with weakening the explicitness of the meaning. In turning this reflection into a studio window, he evoked his work as a painter—not the painter seated at his easel, but the

painter regulating and calculating the effect of light. He evokes the mental operation that directed the appearance of the painting: what is painted here is a *cosa mentale*, the light of the painter, master and creator of an illumination that animates his work, a light that is diffused inside the painting.

In this light that he alone has created, the painter is not visible; he is absent from the world that he sets before us. This clear "retreat" of Vermeer in his work has often been remarked. Lawrence Gowing sees in Vermeer's detachment the most personal revelation of himself, and, after him, Edward Snow supposes (with regard to *The Art of Painting*) that "what the artist thereby expresses of himself is only revealed in his absence from the visible, the visible which *is* his absence."[47] It is an apt formula, since its enigmatic character gives us (unintentionally) a hint of the strictly religious nature of the relationships that tie Vermeer to his creation: invisible in the painting, imperceptible in this perception of himself that he offers to the view and that he has completed purely *amoris causa*, the painter is like the Christian God, invisible in the visible world that he has created through his love and that he illuminates with his light.

The historical approach might lead us to imagine a Catholic investment in this religion of painting that animates Vermeer, that led him to substitute the emblem of the cerebral aspect of his art exactly where the commission required the symbolic figure of the Savior. This question, however, is no doubt a secondary one today. For Vermeer is neither a "Catholic painter" nor a "great painter" because of his Catholicism. Even if what specifically differentiates him within Dutch painting is tied to the "irreplaceable deviation" that consisted in his converting to Catholicism before becoming a painter, this does not exhaust the meaning of his work.

Leonardo da Vinci, for other reasons, thought that the spirit of the painter transforms itself into "an image of the spirit of God."[48] Vermeer took this ambition of the painter into the private world; he made interiority the mystery he celebrated and, at the same time, he exalted, in a measured way, the luminous color that Leonardo used. Vermeer thus invites the viewer to share the inaccessible privacy of his paintings, at the cost of an enigmatic experience: the presence of a painted picture.

❖ *Appendix 1* ❖

The Mysterious Vermeer
(*L'Opinion*, 30 April, 7 and 14 May 1921)
Jean Louis Vaudoyer

I.

The greatest pleasure of the admirable exhibit of Dutch art now at the Jeu de Paume in the Tuileries is that it brings to Paris three paintings by Jan Vermeer of Delft.

These three paintings are the *View of Delft*, the *Head of a Girl* (both in the museum of The Hague), and the *Milkmaid*, formerly in the Six collection, now in the Rijksmuseum in Amsterdam. Bringing these three canvases together with the Louvre *Lacemaker*, one can now begin to form an idea of this prodigious genius, this king of painters, although in our opinion it would have been better to bring to Paris either *The Love Letter* or the incomparable *Woman in Blue Reading a Letter* from this same Rijksmuseum, as these two reveal more clearly than the *Milkmaid* the quality of inner poetry with which Vermeer bathes his most beautiful works.

Never when we speak of Vermeer of Delft, have we felt so strongly as now the vanity of attempting to translate into words the impression and emotion that the viewing of a work of art brings to us. For Vermeer, the subject and the expression are one and the same. He is the epitome of painters; the power that emanates from his canvases is uniquely determined by the way in which the paints are arranged, treated, worked. In a Rembrandt, in a Watteau, the faculties of the imagination collaborate with the material. The *Night Watch* or the *Embarkation for Cythera* seduce us by an initial lyrical transposition, as the subject of the canvases could have been the subject of a musical or poetical work. Music or verse would lose nothing of their own in representing the equivalent of these warriors walking in the shadows, these figures from fairyland peopling a dream world. But Vermeer invents nothing, makes no comment. In his canvases, the art of composition is employed in the most secret, most dissimulating manner. The basic elements of some of his pictures, for example the Amsterdam *Love Letter* or the Windsor *Music Lesson*, could be caught by a chance snapshot. The true magicians among artists are perhaps, in the end, not those who, relying on all the liberties and privileges granted by imagination, depict on their canvases an arbitrary, suppositional universe rich in all the prestige of illusion and trickery, but those who, without daring to disguise the appearance of reality, manage to give us an impression of grandeur and mystery, nobility and purity, by means of this humble and subdued reality. Such an impression is like that which we feel irresistibly and spontaneously for nature or for the human race: for example, when we unexpectedly catch sight of the reflection of the azure sky in the water, or the calyx of an open flower, or the velvet smoothness of the earth that the spade has just

turned over, or the blue vein that runs across the back of a hand, or the careless glance of a child who passes, running.

Perhaps, in speaking of Vermeer, we are undertaking to speak of feelings that are by their very nature indescribable. But the admiration that this painter inspires so much resembles love, and those who are enamored of Vermeer are all so fervent, so dedicated, that we will doubtless be pardoned somewhat by them. We address ourselves to the others in a spirit of propaganda, with the immodest hope of arousing their envy.

Vermeer's life and the account of his works are no less curious and unusual than the nature of his genius. In the excellent book by Gustaf Vanzype (*Vermeer of Delft*, Van Oest, ed., Brussels), on which we rely in writing these pages, one can find the details of a story that we will only summarize here.

In the middle of the last century, Vermeer of Delft was decidedly not only unrecognized but unknown. This artist whom it is acceptable to prefer to Rembrandt, as a painter if not as a poet, had disappeared from the history of painting. It was a Frenchman, W. Bürger (whose real name was Thoré) who, about 1855, began to rescue Vermeer of Delft from oblivion.

Fromentin published *Maitres d'autrefois* [*Old Masters*] in 1875. He devotes fifteen pages to the dull Peter Potter; he complacently studies Metzu, Cuyp, twenty others, but of Vermeer he says only: "Van der Meer is almost unknown in France, and as he has a way of seeing that is rather odd for his country, a trip might be in order if one were determined to be well informed on this particular aspect of Flemish art."

There were nonetheless signed canvases of Vermeer in Europe, in museums and private collections; but for almost 300 years, this prestigious signature carried no prestige either with curators or collectors, and Vermeer's work was callously attributed to a celebrated name, a name that could contribute to the luster of a gallery. Thus the *Diana and Her Companions* (now at the museum in The Hague) was for a long time a work of Nicolas Maes. Pieter de Hoogh [sic] was for two centuries the author of a young girl reading, and also of the admirable *Art of Painting* of the Czernin Collection. Other works of Vermeer have been attributed to Rembrandt, Terburg [sic], Metsu, and Jacob Vandermeer. This prolonged and general blindness does no honor to scholars or artists. That a person looking at a Vermeer canvas before 1850 should not have divined (not by intellectual effort but by listening to instinct) that one was dealing with a unique work, one absolutely different from the works of the artist to whom it was attributed, is beyond imagination. Vermeer's craft, his harmonies, the feelings that emanate from his canvases, have no possible imitators and, in a manner of speaking, no relatives. One could easily make a fake Rembrandt, a fake Franz Hals, a fake Goya, a fake Delacroix, but it seems impossible to us that one could ever succeed in making a fake Vermeer. Likewise, it seems impossible that, confronting a Vermeer, one could long hesitate to recognize the artist.

Here is everything we know about his earthly existence. He was born in Delft in 1632 (we have his birth certificate); and we know by his marriage certificate, which is also extant, that at age twenty-one, still in Delft, he married Catherina Bolnes. The

books of the Delft painters' guild record his admission as master during this same year, 1653, and his promotion to the honor of director in 1662; finally his return to this function in 1670. It was also in Delft that Vermeer died, 13 December 1675. The "death notice" found by Henry Havard bears in the margin the notation: "leaves eight minor children."

According to M. Vanzype, there is every reason to believe that Vermeer never left Delft. All those who have been to Delft agree that this tranquil little city, where the light is at the same time of earth and of sea, is the intimate inspiration of the painter. In one of the remarkable articles that the highly talented writer who publishes under the name of Foemina did for *Le Figaro* before the war (and which someday an editor should gather in one volume), we read this: "Delft is one of the most unusual cities in all of Holland. One sees there polished blacks, bluish, deep, like mussel shells, or a glossy tar, and bronze and flowing tones that resemble bunches of seaweed. The canals reflect color with extraordinary force: yellows, greens, blues, such as one finds on ancient polychrome faience. White is never white, but blond like bread crust or ivory, and its color is so rich that the humblest things evoke an image of precious materials: amber, gold, coral, and all the green gems."

All his life, Vermeer painted not only in his city but in his neighborhood, in his home.

It is said that he had been Rembrandt's pupil; nothing, however, permits us to establish this, and there is really nothing in common between the two, between this great analyst and this great visionary. Carel Fabritius has also been put forward as Vermeer's master. Some excellent works of Fabritius can be seen in the same exhibit at the Jeu de Paume. They are hardly "Vermeerian," but they are less distant from the works of Vermeer than are Rembrandt's works. Fabritius died dramatically, in Delft in 1654, at the age of thirty-four. He was Vermeer's elder by twelve years, and was received as master of the guild to which Vermeer belonged only a year before he did. Which allows M. Vanzype to write: "The likely hypothesis is that Fabritius was the companion, the friend of Vermeer, that he had a certain ascendancy in his youth, gave him advice, and it is thus that Vermeer was indirectly and slightly touched by the teaching of Rembrandt that had so penetrated Fabritius." But it seems certain that Vermeer had received the rudiments of his art from a certain Leonard Bramer, an artist of second rank, whose brother appears as godfather on Vermeer's birth certificate. This Leonard Bramer, born in Delft, had traveled in France, lived in Rome. He was a friend of Rembrandt, who painted his portrait. "When Vermeer began his apprenticeship in 1667, Bramer, aged fifty-one, had returned to Delft." It would not be at all displeasing to learn that this Bramer was Vermeer's master. It seems entirely unnecessary to go to any lengths to introduce the great shadow of Rembrandt into the formation of the painter of the *View of Delft*. That Vermeer did not have to undergo the despotic influence of Rembrandt seems fortunate for Vermeer, and for us.

It is also known that Vermeer was poor. When he was received at age twenty-one as a master, the register of the Guild of St. Luke tells us that Vermeer did not have the

means to pay the fee: he owed six florins and only paid one florin and ten cents—the rest he was to pay only three years later, in 1656. Finally, it is known that during his lifetime Vermeer was a local celebrity. A certain Dirk van Bleysweck [sic] cites him in 1667 as among the glories of Delft; and, in 1665, a certain Balthazar de Monconys writes in his *Voyages*: "In Delft, I saw the painter Vermeer, who had none of his works; but we saw one at a baker's, who had paid six hundred pounds although there was only one figure."

This local fame hardly survived Vermeer himself. The catalogue of a sale in Amsterdam in 1696, that is to say only twenty-one years after Vermeer's death, has been found. Twenty-one of Vermeer's paintings appear in this catalogue. Among these paintings is *The Milkmaid*, sold then for 175 florins (at the sale of the Six heirs in 1907 this *Milkmaid* was valued at 500,000 florins). As to the painting of the house in Delft, which has just been sold in Amsterdam for more than 3,500,000 francs, it brought 72 florins in the 1696 sale. The same catalogue mentions the marvelous *Head of a Girl*, which is the pearl of the exhibition at the Jeu de Paume. This masterpiece was sold then for 36 florins; but it was to reach a still lower price later, for it was auctioned in a public sale at The Hague for 2 florins and 30 cents. Finally, it is interesting to know that the Louvre *Lacemaker*, after having brought 28 florins at the 1696 sale, brought 84 francs in 1813 at the Muilman sale (Amsterdam); in 1817, at the Papeyrière sale, 501 francs; in 1851, at the Nagel sale, 365 florins; and that the Louvre bought it from a Rotterdam collector in 1870 for 1,270 francs!

We hope that these extra-esthetic details will not be thought pointless. They show both the capriciousness and the laziness of taste among buyers. The foolish vanity of paying a high price for canvases signed with great names and leaving aside marvels without certain attribution or without known signature is an eternal foolishness. It is particularly amusing (or, if you wish, distressing) in this instance, now that the reappraisal of later years has made Vermeer of Delft one of the most expensive painters in public sales and that, as M. Vanzype justly says, "when a museum owns a single Vermeer of Delft, often this modest picture becomes its most precious jewel."

Since the work of M. Bürger, the passionate game for scholars has been to establish the corpus of Vermeer's work. The kernel is given by the twenty-one pictures of the 1696 sale. Of these twenty-one paintings, nineteen have been identified with great likelihood of certainty. In addition, seventeen other pictures are reasonably attributed to Vermeer, so that we now know thirty-six pictures of the painter.

We would like to try next to say what these paintings represent and contain; also to try perhaps to define the unusual and profound attraction that they exercise over us.

<center>II.</center>

Without being too arbitrary, one can divide the paintings of Vermeer into four groups. First, pictures with subjects; second, landscapes; third, pictures showing people in interiors; fourth, portraits.

<center>90</center>

The first group consists of only four works, which are rather disparate: *The Procuress* (at Dresden), *Diana and Her Companions* (at the museum of The Hague), *Christ in the House of Martha and Mary* (in an English collection), and the *Allegory of Faith* (of Dr. Bredius). *The Procuress*, a large canvas showing a brothel scene [*cabaret galant*] like those that Dutch artists of the time liked to paint, is signed and dated 1636. Vermeer was then twenty-four, which allows us to say that *The Procuress* was one of his first canvases. We do not know this picture, but M. Vanzype, whom one can certainly not accuse of lack of warmth toward Vermeer, thinks that "everything or almost everything that is known of the painter is superior to this skilled work where," he says, "we see nothing yet of the clear soul, the delicate sensibility, the special vision so exceptionally broad, noble, and pure, that will distinguish Vermeer from the entire epoch."

It is certain that there must be admirable bits in *The Procuress*: the oriental rug that covers the table, the face of the woman under the light headdress that falls to her bodice, where, it seems, one already sees the famous Vermeer yellow. But it is also certain that the acceptance of a subject repeated hundreds and hundreds of times by Vermeer's contemporaries shows a personality that has not yet fully disengaged itself from the surrounding taste. And if we also accept the *Diana and Her Companions* and *Christ in the House of Martha and Mary* as belonging to Vermeer's beginnings, we can say that the variety of these three subjects tells us of the anxiety and hesitation of a burgeoning genius.

This *Diana* resembles nothing that was painted in Vermeer's time. It is a picture of modern feeling, divinatory, incredible. With regard to Vermeer one can of course speak of Correggio, but it is rather of Prudhon, of Corot's figures, of Courbet, of Fantin, of the earliest Degas that he makes us think. No Dutch artist ever reconciled nobility of form and sobriety of emotion as he does here. There are five women, perhaps all based on one model, in a twilight landscape, dressed in vaguely antique clothing. The one who is Diana is seated in profile, almost in the middle of the canvas; her robe is yellow. A woman dressed in dark colors kneels before her and washes her feet, as other servants do for the Bathshebas in the Louvre. Beside Diana another young woman is seated, with her feet in the water; and, behind, one sees a nude figure, seated, shown from the back, and a standing figure dressed in black, both serene and mysterious.

Such a picture, painted in Delft in the middle of the seventeenth century by an artist who had never been in Italy, remains inexplicable and truly miraculous. One can imagine that Vermeer was inspired by the engravings that Leonard Bramer had brought back from Rome and had shown to the person who was probably his student. By imitation, by training, Vermeer came to paint that *Procuress* where his inner genius had so little to express; he felt that it was not this that he ought to be doing, but he did not yet know where to go. The beautiful Italian allegories seduced him, as did the names of the gods. Perhaps he was destined to paint mythological pictures; he tried the experiment. It produced the curious *Diana*, where the presence of the model makes itself felt everywhere and where the poetry springs less from a stylistic decision than from involuntary obedience to a temperament that was igno-

rant of itself. Having painted this *Diana*, Vermeer, still hesitant, still divided, tried a new experiment: religious painting, the *Christ in the House of Martha and Mary*. This painting is in Scotland. It seems admirable. In it Vermeer comes noticeably closer to the real and familiar world in which he would live: Martha offering the bread to our Lord is the queen of all the servants that Vermeer will paint afterwards; and one can well imagine that it was in giving plastic form to this figure that Vermeer discovered what he loved and that he decided to devote himself to representing the least anecdotal and least bustling domestic scenes.

However, allegory and religion were once again to inspire Vermeer. We want to speak of that strange *Allegory of Faith*, discovered by Dr. Bredius at Moscow, which could be seen before the war in the museum of The Hague. This painting is certainly later than the two preceding paintings. Here, Vermeer's style, both faultless and smooth, is that of his most beautiful interior scenes, and one finds in it certain accessories that the painter cherished, for example, the carpet, the chair, and the tile flooring. It would be futile to attempt to describe this picture, complicated and obscure as it is, like the religious riddles of some Flemish primitives. It shows us that Vermeer had altogether forgotten, when he painted this picture, the Italian engravings that pleased him in his youth. This touching woman of the *Allegory of Faith* is for him an unexpected visitor, almost an intruder, who comes with her serpent and her chalice, her globe and her crystal ball to install herself with Vermeer, who does not for a second think of sacrificing for her, in his canvas, his dear tapestry and tiles, his chair, and his oriental rug.

Both landscapes in his oeuvre are views of Delft. The more beautiful is at the Jeu de Paume exhibit. Out of doors, the painter was as faithful as a camera. This fidelity is such that it must be said that a reproduction of this picture seems at first to be nothing more than an example of a very good photograph of a landscape. We will not conceal the fact that, before seeing this painting at The Hague some time ago, we would have preferred a reproduction of any Poussin at all, any Claude Lorrain, and even any Vernet to the reproduction of Vermeer's *View of Delft*. But once you have seen the original, the remembrance that you keep of it transfigures any reproduction; and a feast of colors, light, and space immediately sweeps through your memory. You see again this stretch of rose-gold sand that takes up the foreground of the canvas, where a woman in a blue apron creates around her, by this blue, an incredible harmony; you see again the dark, moored barges; and these brick houses, painted in a material so precious, so massive, so full, that if you isolate a small surface of it, forgetting the subject, you can easily think you have ceramic before your eyes rather than paint. You see again, especially, this immense sky that, with the roofs of the town at the zenith, gives an almost vertiginous impression of infinity. And finally you savor again this odor, this breath of the climate, exhaled by the canvas, that penetrates you like the unexpected perfume of water and the sudden sensation of the air when, after you have spent a long time traveling in a closed compartment, you lower the window and receive from nature the invisible but physical witness of a

change of place. Vermeer's *View of Delft* is perhaps the painting that expresses better than any other in the world the meteorological poetry, if one dares to speak thus, of a landscape. One can hardly say how pretentious the slack and scattered games of the Impressionist painters appear when one has looked at this compact and consistent canvas for a long time.

But in our opinion it is not in these landscapes, no matter how beautiful they are, that Vermeer expresses the depth of his genius. The masterpieces of Vermeer are the interior scenes.

We understand very well the implications of imperfection and inadequacy that attach to this term, "interior scene." The word "scene" suggests action; but with rare exceptions one can say that nothing happens in Vermeer's paintings. And maybe, finally, one of the reasons for their prestige among us lies in the contrast that exists between the immobile, tranquil personages living in interiors as calm and pure as mirrors, and this passion, this tyranny of colors that weighs on them and by which they seem to be dominated, bewitched, enslaved.

Of what do the most important works of Vermeer in this group consist? Here is perhaps the most beautiful of them all, the *Woman in Blue Reading a Letter* of the Rijksmuseum in Amsterdam: a map hangs on a white wall; in front of this map, a woman dressed in blue is seen in profile; her hands, raised to waist height, hold a letter. She is standing near a table, looking at this letter, facing the light, which comes from the left; behind the table are two chairs. And then there is the incomparable Windsor *Music Lesson*: a square room which the light enters (again from the left) through the panes of leaded windows. In the right foreground, there is a table covered with a large oriental rug (the rug of *The Procuress*); then after this table, a chair (the chair of *Woman in Blue*) and a violoncello are only partly visible; finally, at the back of the picture, in front of the virginals against the wall, a standing woman is seen from behind and, near her, a young man watches her gravely, without making a gesture. Above the clavecin, on the wall (white, as in almost all of Vermeer's paintings), is a mirror in which one sees the face of the musician. *Lady Standing at the Virginals* (in the National Gallery, London) shows a lady standing in profile, her hands on the keyboard; she turns her head toward the painter and her back to the light that comes from the left. (*The Lacemaker*, in London, is the only painting of Vermeer where the light is to the right of the painter.) The *Woman with a Pearl Necklace*, in the Berlin museum, is also standing, also in profile, in front of a white wall (which is never really white, that goes without saying) to which Vermeer knows how to give the precious quality of pearl. One could cite further, to note the same elements, the same arrangements, the same accessories: the *Girl Reading a Letter at an Open Window* of Dresden; *The Concert*, in Boston; *The Love Letter* in Amsterdam. This last painting, along with *The Art of Painting* (in Vienna), is the one in which Vermeer no doubt took the boldest liberties. Can one say that this is a carefully arranged picture? The painter has put his easel in a rather dark room, not far from an open door, so that he has in front of him at his right, in this room where he is, the door frame, the back of a chair, and a raised tapestry portiere; at left, the door itself.

Then one sees, on the threshold of a neighboring room, a broom with its handle propped against the other side of the wall, and a pair of slippers lying on the black and white tiled floor. This second room has a rather bright light coming from the left, lighting a woman seated on the axis of the open door. This woman has been playing a mandolin; a servant has just brought her a letter and remains standing near her mistress, who interrupts her music and raises her eyes. At the feet of these two women, a basket full of linens and a lacemaking cushion (which we see again in the Louvre canvas); behind them one sees the white wall with two framed pictures, the embossed leather of a hanging, and the corner of a chimney.

It is needless to continue such descriptions. We hope that they have given an impression of monotony. For it is this very monotony that forms the solid basis, the foundation of these works. Vermeer's privilege was to free from this narrow world, sleepy and provincial, the undivided soul of painting with all its secrets.

III.

We think that Vermeer is the only painter in the world who could have drawn such a universal beauty from such limited subjects. Of course there have been other painters of the intimate, but we would not be so imprudent as to compare the art of such as Chardin with the art of Vermeer; for Chardin, we dare say, would soon lose his equilibrium compared to the inflexible stability that, when you look at a Vermeer, forgetting the subject so as to consider only the style in which it has been treated, makes you think of an antique marble, a wall, a monument.

By what witchcraft did Vermeer, representing the most daily and commonplace sights, manage to give the viewer so mysterious, so grand, so exceptional an emotion? A Michelangelo, a Tintoretto, a Poussin, a Delacroix forces us to move out of real life, and their power over us is born of a lie. The new worlds that these painters create are the work of the spirit. The Sistine Chapel, the Scuola di San Rocco, the Kingdom of Flora, Apollo and the Serpent—these are subjects that have in themselves, regardless of their treatment, a force of suggestion totally lacking in the subjects of Vermeer's paintings. And nevertheless, how quickly are we transported out of the real by these works that seem to be first of all only works of the senses! It is because colors, for Vermeer, are words of both a physical vocabulary and an ideal vocabulary. A yellow and a blue are raised to the dignity of persons; they are, in Vermeer, the real actors in the drama, and the painter's brushes, with the collaboration of light, make them play a role without which these paintings would be nothing more than a "young woman at her toilet," or a "woman reading." Walter Pater wrote: "Color is not only a delicious property of natural things, but it is like a spirit that animates them and makes them speak to the spirit." This definition applies perfectly to the painter of whom we speak. "But," one might ask, "could one not apply it equally well to most painters, from Botticelli (it was about him that Pater made the observation) to Van Gogh, from Van Eyck to Renoir?"

Surely one could. However, with Vermeer alone (or rather, as we would like to have space to show, with Vermeer, with Piero della Francesca, and with the first paintings of Corot), this spiritual quality of colors (and the word "color" to our mind includes the word "light") becomes the only imaginative element by which the painting affects us. No one else has to such an extreme degree been able to compel a material means to produce effects that end by appealing more to the spirit and the heart than to the eye.

It goes without saying that Vermeer obtains this result by treating these fairy-colors with a technique that is to the highest degree knowledgeable, refined, courteous, loving. There is in Vermeer's craft a Chinese patience, an ability to hide the minutiae and processes of work that one finds elsewhere only in the paintings, lacquers, and carved stones of the Far East. Almost all modern painters, in reducing painting to the state of a sketch, have given the principal role to color and light; and that is, when one evades all that these painters evade, an easy success. But Vermeer makes his canvases as much art objects as paintings. If, in viewing *The Lacemaker* (at the Louvre) or *The Milkmaid* (at the Jeu de Paume), one devotes attention to a detail of the picture, one can quickly cease to believe that one is before a frame, and imagine oneself before a window where the most precious, most exceptional jewel is enclosed.

The color and the material of a picture by Vermeer sate the sensual appetite, the gustatory expectation that always draws us when we enter a museum. But this succulence of the matter and the color in Vermeer exceeds, after the first tasting (if one can use the term), the satisfaction of the gourmand, the lover of good food. Even if the Vermeerian color is meticulously worked in a smooth and skillful mixture, lovingly prepared, it remains, despite this fervent application, this shrewd awareness, this minute labor, natural. Having first made us think about things that one can touch, like enamel and jade, lacquer and polished wood, then about things that result from complicated and delicate recipes, like a crème, a coulis, a liqueur, it leads us finally to reflect on the living things of nature: the heart of a flower, the skin of a fruit, the belly of a fish, the agate-like eye of certain animals; and especially, it causes us to ponder the very source of existence, to reflect on blood. Since everything is exceptional and unexpected with this man of genius we concern ourselves with, one notes immediately that although Vermeer makes us reflect on blood, he rarely uses reds. But blood is evoked here not by nuance, but by its essence. It can be, if you please, yellow blood, blue blood, ocher blood, since we are dealing with a magician. This heaviness, this thickness, this sluggishness of the material in the pictures of Vermeer, this dramatic density, this cruel depth of tone (even when the tone is white, gray, pale gold) often gives us an impression such as when we see the shiny surface of a wound, covered as it were with a rich varnish, or, perhaps, a spot made on the kitchen tile by the blood that drips and spreads itself beneath a suspended carcass. It goes without saying that this comparison, which becomes disagreeable and offensive when one explains it in detail with the words that we are obliged to use here (please excuse us), is of an entirely different nature when one feels it without noticing, as in

fact has been the case for a very long time for those who have viewed these attractive paintings.

What is more, this secret correspondence is only one of many special features that make Vermeer the most special of all painters.

Craft is so all-powerful in Vermeer that it acts not like a reproductive faculty, but like a creative faculty. Sometimes, before these paintings where technique and procedure indulge themselves so little, one gives in to the fantastic and absurd idea that Vermeer's craft works like the light of the sun, which draws out of the shadows all that was hidden there, ready to give it to the light in one stroke by a kind of power that certainly contains magic. There is no "effect" in these paintings in the sense that is intended by admirers of the chiaroscuro of Rembrandt, or the *brio* of Velasquez, or the "touch" [*patte*] of Franz Hals or Fragonard. A Fragonard looks like a bouquet through which air flows, which the light disperses, empty and torn. A Vermeer is a cup of honey full to the brim, the insides of an egg, a drop of melted lead. When one has just looked at Vermeer's paintings, everything that the great painters insist on letting us see of their technique, their know-how, their procedures, seems (unjustly, by the way) to be vanity, feebleness, vulgarity, a kind of bluff. Vermeer, with a modesty and decency that must moreover be unconscious, hides all that he knows, all that he does; his ambition is that of a car painter, who puts coat on coat on the panels of the body, then sands, then repaints, then sands again until the least trace of the brush marks is effaced, lost, obliterated. The "linkage" between colors, the "passages" are incredible in Vermeer, all the more so since Vermeer works not by the interpenetration of values but by their juxtaposition.

If we come back now to Vermeer's figures, we note that, except of course for portraits, they seem to be unaware of the painter and the viewer. The *Lady Standing at the Virginals*, in London, is perhaps the only exception to this mysterious law. It may be because of her gaze, directed at us, that this canvas, despite its beauty, does not move us in the same way as do his readers in profile or his musicians, his drinkers who disdain us, turning their backs. In the Boston *Concert*, the Windsor *Music Lesson*, the extraordinary poetry of contemplation that flows from the canvases certainly has to do in large part with the presence of these figures who, with their backs turned, are busy only with their virginals, their song. Vermeer felt this disdain for the public, this need to keep to oneself, so strongly , so jealously, that he managed to preserve it for the future; the only mortal semblance of him that posterity possesses is a seated man who paints the figure of a being dear to him among dear familiar accessories—but this painter turns his back on us. He prevents us from ever knowing his face; and if one goes to dreaming childishly, one tells oneself that he will never read on our faces our fervent admiration.

The painting to which we refer is at the Czernin gallery, in Vienna. It is called *The Art of Painting*. All the art of Vermeer is found in it, all his repertory of furnishings, and if one can say so, all his soul. In the foreground, here is the tapestry with leaves,

then the chair, then the table with fabrics; all the furniture and all the objects here are supernumeraries, "confidants," Ismenes or Arsaces almost alive, familiar but deferential around the principal personages. Then, in front of the cream-colored wall, here is the model with lowered eyes, probably the painter's daughter, a child who is without any doubt the same whose divine head in the blue turban is included, to torment our hearts, in the exhibit at the Jeu de Paume. She is naively costumed as a Muse, having thrown over her robe to that purpose a large piece of fabric. She presses a heavy book against her, and, to look allegorical, holds a trumpet that is hardly more than a slide trombone. Her head is encircled with a heavy, awkward crown, hastily put together with some leaves gathered from the vine that grows outside, on the house. The famous map is hung on the wall behind her; and the light comes toward her, as usual, from the left of the painter. Turning his back to us, Vermeer is there, painting this touching, sweet figure. He lets us know how he dresses himself, but his face remains unknown to us, like his life, like his death. And, faced with this double allegory, one asks oneself whether destiny did not deceive the fierce hope of Vermeer when "modern learning" drew from oblivion, where they were lost for two centuries, the work and the name of Vermeer, to subject them to this already brilliant fame that is today only at its beginning.

About the *Girl in a Red Hat*
National Gallery, Washington, D.C.

The *Girl in a Red Hat* in the National Gallery, Washington (fig. 45), enjoys exceptional esteem and sometimes passes for the highest and most concentrated expression of Vermeer's genius. Even smaller than *The Lacemaker*, this panel of 23 × 18 cm truly has the charm of an extraordinary vivacity, unmatched even in Vermeer's work. If in spite of this I do not take it into consideration in the present study, it is because its authenticity is now the subject of discussion among scholars, a discussion both passionate and troubling. It is well to present the dossier briefly: it has some interest for the critical fortunes of Vermeer.

The first doubts about the authenticity of the panel were formulated by Swillens in 1950. In 1975, Albert Blankert worked out the tightest argument. According to him, there are five reasons against attributing the work to Vermeer.[1]

—Technically, the work is unique among the known work of the painter. Along with the *Girl with a Flute* (also in the National Gallery and now unanimously excluded from the Vermeer catalogue), the *Girl in a Red Hat* is the only "Vermeer" painted on wood. It is also the only Vermeer painting done over an earlier work, a portrait "in the manner of Rembrandt" whose underlying presence was revealed by X-ray.

—The "instantaneous" quality of the image is hardly in keeping with Vermeer's habitual manner.

—The pictorial treatment of the sleeve and the lion heads indeed suggests Vermeer's style but is distinguished from it by the lack of skill in the transitions between light and shade. The absence of care in such passages (contrasting with Vermeer's usual practice) is not in accord with the virtuosity demonstrated in the rendering of light.

—The position of the figure contradicts the arrangement of the typically Vermeerian lion heads. The young woman's pose implies that she is seated on a chair, on the back of which the lion heads would be facing the wrong way. This is never the case with Vermeer. (Moreover, the fact that these lion heads are too close to each other and badly aligned[2] is also not in keeping with the meticulous attention that Vermeer brought to the definition and spatial location of his objects.)

—Finally, the indefinable character that the rendering of the material of the hat gives it (painted straw, velvet, or another material?) contradicts Vermeer's way of reconstructing "with almost palpable precision" the textures of the materials he represents.

For Blankert, these five anomalies[3] indicate that the panel is not by Vermeer; it would be one of the numerous pictures inspired by his art in the eighteenth century

and at the beginning of the nineteenth.[4] In 1977, Arthur Wheelock refuted this thesis and confirmed the attribution to Vermeer for essentially technical reasons: chemical and microscopic analyses have shown that the pigments utilized are typical of the seventeenth century and, particularly in the light accents, the painterly technique is very close to what we observe in the *Woman Holding a Balance* (fig. 20) and *The Concert* (fig. 4).[5]

This is a strong argument, but is not clearly decisive.

First, as Blankert in turn proposed, the presence of seventeenth-century pigments can be explained by the presence of the underlying portrait "in the manner of Rembrandt."

The comparison of the pictorial technique of the *Girl in a Red Hat* and *Woman Holding a Balance* is less convincing than it seems. In fact, in 1977, at the same time that he was refuting Blankert, Wheelock agreed with him in rejecting *Girl with a Flute*, justifying this rejection on purely stylistic grounds. But in his work, *Perspective, Optics, and Delft Artists Around 1650* (also published in 1977, but written in 1973), Wheelock grouped these two panels together without hesitation and showed an equal severity toward both with respect to the luminous treatment of the clothing. In contrast to *The Lacemaker* (fig. 40; plate XIV), the "globules [of light] are indiscriminately applied to the material, often in a discordant fashion."[6] Even so, he does not reject the two works but, in opposition to Goldscheider, proposes that they date not from about 1667 (like *The Lacemaker*), but from the beginning of the 1660s. The admiration that Wheelock later evinces for the *Girl in a Red Hat* leads him to see in it a work of Vermeer's maturity and to push the date of execution back again toward 1666–1667, without further mention of its stylistic "inadequacies."

The stylistic appraisal of its authenticity is thus a particularly delicate matter and, as Wheelock himself wrote in 1988, the "sensual" pleasure that the panel elicits "makes objective appraisals of its relationship to Vermeer's other paintings difficult."[7]

This being so, one is tempted to recognize in the seductive effectiveness of the panel and the inventive quality of its anomalies within Vermeer's oeuvre the typical markers of a successful fake, a true fake—one that we know is not copying an original but that imitates the technique of the master and repeats his characteristic motifs, combining them in a way that is original enough that the result can be attributed to the master himself. One finds oneself thinking that the forger combined Vermeer's "tricks" with a pose in the manner of Franz Hals.

Two arguments support this hypothesis.

Incontestably, the effect of the painting is different from the effects that are properly Vermeer's own. In 1948, de Vries touched upon this peculiarity in disquieting terms: "*The Young Woman with a Flute* and the *Lady in a Red Hat* are conceived in a mood that goes beyond the habitual reserve of the artist. . . . The extraordinary vivacity of the execution, the strictly plastic point of view of the artist make these little pictures seem to reach beyond the painting of the seventeenth century and strike us as products of the nineteenth century."[8]

The date the panel appeared on the art market may itself be significant. It was on 10 December 1822 that it is cited, for the first time, in the catalogue of the auction of the Lafontaine collection in Paris. This date corresponds to the period when the notoriety of Vermeer had for some time been established among collectors and had even reached art historians—while the price of his work had seen a marked increase, thus making it worthwhile to produce a "true fake" more elaborate than a simple work "in the manner of."[9]

There is no resolving so delicate a problem here. Nothing after all would have prevented Vermeer from trying out variations or inventions that might perhaps appear less unusual if the body of his work had come down to us in more complete form. But there was clearly no question of including this much disputed panel here, despite its charm, as belonging to the certain corpus of Vermeer's paintings.

❖ *Notes* ❖

CHAPTER 1

1. Vaudoyer 1921, 487. Hélène Adhémar, 1966, reprints in part the three articles by Vaudoyer. Their interest justifies their inclusion here, see Appendix 1.

2. Thoré-Bürger 1866, 297. On the importance and value of Thoré-Bürger's work, see Rebeyrol 1952.

3. Misme 1921.

4. Adhémar 1966. Proust's celebrated passage is recalled by Vaudoyer's description of the *View of Delft* (fig. 44; plate XIII): "these brick houses, painted in material so precious, so massive, so full, that if you isolate a small surface of it, forgetting the subject, you can easily think you have ceramic before your eyes rather than paint." Equally, for the "craft" of Vermeer: "There is in Vermeer's craft a Chinese patience, an ability to hide the minutiae and processes of work that one finds elsewhere only in the paintings, lacquers, and carved stones of the Far East." Vaudoyer 1921, 515 and 543.

5. Nothing seems to indicate that Vermeer had a similar effect before his rediscovery by Thoré-Bürger. On the other hand, when modern commentators abandon the neutrality of the catalogue and convey the feelings that Vermeer's painting inspires in them, they sometimes develop the most unexpected digressions. For instance, with regard to the role of female figures in Vermeer, Lawrence Gowing (1952, 61) sees a fear of woman, who is a "source of danger" when she is "too closely examined"; Jean Paris (1973, 73) sees in *The Procuress* (fig. 3) the "profound onanism" of the painter; Edward Snow (1979, 158) identifies "incontestably sexual" connotations in *The Milkmaid*, where Vermeer uncovers in the woman "what he lacks . . . a good image of his own phallic sexuality." In the context of rigorous analysis, such a wild approach has every chance of appearing outrageous.

6. Martin Kemp thinks it possible to show that "Jan Vermeer did respond to these characteristics [those of images obtained through the camera obscura] in his paintings, enhancing them in such a way as to transform them into significant features of his highy individualized art." It is this "reinforcement" that we need to understand, what it involves and how it is elaborated. Noting that the effect painted by Vermeer "does not replicate what can be seen in a camera obscura in a literal sense," Kemp sees in this transformation a "form of painterly shorthand." The interpretation falls a little short. Kemp 1990, 193–94.

7. Vermeer's activity corresponds to the period that stretched from the Treaty of Munster (which established the independence of the United Provinces) to the invasion of these same provinces by Louis XIV between 1672 and 1678, in a city, Delft, that fell progressively into the role of provincial town. According to Price (1974, 155), it may be significant that Vermeer's activity coincided with the end of the Dutch economic expansion. But, even while emphasizing that it is dangerous to

try to deduce from the state of society, the state of mind of an individual, Price reaches an erroneous conclusion about Vermeer's "lack of artistic and social ambition." Painting was not, in fact, for Vermeer, a tool of social ambition, but his paintings are, in fact, proof of an exceptional artistic ambition.

8. Merleau-Ponty 1969, 99.

9. Proust 1988, 3, 693. The fame of *Remembrance of Things Past* confuses the current approach to Vermeer's painting. In citing Proust, it is too easy to forget that Vermeer's painting has a tactical function in the novel.

10. Montias 1989 (1990). On the artistic milieu of Delft in the seventeenth century, see Montias 1982.

11. Montias 1989, xv (1990, 10).

12. Malraux 1951. The same approach makes Malraux want to see the artist's wife and eldest daughter in all the various female faces of his oeuvre. The chronology disproves these personal suppositions.

13. Montias 1989, 135 (1990, 150), notes that until the 1670s Vermeer is rarely found in the notarial documents of Delft, while his father, Reynier, innkeeper and art dealer, was on the contrary, very sociable.

14. Chastel 1978, II, "Le Tableau dans le tableau," 75 (1967).

15. Arasse 1989.

<div align="center">CHAPTER 2</div>

1. See Blankert 1988, 185ff. As an example, the *Woman in Blue Reading a Letter* (fig. 30) went on sale in 1791 under the name Van der Meer and, well before the "discovery" of Vermeer's light in the nineteenth century, the anonymous notice emphasizes that "the pleasing light and shade lend it a fine appearance, as is commonly characteristic of this famous master."

2. Blankert 1988, 194.

3. Ibid., 158.

4. Ibid., 147–48. But van Bleyswijck cites the specialist of church interiors, Hendrick van Vliet, still living at this date (Liedtke 1982, 57).

5. "Thus died this Phoenix when he was thirty years of age/ In the midst and in the best of his powers/ But happily there rose from his fire/Vermeer, who, masterlike, was able to emulate him." This translation is from Blankert 1978, quoted in Montias 1989, doc. 315. For the two versions of this poem and the possible intervention of Vermeer in its redaction, see below, n.31.

6. In May 1696, forty-five pictures, including twenty-one Vermeers, went up for auction in Amsterdam when the Dissius collection was sold. It is all the more astonishing that this important sale escaped Houbraken since it was announced in April by a notice mentioning "excellent artful paintings, among them 21 pieces painted extraordinarily vigourously and delightfully by the late J. Vermeer van Delft, representing several compositions, being the best he ever made." See Blankert 1988,

155, 213. According to Wheelock 1988(B), 44, Houbraken must have been living at Dordrecht, not Amsterdam, at this time.

7. See Montias 1989, 265–267 (1990, 303–5). Given the small number of works completed, the difference is important. It is due to the various ways adopted by Montias for calculating, which take account of works surviving and lost, cited and not cited in the sources.

8. The catalogue of Pieter de Hooch counts 163 "certain" pictures, 15 "uncertain," but 294 works lost or known only in written sources and thus not certainly attributable (and 43 wrongly attributed), see Sutton 1980, 73–144.

9. See Naumann 1981, 25.

10. On all these points, see Montias 1989, 234ff. (1990, 246ff.). It should be emphasized that the baker in question, Hendryck van Buyten, was not exactly a "corner baker"; he had a considerable fortune, according to Montias one of the largest found in the inventories of Delft.

11. Montias 1989, 262 (1990, 270).

12. Montias 1989, 207–8 (1990, 219–20).

13. One would like to know which paintings Van Berckhout saw on 21 June 1669. Of the known works of Vermeer, we can be certain about only one, *The Art of Painting* (fig. 27; plates V–VI), done about 1666–1667, which stayed in Vermeer's home until his death. One would like to be able to say that *Love Letter* (fig. 17) was also there; the work dates from 1667 according to Blankert, 1669–1670 according to Wheelock, and its use of perspective constitutes an "extraordinary" and "curious" effect, so much so that it was imitated by Pieter de Hooch in his *Couple with a Parrot*, now in Cologne (fig. 16). Unfortunately, the exact chronology of Vermeer is too insecure to permit any such certitude.

14. The remark is less unexpected for this painter, in view of the fact that Bischop was a follower of N. Maes and that perspective, demonstrated through the interlocking of articulated interior spaces, was something of a specialty for them—perhaps under the influence of such Delft painters as G. Houckgeest, Emanuel de Witte, K. Fabritius, or Pieter de Hooch himself. One should at the same time be wary with respect to the appreciation of Vermeer as a master of perspective. It is a ready-made formulation of the Delft school and painters who took inspiration from it. It is true, though, that there is no reason to neglect the perspective construction of Vermeer's paintings; rather the contrary, as we will see.

15. Montias 1989, 171 (1990, 184).

16. Haak 1984, 31. On the strength of this artisanal tradition, see Alpers 1990, 198ff.

17. Montias 1989, 223–25 (1990, 235–36). As a result of this request, which the Court granted, Vermeer's wife was declared personally bankrupt and Vermeer's estate was to be administered by a trustee, the scientist Leeuwenhoek.

18. On the economic background of Dutch painting, see Price 1974, 119ff.; Larsen-Davidson 1979, 25ff.; Sutton 1980, xv-xviii. It is true that there was an

alternative, a patron reserving for himself all or part of the production of an artist, especially of a "fine painter," whose work, time-consuming and therefore costly, was reserved for an elite; see Gaskell 1982; Montias 1987, 462; Alpers 1988, 95–96.

19. Thus the *Colf Players* (1658–1660) copies and enlarges the little girl who appears in the painting *The Room*, of which three known versions exist, as well as four known by description, and nine copies, see Sutton 1980, 86–88.

20. "In Delft, I saw the painter Vermeer who had none of his works; but we saw one at a baker's. He had paid 600 pounds, although it was only one figure, which I would have thought too dear at six pistoles." On this text, the exorbitant price of a Vermeer "tronie," see Montias' analysis, Montias 1989, 180 (1990, 191–92). Vermeer's reputation is confirmed as early as 1663 by the identity of his visitor: a mathematician and physicist, Balthasar de Monconys (1611–1665), was acquainted with Gassendi, Pascal, Athanius Kircher, and other members of the European intellectual elite. His *Voyages* went through four editions in French (1665–1666, 1677, 1678, 1695) before being published in German (1697); see Schwarz 1966, 172.

21. On all these points, see Montias 1989, 182ff. (1990, 194ff.).

22. The principal debt of the Vermeer estate was 726 florins owed to the baker, H. Buyten. According to Montias' calculations (Montias 1989, 217–18 [1990, 229–30]), this sum represented between two and three years' supply of bread (depending on whether the bread was white or dark). Montias also shows the role played by Vermeer's mother-in-law, Maria Thins, in the financial balance of the "Vermeer accounts."

23. See Montias 1989, 160–62 (1990, 174–75).

24. Alpers 1988, 66, wrongly makes *The Art of Painting* (fig. 27; plates V–VI) into a commonplace by seeing it as an example of the genre of the self-portrait of the artist in his studio. It is correct to assume an osmosis between the artistic and familial lives of some painters: in the illustration of the *Houdewick* of Jacob Cats, the mother of the family is shown as the spouse of a painter (see Brown 1984, 59). But this is clearly not the case with Vermeer. On the question of the meaning of the way the tapestry is shown in *The Art of Painting*, see chapter 6, n. 13 below.

25. At the beginning of 1673, when his financial situation was already hardly satisfactory, instead of using to his advantage the "Mechelen" inn that he had inherited from his mother, Vermeer rented it to a pharmacist for an annual rent lower than what the previous tenant had paid (Montias 1989, 205 [1990, 217]). In a similar situation, other Dutch painters would have renounced painting and become innkeepers, possibly exercising at the same time their "Ingres violin." In 1668, Hobbema married a maid in the service of the burgomaster of Amsterdam, Lambert Reyn, and was appointed to the post of municipal wine gauger. The rhythm of his pictorial production fell off, even if he did not completely renounce his art (as Alpers says, 1990, 199; 1983, 112), since his most celebrated painting, *The Avenue, Middelharnis*, is signed and dated 1689.

26. Blankert 1988, 79ff., and Montias 1989, 102–7 and 139–153 (1990, 116–22 and 154–67).

27. But this portrait is a "portrait of an unknown person" (probably one of Vermeer's daughters, see Montias 1989, 196–97 [1990, 208–9]). It has no particular social use, and constitutes a "real" variation of the "ideal" head ("tronie") of *Girl with the Pearl Earring* (fig. 42), confirming that Vermeer's preoccupation was specifically with pictorial questions.

28. See below, page 82.

29. On these points, see de Jongh 1971, 156. On the concept of genre painting in Holland, see Brown 1984, 61–63; Sutton 1984; Blankert 1985.

30. If Gérard de Lairesse had little esteem for the portrait, he admired the interior scenes of van Mieris; see Brown 1984, 62–63. The "noble art" could be practiced in a genre inferior to history painting; in that event it was the ambition and the exacting standards of the painter that determined the nobility of his work.

31. Blankert 1988, 155, brings up a detail that supports this idea. The last verse of the poem of Arnold Bon cited by Bleyswijck in 1667 celebrating Vermeer as the Phoenix resuscitated after Fabritius' death (see above, n.5), appears in printed volumes in two different versions: "Vermeer, who masterly trod his path," and "Vermeer, who masterly emulated him." Since Bleyswijck's work had only one edition, the correction can only have been introduced in the middle of the impression. Bleyswijck's editor was none other then Arnold Bon, the author of the poem. The modification must have had a serious motive, and it is likely that the version making Vermeer a possible rival, not just a follower, of Fabritius dates from 1667, the date of publication, when Vermeer had already been a syndic of the Guild of St. Luke and was better known than in 1654, when the poem was probably written. Blankert suggests the hypothesis that it may have been at the request of Vermeer himself that the poem was modified. Such an intervention would further indicate the attention that the painter paid to his reputation (and to the words by which it was furthered) and that the modification is far from neutral. The first version stressed the fact of Vermeer's following the path already traced by Fabritius; the second emphasizes the competition between two successive masters. On the contemporary idea of *aemulatio*, see de Jongh 1969, 56ff., who cites in particular Samuel van Hoogstraten.

32. Leonardo da Vinci 1960, 42.

33. Montias 1989, 202 (1990, 214). It has sometimes been thought that the *Allegory of Faith* was commissioned by the Jesuits of Delft, whose church was practically next door to the house where Vermeer lived. But the fact that it went on sale in Amsterdam in 1699 leads me to think that the commission was a private one, since the Delft Jesuits would have had no reason to sell the picture between 1670 and 1699; see Montias 1989, 257–58 (1990, 266–67). On the Catholic iconography of the allegory, see de Jongh 1975, 70–75. One can add that the substitution of a Christ on the Cross for the Sacrifice of Abraham called for by Cesare Ripa shows a Catholic choice in Holland at that time. The Sacrifice of Abraham was in fact at that time a theme with unmistakable Calvinist associations (Smith 1985, 295). Furthermore, the pose of the figure, with her hand on her heart, is taken directly from Ripa's *Fide cattolica*, where the gesture signifies that true faith lies in the heart, as against

feigned faith, which often shows itself in a "mortified appearance of the body"; Ripa 1970, 150.

34. Montias 1989, 175ff. (1990, 188ff.), especially 1990, 193, where it appears that Vermeer was chosen in 1669 to defend the interests of two lay sisters, Catholics, who lived in Amsterdam and were the sisters of two Jesuit priests.

35. Ibid., especially 129–31 (144–46).

36. Wheelock 1988(B), 48, points out the Catholic quality of the theme of Martha and Mary. Montias 1989, 142, (1990, 156) emphasizes the Catholic meaning of the introduction of the crucifix in the copy that Vermeer made of the *Saint Praxedes* by the Florentine, Ficherelli.

37. I would like to thank Prof. J. M. Montias for sharing this information from a work in progress.

38. Wheelock 1988(2), 118. According to Wheelock, *The Allegory of Faith* would thus be Vermeer's only failure.

39. Ibid.

40. Montias (1990, 267).

41. Ibid., 257–58 (266–67). See Sutton 1984, lv.

42. Montias 1989, 202 (1990, 214).

43. On the hierarchy of genres in Holland in the seventeenth century, see especially Blankert 1980.

CHAPTER 3

1. On the reasons for this uncertainty and the reservations about the *Girl in a Red Hat* (fig. 45), see Appendix 2.

2. Maria Thins owned a number of paintings, among them a "painting where a procuress points to her hand," very likely van Baburen's *Procuress*, and a "painting with a person nursing," probably a Roman Charity telling the story of Pero nursing at the breast her imprisoned father Cimon, no doubt the same painting whose left side appears in *The Music Lesson*. Moreover, the inventory after Vermeer's death indicates that he owned, among other paintings, two Christs on the Cross (one of which was without doubt the copy of Jordaens that appears in *Allegory of Faith*), a Cupid (almost certainly the one that appears in *Girl Interrupted at Her Music*, fig. 13, and *Lady Standing at the Virginals*, fig. 14), and a "painting where are shown a bass viol with a skull" (perhaps the musical still life painted in the background of *A Lady Writing a Letter*, attributed to Cornelius van der Meulen). See Montias 1989, 188, 190 (1990, 200, 202).

3. On the other hand, the landscapes painted on the lids of musical instruments are no doubt Vermeer's inventions, which he varied according to the occasion. As to the landscapes on the walls, they are usually so hazy that one can at best consider them as sketches "in the manner of" a certain painter or school. The appearance of these sketches would make an interpretation of Vermeer's landscape art quite difficult, indeed arbitrary.

4. Noting for example that the frame of van Baburen's *Procuress* changes from *The Concert*, painted about 1665 (where it is represented in ebony wood) to *Lady Seated at the Virginals* (about 1673, where it is in gilded and sculpted wood), Montias 1989, 192 (1990, 204) emphasizes that this transformation corresponds to an evolution in the fashion of framing attested elsewhere in the years 1660–1670.

5. De Jongh 1971, 146ff.

6. Wheelock 1988(B), 41.

7. See Gowing 1952, 123–24 and 126n.83. But Maria Thins could also have owned a copy more faithful to the original than the Amsterdam copy.

8. This is not the only time that Vermeer did this kind of proportional cropping: in *Girl Asleep* (fig. 12), the truncated picture shown in the upper left corner (a Cupid) occupies a rectangle exactly proportional to the format of the work itself. It is not an accident that this Cupid plays an emblematic role equally forceful and indeterminate in the general economy of *Girl Asleep* (see below).

9. See de Jongh 1975, 69ff. and below, pages 84–85.

10. Blankert 1988, 190, mentions three possibilities: J. van Loo, Christiaen van Couwenbergh, and Peter Lely.

11. One can imagine that the same holds true for the very large *Still Life with Musical Instruments* shown in the *Lady Writing a Letter* of the National Gallery, Washington (fig. 11). This citation clearly exceeds the usual dimensions of this kind of picture—those that the painting "with bass viol and a skull" would doubtless have had. This painting belonging to Vermeer was hung with nine others (including a "big painting representing Christ on the Cross") in the "inner kitchen" of the painter's home; see above, n.2.

12. Wheelock 1981, 108.

13. Goldscheider 1958, cited in Bianconi 1968, 13.

14. See Blankert 1978, 44; Wheelock 1981, 106; N. Salomon 1983; Gaskell 1984; Blankert 1988, 183. These references are limited to the most recent and serious interpretations. The first "emblematic" interpretation goes back to 1938 and already proposed the theme of Vanity, see Sutton 1984, 343.

15. These remarks hold true for any iconographic approach that tends to assimilate the interpretation of a painting to its "reading" (by means of a text or texts that it is supposed to "illustrate"), without attending to the way the text is worked out in the painting. The idea is especially important for Vermeer, insofar as the very approach of iconography tends to clarify what he deliberately makes uncertain: it makes explicit what he intended to be elusive and, sometimes, it declares and reintroduces what he excluded or concealed. On this point, see Snow 1979, 122, on the "process of exclusion" of iconographic determinations in *Girl Asleep* (fig. 12). De Jongh 1975, 84, suggests that iconography ought, sometimes, to know how to be an *ars ignorandi*.

16. On the use of the terms *transitive* and *reflexive*, see Recanati 1979, 31ff.

17. See Snow 1979, 35–36, according to whom everything in Vermeer's paintings works as though "reflections upon themselves."

18. On the well-known *musicos* of Amsterdam, meeting places for prostitutes and clients, see Sutton 1984, lxii, and Schama 1987, 467–80. According to Gowing 1952, 48, Vermeer's world translated the theme of venal love to domestic terms.

19. The interpretation of Swillens 1950, 104–5, relies on the only identifiable element of the Cupid, which is an addition by Vermeer—the fallen theatrical mask. Wheelock 1988(B), 74, takes up the idea of the amorous deception: the Cupid with mask is very close to an emblem of the *Amorum emblemata* of O. van Veen entitled "Love requires Sincerity."

20. Kahr 1972, 127, 131.

21. Gowing 1952, 50–51.

22. Blankert 1988, 173.

23. Montias 1989, 150 (1990, 164–65).

24. According to de Jongh, the Finding of Moses is an allusion to the banning of the star cult by Moses (cited by Blankert 1988, 190). For Wheelock 1988(B), the Finding of Moses suggests that the astronomer reaching for the celestial globe is seeking spiritual direction, since the life of Moses prefigures that of Christ and thus indicates the working of Providence in history.

25. It is possible that the presence of this Finding of Moses is associated with the high opinion then accorded to epistolary activity and the missive that allows the communication of secrets at a distance, the content of the message revealing itself without its carrier's knowing—like Moses confided to the Nile and received by the daughter of Pharaoh to become the future leader of the people of Israel. On the popularity of epistolary manuals in Holland in the seventeenth century, see de Jongh 1971, 178–79. On the prestige of the missive, see Alpers 1990, 332–33.

26. We see this again in the way that Vermeer makes use of the frame of the picture represented so as to put his principal figures in the midst of the surface ensemble. The effect is particularly clear in *Lady Standing at the Virginals*.

27. The "narrativization" of the painting is all the more forceful for its having been conceived as a pendant to the *Young Man Writing a Letter* (fig. 32). On these two pendants, see Robinson 1974, 59–61. The principle of pendant pictures is fundamentally narrative or moralizing since the pair tell a story on the condition that what is not shown on one is completed by the other.

28. In an uncertain manner, it is true, if we consider the role of the dog in the *Morning of a Young Lady* by van Mieris, which no doubt illustrates a proverb with saucy overtones.

29. This division is noted by Paris 1973, 83.

30. De Jongh 1971, 183.

31. Gowing 1952, 22.

32. Chastel 1978, II: 75.

33. Ibid., 86.

34. See Wheelock 1988(B), 56. On the importance of the progressive exclusion of the male figure in Vermeer, see below, pages 63–64.

35. The mirror is a classical attribute of Painting. See the representation of the

imitatio sapiens as a woman gazing at herself in a mirror in Bellori, *Vite de pittori, scultori et architetti moderni* (Rome, 1672), 253 (Van Dyck).

36. This arrangement occurs so often in Vermeer that Swillins 1950, 70f., also considers it fundamental to his work; see his projection drawings, ills. 43ff. In *The Music Lesson,* the top of the white pitcher on the table gives a kind of visual signal marking the height of the geometric horizon of the perspective.

37. Only five of Vermeer's works use the side wall and the floor paving together to give the framing effect. In three of them (*The Glass of Wine* fig. 35; *Woman with Two Men,* fig. 36; and the Beit *Letter,* fig. 10), the side wall comes forward toward the viewer beyond the visible part of the floor. Only the *Lady Standing at the Virginals* (fig. 14) has a floor that, like the one in *The Music Lesson,* comes farther front than the wall. But this choice is less clearly marked in the *Lady Standing at the Virginals*; it is the chair and especially the woman and the virginals that are farther front than the represented floor—which is not the case for the table in *The Music Lesson.*

38. Nicholson 1966, 3–4. Blankert 1988, 167n.67 cites other examples.

39. Psalms 30 and 70: "In te Domine speravi/ Non confundar in aeternum." As the text reappears several times in Metsu, one can imagine that it also was found on a real instrument.

40. Alpers 1983, 187 (1990, 310).

41. Gowing 1952, 124 and 126. Montias 1989, 195 (1990, 207), takes up the hypothesis and makes it explicit: "the picture on the wall hints, by focusing only on Cimon in chains, that the gentleman-listener is enthralled by the young woman. He is bound by virtual fetters, a metaphor for Cimon's irons. The analogy may be extended a step further: milk and music, each in its way, assuage the pains of captivity."

42. Valerius Maximus 1935, 445 (V, 4): "Cimon (Mycon) her father had likewise been imprisoned. She (Pero) fed this very old man by giving him her breast like an infant. The eye is arrested with astonishment at the sight of such an action represented in painting; the emotion that one feels in the presence of the scene before one's eyes brings alive a scene of the distant past, and in the silent forms one believes one sees living, breathing human beings."

43. Gowing 1952, 126n.84. According to Pliny the Elder 1985, 61, 173–74, the painter Cimon of Cleones "invented *catagrapha,* that is, three-quarter views and the way of varying the arrangement of faces, looking behind, above, or below."

44. On the theoretical function of the gaze inscribed in the painting, rotated at ninety degrees and lateralized, see Marin 1977, 76–80: "The typical process, especially those processes by which the iconic narrative representation is formed, is precisely to deny the existential character of depth, to lateralize it, reflect it, or represent it as width."

45. Aristotle compares the disinterested joy of the benefactor and the artist (*Ethics* IX, 1167–1168a); Seneca (*De Beneficiis* II, 32) enlarges on the idea by suggesting that the work of art, like the benefaction, brings a threefold reward to its author: the awareness of having made it (*fructus conscientiae*), fame (*famae*), and

financial benefit (*utilitatis*). At the end of the fourteenth century, Cennino Cennini, 1975, 31, thinks that the artists who most merit attention are those who are inspired by the love of art (*l'amore dell' arte*). In 1624, in his *Elements of Architecture*, Sir H. Wotton expounded the Italian conception of the three degrees of perfection in a work of painting; the highest is reached by works done *con amore*, which Wotton explains does not mean an affection for the person who commissioned the work, but for the work itself, by reason of a special attachment to it or to its theme. Cited in Juren 1974, 30.

46. See *National Gallery Illustrated General Catalogue* (London, 1973), 327 no. 3832. See also Haak 1984, 35. Clotilde Misme 1925, 160, pointed out that the three mainsprings of artistic activity make up the fourth, fifth, and sixth chapters of the last book of the *Indeyling tot de Hooge Schoole* of Samuel van Hoogstraten, published in Amsterdam in 1678. Hoogstraten was a contemporary of Vermeer and Vermeer owned two portraits (tronien) by him; Montias 1989, 172 and 221 (1990, 185 and 233). Gowing had earlier (from a quite different point of view) associated the perspective box of Hoogstraten with *The Music Lesson*; 1952, 115n.77.

47. Here a comparison imposes itself between *The Music Lesson* and *The Studio* of van Mieris (formerly in Dresden, destroyed during the war). In the latter, a young woman regards the seated painter while her portrait is begun on a canvas that, as Smith 1987, 420, points out, "could at first glance almost be taken for a mirror." Even with clear differences in representation, *The Music Lesson* repeats and transforms the exchange of gazes between the model and the painter, as well as the kind of amorous relationship that ties them together. As Smith indicates, an atmosphere of seduction and illicit love is suggested in the van Mieris, according to the iconographic conventions of the period, by the gestures of the personages, the little statue of Cupid, and the carafe of wine brought by the servant. In Vermeer, the relationship is no longer anecdotal but theoretical, having to do with the gaze of the artist at his own work. For another example where the aesthetic gaze and physical desire are combined in the painter's studio, see Steinberg 1990, 113ff.

48. For Snow (1979, 59), *The Music Lesson* and *The Art of Painting* are the two most "self-reflexive" of Vermeer's paintings, and the inscription on the virginals in *The Music Lesson* suggests "an allegory of the pleasure and melancholy, not merely of love . . . but of art itself."

CHAPTER 4

1. For a point about these interpretations, see Bianconi 1968, 93–94, and Asemissen 1989, esp. 17 and 54ff.

2. This is one of the common problems of iconography as it is traditionally understood. Once it has identified the conceptual, textual, or theoretical material used by the painter, it generally disregards the way it is handled in the painting, the "way it works in the work." It is, however, this that gives the specificity and individuality of articulation that a painter, in a particular painting, gives to themes that he shares with his contemporaries.

3. In the chronological order of Vermeer's works, *The Procuress* (signed and dated 1656) is reasonably considered a pivotal work. Although its current title makes it the first of his "genre scenes," it can also be considered as a representation of the biblical theme of the Prodigal Son. See Montias 1989, 146 (1990, 160–61); Wheelock 1982, 54. The large dimensions of the *View of Delft* (98.5 × 118.5 cm) correspond to those of the genre of the topographical view and mark the ambition of Vermeer.

4. Vermeer was a syndic or headman for the first time in 1662, then again in 1672.

5. Montias 1989, 219, 229–30 (1990, 231 and 241–42).

6. See Bianconi 1968, 94.

7. On Courbet's *Studio*, see, e.g., Toussaint 1977, 241–77.

8. On this "hierarchy of genres" in Holland in the seventeenth century, see Haak 1984, 60–70; Brown 1984, 61; and Blankert 1985, 9ff.

9. Asemissen 1989, 17–19. The list of crafts is given by Montias 1982, 75: "All those earning their living here by painting, be it with the fine brushes or otherwise in oil or water colors, glassmakers, glass sellers, faiencers, tapestry-makers, embroiderers, engravers, sculptors working in wood or stone, scabbard makers, art printers, book sellers, sellers of prints or paintings." According to Asemissen, if glassmakers and faiencers are not on the "program" of *The Art of Painting*, it is because these two crafts were not subordinated to painting in the Delft guild, but "about on the same level."

10. Asemissen 1989, 21.

11. Ibid., 49 and 54.

12. See below, page 43. Asemissen's argument, ibid., 22, according to which the painters of Delft did not need to form a separate group as their colleagues in other cities were tending to do, is hardly convincing. The magnitude of the conflict is well illustrated by the decoration that Willem Doudyns made in 1682 for the ceiling of the De Pictura brotherhood in The Hague. At its center he showed the "titular genius of the city of The Hague, under whose protection come painting, sculpture, painting on glass, and engraving. At the side one notices Pallas accompanied by the Love of Art chasing out of the Heaven of Art the building painters with their ladder and their pot of paint, the binders with their vise and their press, and the chairmakers with their equipment." Houbraken, cited by de Jongh 1971, 191n.84.

13. It is significant that this inner border is emphasized in the portion that falls between the painter and his model, with its color strengthened in that part without apparent reason.

14. See Welu 1975, 538.

15. See Van Gelder 1958, 14; Tolnay 1953, 269; Welu 1975, 540–41.

16. Asemissen 1989, 51 and 34–36.

17. Welu 1975, 540n.61. The map of the Seventeen Provinces that appears in the background of the *Woman with a Wine Jug* (Allart-Hondius edition) continued to be published and sold as late as 1671.

18. Ibid., 541n.62.

19. Asemissen 1989, 30: "The fold brings out the fact that the painter is associated with the right side of the map, where Holland is found—Delft being placed above his head and the Zuiderzee with its characteristic contours being located exactly above the easel. That such a provincial dimension could have a patriotic motive in one sense or another and could express for example an identification with the historical role and importance of the province is what the first picture (*Officer and Laughing Girl*) proves, thanks to the relationship that is established between the soldier and the map of Holland." The proof is nonetheless shaky.

20. On this tradition, see, e.g., Huvenne 1984, 25, and the references given by Alpers 1990, 224n.1.

21. Marin 1980, 52.

22. See Alpers 1990, 215ff., especially 232–33, which discuss the "aura of knowledge" that then surrounded the cartographic object.

23. Ibid., 233ff.

24. Alpers 1983, 122 (1990, 211) says that the map of the *Art of Painting* "is a summa of the mapping art of the day." See also Welu 1978, 26.

25. Alpers 1990, 274ff.

26. See Welu 1978, 19–22. This balancing is all the more meaningful in the *Art of Painting* in that it is emphasized by the two divergent directions indicated first by the presumed gaze of the painter at his model and second by the maulstick. The presence of the latter is particularly interesting. It is, as has been stated, incongruous during the initial phase of the work; and, in a surely deliberate detail, Vermeer puts its pommel slightly outside the canvas in progress, exactly on the view of the House of Brabant. Moreover, he gives the pommel a red color whose accent punctuates the color pattern of the map in that precise spot. That this color was deliberately chosen by Vermeer is confirmed by the fact that his own maulstick had an ivory pommel. See Montias 1989, 191 (1990, 203). Reasons having to do with the balancing of colors certainly explain this decision, but if we note that Clio is placed so as to be both in front of the Protestant House of Holland and under Catholic Flanders, while the painter is placed under Holland, his maulstick pointing to the House of Brabant, we can also imagine that the two divergent directions of the gaze thus proposed in the picture constitute an allusion to the division of the former unity of the Netherlands. It is doubtless no accident that the black crosses in the design of the marble pavement repeat and emphasize this double direction, the double focus or vanishing point (not the mathematical one) of the gaze.

27. Welu 1975, 529–40.

28. See ibid., 530: "The scientific objectivity of Vermeer's cartographic portrayal should be considered in relationship to Vermeer's 'realism.'"

29. Ibid., 530–32. Vermeer no doubt owned a copy, since it is present in his work of about 1657 (*Officer and Laughing Girl*) and in 1669–1670 (*Love Letter*).

30. The hypothesis according to which the blue would correspond to the presence of a green whose tonality would have changed (like that of the laurel leaves in Clio's crown or the leaves of the trees in *The Little Street*) is not supported by chemical analysis. The green, in any event, would be the only one that Vermeer

would have used for a map, and it is not found in other versions of the same map. It is more reasonable to see it, as Montias does (1989, 190 [1990, 201]), as a color introduced by a concern for color composition.

31. Gowing 1952, 22. See also Alpers 1983, 120 (1990, 210–11) who insists on the "pictorial presence" of Vermeer's maps and considers the one in the *Art of Painting* a true "piece of painting."

32. This is also what characterizes the only "accident" of the painted map in *Officer and Laughing Girl*: the place where one of the printed sheets on the lower edge is coming unglued is painted as a spot of pictorial material more than as a precise rendering. In speaking of this slight drip of paint as representing "coming unglued," the description gives itself over to exactly that "violence" referred to by Panofsky, 1932. All description, even before it begins, must in some sense invert the meaning of the purely formal elements of representation in order to make them into symbols of something represented. In *Woman Playing a Lute*, in spite of the present poor condition of the pictorial surface, the big map of Europe that takes up the upper right part of the painting marks a progression in the desire to "render" and "depict" the superficial damage to the map, in particular the flaw that runs vertically from the south of Ireland to the north coast of Spain.

33. Welu is too positive when he supposes that the few traces that he sees on this map were "evidently more visible formerly than they are today," 1975, 544n.84. Nothing prevented Vermeer from painting the cartographic drawing more forcefully. The framed nautical map partially visible in the background clearly has a very different function from that of Vermeer's other maps. The fact that it is framed is enough to differentiate it. It is, in the full meaning of the term, a picture-within-the-picture whose analysis could be profitably pursued at the iconographic level: it is properly speaking, an attribute of the geographer.

34. Alpers 1990, 209ff.

35. Gowing 1952, 109. It is not unimportant that the wall of *The Milkmaid* was, at an early stage, decorated with a map, Wheelock 1988(B), 66. Substituting a "description" of the luminous appearance of the wall constitutes a choice even more significant in that, as Gombrich insists (1975, 143), it is impossible to "map appearances." What is at stake in this substitution is indeed the "demonstrated knowledge" that painting transmits.

36. See, e.g., Blankert 1988, 157, and the anecdote reported by Thoré-Bürger 1866, 462: "In Vermeer, light is not at all artificial: it is precise, and normal, as in nature, and such as a scrupulous physicist could desire. . . . Someone entering the rooms of M. Double, where the *Officer and Laughing Girl* was exposed on an easel, went to look behind the picture to see where the marvelous glow at the open window was coming from." On this anecdote, see below, page 79.

37. Gowing 1952, 20ff. He suggests, 23, that in *The Art of Painting* this choice is concentrated in the representation of the hand of the painter at work, which "has an unexpected shapeless appearance that has few equivalents" in European painting. On the meaning to be given to this detail, see below.

38. Ibid., 20 and 19; see also 21: "However firm the contour in these pictures,

line as a vessel of understanding has been abandoned and with it the traditional apparatus of draughtsmanship. In its place, apparently effortlessly, automatically, tone bears the whole weight of formal explanation." A dozen years earlier than *The Art of Painting*, *The Milkmaid* is a decisive work. As Gowing notes, 111, the pointillé does not function as representation, as the "granules of light are scattered irrespective of the textures on which they lie," and this choice indicates that Vermeer is "approaching an abdication of the traditional demands upon painters to know and understand" what their representation is meant to transmit. For a technical and theoretical discussion of this point, see below, page 69ff.

39. These two types of lost unity, political and pictorial, are in fact jointly represented in the painting; they are indissolubly bound, and iconography errs in trying to distinguish too clearly the "levels of meaning."

40. See Gowing 1952, 137, and Wheelock 1985. This technique is especially noticeable in the *Girl with the Pearl Earring* in the Mauritshuis in The Hague (fig. 42). It is obviously significant that this is one of the rare busts (*tronie*) painted by Vermeer and that its placement on the canvas is very close to that of the allegorical bust begun by the painter in *The Art of Painting*. The comparison confirms that Vermeer's technique is not what he assigns to the painter in his allegory. Two objections can be raised to this idea. 1) If Vermeer made preparatory drawings in white chalk (like the painter of *The Art of Painting*), these have escaped modern techniques of examination. Such examination has revealed, however, that Vermeer sketched on the canvas the principal masses of his composition and that sometimes in the process of executing a work he did not hesitate to change important elements of it (Wheelock 1985, 397ff.). This is not the technique of the figured painter. 2) This type of preparatory drawing is very common in the theme of the painter at work; its presence in Vermeer would thus be a commonplace. But it is in classical painting that its presence is common, and nothing would have prevented Vermeer from giving his painter a kind of "preparation" identical to his own. On the contrary, he placed the practice of this painter in the classical context of preparatory drawing done on the canvas itself—which was not his personal practice.

41. It betrays itself in the sense that Panofsky gives to the term (1955), 14, in distinguishing "subject" from "content" to propose that the latter is what the work "betrays" without "parading" it.

42. It is significant that this hand is located on the geometric horizon of the picture and that it thus corresponds to the position that Vermeer assigned for his own line of sight. See below.

43. Félibien 1972, 282–83.

44. Tolnay 1953, 271. For numerous examples of the painter seen from behind in front of his canvas, his face visible, see Bonafoux 1984.

45. Welu 1975, 538.

46. On the self-portrait in *The Procuress*, see Wheelock 1988(B), 25; Montias 1989, 147 (1990, 161).

47. See Hulten 1949, 94.

48. See Arasse 1985, 81–84. I would only add today that the opposition be-tween the cat and dog shown on either side of the painter is to be understood as a function of their iconographic value as associated with Painting. Positioned under the mirror, the cat can evoke the sense of vision; placed under the self-portrait in progress, the dog no doubt evokes fidelity, as in the Hogarth self-portrait in the Tate Gallery in London. Their conflict is traditionally at the basis of the art of the portrait. There are numerous witnesses to the difficulties that painters sometimes experience when their portraits show the subjects as overly faithful, insufficiently idealized reflections (see, e.g., the misadventures of Nicolas Maes, de Jongh 1971, 155). The *Iconology* of Cesare Ripa makes the cat and dog the example-attribute of *Contrasto* (1970, 88). My thanks to Prof. Stoichita for drawing my attention to this passage of Ripa, from which he draws different conclusions from mine.

49. Asemissen 1989, 37–38.

50. Ibid., 37.

51. On the error of relating this difference in precision in the depth of the field to the use of the camera obscura, see below, page 70ff.

52. See above, chapter 1, note 13.

53. On the position of this vanishing point and its typical character in the struc-ture of space in Vermeer, see below, page 34, 59ff.

54. Guillerme 1976, 1080, cited by Lecoq 1987(B), 192. On the painter as the one who sees and makes seen, "celui qui voit et donne à voir," see Georgel 1987, 127, and Lecoq 1987, 188, who points out that "in Italian texts of the sixteenth and seventeenth centuries, the expression 'donner à voir' is often employed as a synonym for 'paint' or 'make.'"

55. This choice of Vermeer is confirmed if we compare the position of his painter and that which Gumpp gives himself in his *Self-Portrait* in the Uffizi (fig. 26). In the latter, the hand is painted at rest, the brush far from the canvas. One can reasonably suppose that the painter is represented looking at himself in a mirror. Thus on this point I would qualify the analysis of Lecoq 1987(B).

CHAPTER 5

1. According to Hulten 1949, the canvas bears at this point the mark of "some-thing that seems to have been a hole." This leads him to conjecture that the network of sight lines was constructed with the help of a needle and thread. As Asemissen suggests, it would be well to make a careful study of the various paintings of Vermeer that show a strict perspective construction. However, for the following pages, what matters is the result of that construction, its visual effect and the relationships that it establishes between the apparently three-dimensional space and the surface of the painting, between the locale and the figure.

2. I have excluded from this count three canvases whose geometry is too allusive to permit a sure reconstruction of the perspective scheme (*Woman in Blue Reading a Letter* in Amsterdam, fig. 30, *Lady Writing a Letter* in Washington, fig. 11, and *The*

Lady with a Maidservant in the Frick Collection, fig. 43). But in all three cases the slant of the tabletop suggests a point of view lower than that of the figure that is represented. Of the twenty-four remaining canvases, *The Procuress* in Dresden has an aleatory perspective (but a clear view from below). Only three pictures indicate a view from above the figures. In *Girl Asleep*, this view from above is quite pronounced; it is much less so in *Girl Reading a Letter at an Open Window*; in *Officer and Laughing Girl*, the geometric horizon is located between the line of vision of the two seated figures. In the twenty other pictures, the horizon is *always* lower than the gaze of the standing figure and, except for five canvases where the horizon corresponds more or less to the gaze of the seated figure—*The Glass of Wine* in Berlin, *Girl Interrupted at Her Music* in the Frick Collection, *Woman Playing a Lute* in the Metropolitan Museum, *Lady Writing a Letter with Her Maid*, Blessington, Beit Collection, and *Love Letter* in Amsterdam—the viewpoint is sometimes even lower than that of the seated figures.

3. Seymour 1964, 328.

4. Wheelock 1977, 297: "The camera obscura is not adequately suited as an aid to genre painting. It is not able to accommodate itself to abrupt variations in distance. Should Vermeer have used the camera obscura as an aid in the *Lady and Gentleman at the Virginals* [*The Music Lesson*], for example, he would have had to refocus the image a number of times to trace an image in the manner Fink has described. If Vermeer did use an optical aid for such paintings, a more appropriate one would be a convex mirror or a double convex lens." Fink 1971, 493–505 pushes the inverse of this hypothesis to an extreme, suggesting that twenty-seven of Vermeer's pictures are faithful transcriptions of images seen in a camera obscura. We will see that this is not so.

5. The chronology followed here is Wheelock's, as it sees a linear continuity in the progressive lowering of the horizon. But this chronology remains hypothetical. It is not necessary to suppose that this evolution was linear. Blankert differs on the chronology of these six paintings but he likewise groups them in the years 1657–1662.

6. These paintings are: *Girl Asleep at a Table, The Glass of Wine* (Berlin), *Woman with Two Men* (Braunschweig), *The Milkmaid, Girl with the Pearl Earring, Woman Holding a Balance, The Music Lesson, Woman Playing a Lute, The Concert, The Astronomer, Love Letter, Lady Writing a Letter with Her Maid* (Beit Collection), *The Guitar Player, Lady Seated at the Virginals*.

7. See chapter 4, note 35.

8. We recognize the same effect in the two exterior views that have come down to us. As Thoré-Bürger noted with regard to *The Little Street*, it is "only a wall, and some openings without any decoration at all. But what color!" (1866, 463). In the *View of Delft*, Vermeer both modifies the appearance of the urban profile in such a way as to stress the continuity of its surface and elongates the reflection of the two towers of the Rotterdam gate so as to make it reach the lower right edge of the picture, while the reflection of the tower of the Schiedam gate and that of the Old

Church join the bank of the Rotterdam canal. X-ray analysis has shown that this work was changed in the course of its execution; the result was to diminish the three-dimensionality of the view and accentuate the frontality of the ensemble, in other words, to reinforce the surface effect of the canvas (Wheelock-Kaldenbach 1982, 9–33). Wheelock 1977, 440, justly observes that "Vermeer did not disguise the fact that the observer was viewing a two-dimensional surface on which there existed a painted representation of a three-dimensional subject. . . . The textures Vermeer creates with his painting technique continually remind the viewer that he is viewing a painting of nature, and not nature itself." In this context it is remarkable to note that in his interior scenes Vermeer diminishes or nullifies the apparent distances between objects by punctiliously making one overlap another on the surface. The continuing circuit of the gaze from object to object is nowhere so evident as in *The Art of Painting*, where the surface continuity is complete from the drapery of the foreground all the way to the map.

9. According to Salmon 1983, 216, the equilibrium of the balance indicates a Catholic inspiration, see above, page 27. One should perhaps be less positive, for the rejection of the doctrine of predestination was not, in Holland, only Catholic. It is this rejection that is at the origin of the condemnation of the Arminians in Dordrecht in 1618 (*Dictionnaire de théologie catholique* I, 2, col. 1969ff.). The owner of the painting (no doubt the person for whom it was originally intended), Pieter van Ruijven, belonged to a family of the Arminian tradition, see above, page 12.

10. This peculiarity of Vermeer has often been noted by scholars. But the luminous blindness of the windows does not necessarily belong with the theme of interior scenes. In Vermeer it is so unusual that some former owners of *Woman with Two Men* had a landscape painted in the place of the window design representing Temperance, see Blankert 1988, 176.

11. With the significant exception of *The Astronomer* and *The Geographer*, two male figures who by their professional activity are turned toward the exterior.

12. Gowing 1952, 48–49, 132–33.

13. Bazin 1952, 21–22.

14. Noticed by Paris 1973, 79.

15. On the importance of letter writing in Holland in the seventeenth century, see de Jongh 1971, 178–79, and Alpers 1990, 319ff.

16. Alpers 1990, 328.

17. Gowing 1952, 34.

18. See Ibid., 100. For an analysis of Dou's painting that is very close to mine, see Brock 1983.

19. I am qualifying the point of view of Blankert 1988, 174. On the amorous tone of the letter in general, see de Jongh 1971, 178–79, and Alpers 1990.

20. In theoretical terms one would say that this curtain is "shown enunciating the *monstration*." See Marin 1983, 5.

21. See Gowing 1952, 145.

22. Didi-Huberman 1986, 113ff., emphasizes the "ruling accident" of the bunch

of red threads. He sees the "streak of vermillion" as the "fulguration of a substance, a color without clearly defined limits." I think it is more interesting to recognize that the blur of this "moment of paint" condenses into a small format the device of the obstacle, recurrent in Vermeer.

23. The precision and the carefully thought out originality of Vermeer's composition is demonstrated *a contrario* by the inability of his imitator to understand it. *The Lacemaker* in Washington, formerly attributed to Vermeer, takes over practically all the elements of Vermeer's painting; but its coherence is destroyed and any kind of analysis is impossible.

24. On reservations about the attribution to Vermeer of the *Girl in a Red Hat* (fig. 45), see Appendix 2.

25. Thus the luminous spot that marks the beginning of the bridge of the nose or the two areas that indicate the alternating shade and light on either side of the left eye do not "depict" the structure of the face in any way. On the contrary, the light nullifies the drawing of the form. In the same way the coil of hair that stands out against the background is not a "cut-out"; rather, it makes something like a spot that is "hair" only by reason of the place that it occupies beside the young woman's head—and the internal structure of the tress is decidedly "unreadable," just like the mass that forms the hair on the right shoulder of the model.

26. Gowing 1952, 20.

27. Alpers 1983, 114 (1990, 201–2) goes so far as to consider that attention to finish and to meticulous artisanal craft "explains why Jan Vermeer, the greatest Dutch artist of the second half of the century, flourished in a city that boasted a tradition of fine craftsmanship as well as the most conservative guild structure." The idea is seductive, but the blurring of contours that one observes in Vermeer shows that one must make careful distinctions.

28. See Seymour 1964, 325. For an extreme example of this point of view, see Fink 1971, 493ff.

29. Wheelock 1977, 293–94, emphasizes that before Vermeer one finds this technique in Kalf and Maes. Attention to the reflection of light on the textures of objects is, moreover, related to an old tendency of northern painting that Gombrich (1976) insists upon. On the prestige of the camera obscura in the seventeenth century, see also Schwarz 1966, and Wheelock 1977(B).

30. Wheelock 1977, 298.

31. Seymour 1964, 325.

32. Wheelock 1977, 292.

33. Ibid., 277.

34. Ibid., 293. Wheelock 1985, 405, points out that Vermeer also used drops of color to suggest the alternation of brick and stone on the Rotterdam Gate. Such a use is clearly arbitrary and does not correspond to what could have been observed in the camera obscura. This makes the attempts at reconstruction collected by Kemp 1990, 193–96, useless.

35. See Wheelock 1977(B), 99.

36. Ibid., 93
37. Ibid., 95.
38. Cited by Seymour 1964, 324.
39. Cited by Wheelock 1977(B), 97.
40. Gowing 1952, 21–23.
41. Panofsky 1939, 9.
42. Gowing 1952, 21–23.
43. This choice is all the clearer since Vermeer earlier had used an exactly inverse procedure: in *The Milkmaid*, the contour (not drawn) of the figure is projected as it were by a luminous line inscribed on the wall in the background, where nothing justifies it, as Goldscheider points out, 1954, 34, seeing there an "irradiation of light." One finds the same "indefinition" within the figure. If the luminous, abrupt spot that marks the bridge of the nose in *The Lacemaker* is anatomically inexplicable, it is impossible in *The Girl with a Pearl Earring* to decide at what points the bridge of the nose is distinguished from the cheek that is in the light. The nose is only "drawn" by its shadow, whose contour is itself indeterminate. In *The Lady with a Maidservant*, it is the whole area of the left wrist that is unrecognizable and in *Head of a Girl*, the uncertain stump that, at the lower edge of the painting, passes for a hand.
44. Chastel 1960, 76–79.
45. Alberti 1950, 82. See Damisch 1972, 44–45.
46. Pliny the Elder 1985, 66: "Ambire enim se ipsa debet extremitas et sic desinere ut promittat alia post se ostendatque etiam quae occultat."
47. Vasari 1983, 5:19. The Italian text says, "quella facilità graziosa e dolce, che apparisce fra'l vedi e no vedi, come fanno la carne e le cose vive" (ed. Milanesi, Florence, 1906, IV:9).

CHAPTER 6

1. Koerner 1986, 10.
2. See especially Olin 1989, 289ff.
3. See e.g., Podro 1987, 83–95, and Olin 1989, 285–87.
4. Koerner 1986, 17.
5. Smith 1988, 48. The phenomenon affects all of northern Europe in the seventeenth century. For Great Britain, see Houghton 1942.
6. See Smith 1988, 45, who stresses the new awareness of the "inadequacies of appearance" as regards "inner realities."
7. As early as 1641, in his preface to the Dutch translation of his uncle Franciscus Junius' *De Pictura veterum*, the lawyer-poet Jan de Brune de Jonghe cites Baldassare Castiglione as the principal authority as regards the prestige of painting. This reference is doubtless justified by the tribute that *The Courtier* pays to painting and in particular to the "easy" gesture of the painter whose hand seems to follow his thought without art or effort. But, in what concerns us, the reference to Castiglione sufficiently attests that a relationship existed in Holland at the beginning of the

1640s between the art of painting and polite manners, between the prestige of the model of refined comportment proposed by *The Courtier* and the new refinement of the art of the painters—as, for example, began in the mid-1630s with the "fine manner" of Gérard Dou and Johannes Torrentius. Fehl 1981, 43n.23.

8. Smith 1990, 165f., emphasizes the role of Carel Fabritius in introducing to Delft in "explicit" form what was "implicit" in the motif of the doorway in Rembrandt.

9. Cited by Montias 1987, 462.

10. Pliny the Elder 1985, 71–72.

11. Typical of this point of view (and in contrast to the widespread idea that Vermeer's strokes cannot be seen) is the light touch that adorns the turban of *The Girl with the Pearl Earring* (fig. 42). What does not show in Vermeer is the thickness of the paint with which this touch is set down, as though the colored material were only light.

12. See above, page 17.

13. The difference of presentation between the two tapestries is particularly suggestive. That of the *Allegory of Faith* faces the viewer, addresses itself to him or her, and, in the rhetoric of the image, is a visual equivalent of the classical *introductio* (see Hessel Miedema, "Johannes Vermeers 'Schilderkunst,'" *Proof* (Sept. 1972): 67–76, cited by de Jongh 1975, 71). The tapestry of *The Art of Painting* plays the same role but is shown folded back on itself, and thus displays both its back (in the upper left corner) and its face. Turning the studio that is represented into a cell normally enclosed within itself, the tapestry turns its back on us, as does the painter. This arrangement suggests that Vermeer is here unveiling the intimacy of creation, which, normally, is not our business, an interior space without communication to the space outside—even that of the domestic world. In this "inner interior," between the facing tapestry and map, the painter exercises the "noble art" to which these two derivatives are appended. I thank Prof. Victor Stoichita for drawing my attention to this point, which he develops in his forthcoming book, *L'Instauration du tableau. Mertapeinture à l'aube des temps.* (Paris: Méridiens-Klincksieck, 1993).

14. Smith 1988, 52.

15. The painting known by the erroneous title, *The Father's Admonition*, was the subject of at least thirty copies and variations. On the use that van Mieris made of it in his *Studio* at the end of the 1650s, see especially Smith 1987, 420–21.

16. On the "logic of the secret," see Zampenyi 1976 and Marin 1984.

17. Thoré-Bürger 1866, 462; see above, chapter 4, note 36.

18. Ibid.

19. Ibid.

20. Kahr 1972, 131. See also, for the *Woman Holding a Balance*, van Straten 1986, 172. Because of the allegorical dimension of the painting, he thinks that the light is mystical, perhaps even divine. Bazin 1952, 23, had earlier spoken in a more general fashion of "aureoles of brightness."

21. Snow 1979, 121–22, rightly stresses that a one-to-one and overly systematic "elucidation" distorts the paintings of Vermeer and can even become "destructive of what in Vermeer does constitute meaning."

22. Meiss 1945. For a precise continuation of this symbolism in the seventeenth century, see Henkel-Schöne 1967, col. 29. The emblem "Tamen haut violata recessit" of Johann Mannich (*Sacra emblemata LXXVI in quibus summa uniuscuiusque Evangelii rotunde adumbratur* [Nuremberg 1625]) is explained by the verses: "Ut vitreos radiis penetrat Sol aureus orbes,/ Quos numquam violant fervida tela tamen:/ Sic Deus ex vera (salvo remanente pudore/ Ante et post partum) virgine natus homo."

23. See, e.g., Sebastian de Covarrubias Ozozco, *Emblemas Morales* (Madrid 1610), I: 1, on God, the sun who hides in his own light ("Col suo lume se medesimo cela"); Julius Wilhelm Zincgreff *Emblematum Ethico-Politicorum Centuria* (Heidelberg 1619), no. 92 ("Monstratur in undis"): "This invisible God only enters into our eyes/ By the reflection of his visible works/ It is only here that can be understood/ His mysteries, hidden from the most ingenious" (Henkel-Schöne 1967, cols. 11–12). For his part, Constantin Huygens, in his collection of epigrams, *Koren-Bloemen*, suggests that "the only virtuous form of picture is the shadow cast in sunlight" (cited by Gaskell 1982, 20), confirming on a grander scale the spiritual and moral value of light for a Calvinist lover of art.

24. Lindberg 1986, 30, 33, 40.

25. Lindberg's analysis (1986, 39), however, invites us to do so, when he speaks of the resemblance between Kepler's thought and that of Marsilio Ficino with regard to light that is "not so much in the illuminated body as it is present to it," or where he mentions that light is defined in terms of surface (ibid., 41–2). Also, we can enrich the reflections on Vermeer's use of the camera obscura by considering the remarks of Jonathan Crary 1990, 38–40, on the "new model of subjectivity" and the "metaphysics of interiority" that the use of the camera obscura implied and developed in the seventeenth century. Crary's analyses support those of David Smith on more than one point about the role assigned to individual subjectivity in relation to the objectivity of the social world.

26. Bazin 1952, 24, brings up the importance in Pieter de Hooch of perspective as a "science of openings" after Vredeman de Vries, but he sees "a trait of the baroque" in "this way of delivering the intimate unit to the light that invades it andd dislocates its intimate concentration."

27. Smith 1985. Constantin Huygens' formula on "virtuous painting" made of "shade projected into the light" (see above, n.23) takes on special meaning in this context.

28. Montias 1989, 202 n.94, moreover emphasizes that in *The Allegory of Faith* Vermeer's image is more restrained than a true Jesuit imagery would have been. He mentions in this regard Vermeer's "quietist temperament."

29. On the place of Catholic painters in Holland and the absence of conflict between their religion and their practice of painting, see Slive 1956; Kirschenbaum 1977; Montias 1978, 94–96.

30. On the concept of a Catholic aesthetic, see Hirn 1912, 8ff. On the contemporary debate over the virtual power of the image in the seventeenth century, see Christin 1991, especially 239–50, "Les Miracles au secours des images."

31. Swillins 1950, 20–21.

32. See Montias 1989, 107 (1990, 122), who recalls in this regard that the parents of Rembrandt also sent their son to a Catholic painter, Pieter Lastman, to finish his apprenticeship. Rembrandt did not convert but Lastman remained an important resource for him all his life, especially with respect to history painting. See Stechow 1969; Broos 1976; and Alpers 1988, 76–77, who takes up the question from a paradoxical angle. There is no recent catalogue on Abraham Bloemaert, and no systematic study of the formative role of his studio, which was active during all of the first half of the seventeenth century. But there is no disagreement about his importance, or the vigor of Catholicism in Utrecht.

33. Christin 1991, 269. The title of the work of Father Richeome published in Lyons in 1611 indicates the nature of this art of looking at painting: *La Peinture spirituelle ou l'art d'admirer, aimer et louer Dieu en toutes ses oeuvres.*

34. Lewalski 1979, 147–56. David Smith 1985, 294, illustrates this difference by contrasting the meditative strategy implied by Velasquez' *Christ After the Flagellation Contemplated by the Human Soul* with Rembrandt's *Saint Paul Meditating* (National Gallery, London). In the first, the human soul participates in the almost hallucinatory living presence of Christ's suffering. In Rembrandt, it is on the Book that the apostle meditates, having even turned away from the text so as to concentrate on the inner thoughts that it has aroused. For an attempt at reading the successive stages of Rembrandt's engravings as phases of meditation, see Caroll 1981; and Caroll 1984 on Rembrandt's conception of the contemplation of works of art as a philosophic activity. On the importance of the use of images in Catholic meditation in the seventeenth century, see Freedberg 1989, 178–88.

35. Cited by Christin 1991.

36. The expression, "revanche liturgique et esthetique," is the title of the last chapter of Christin 1991, 239.

37. Snow 1979, 110–12 and 170.

38. See above, page 18f.

39. De Jongh 1976, 72–74. The translation does not reveal the word play in the Latin text between *capit* (take, contain) and *concipit* (conceive, but also contain within bounds).

40. De Jongh 1976, 75. As de Jongh points out, we do not know whether the Jesuits of Delft owned the *Emblemata sacra* of Father Hesius. We cannot ignore the fact that the illustrations were done from the drawings of Erasmus Quellinus, a painter prestigious enough to have been called the Apelles of Antwerp. His influence on the young Vermeer, particularly on the *Christ in the House of Martha and Mary* (fig. 1), is recognized, as is the fact that Vermeer no doubt met him in Amsterdam between 1650 and 1652 when Quellinus was working there on the New Town Hall. See Larson 1985, 237, and Montias 1989, 105.

41. According to Hesius, the sphere shows that "Minimis exhiberi maximus potest mundus." This formula, although it is said in passing, corresponds well to two aspects of Vermeer's paintings, the "monumental smallness" of his canvases and the double movement described earlier, by which he excluded the representation of the outer world ("maximus mundus") so as to bring it back in symbolic form.

42. De Jongh 1976, 72.

43. Gottlieb 1960 and 1976.

44. This is the fundamental mistake of Berger 1972, who ends up imagining that the glass globe was "improvised" by Vermeer. The title of his study suggests the idea of "conspicuous exclusion" in Vermeer, while Vermeer's exclusion is discreet.

45. The light falls on the upright portion of the chair behind the tapestry in the foreground, whereas in *The Art of Painting* this chair remains in shadow, indicating that it is the window farthest from the picture plane that lets a full light illuminate the model, unlike what happens in the *Allegory of Faith*. Snow 1979, 110, notes the difference in light between the two allegories but deduces from it that the tapestry of *The Art of Painting* hides "a radiant, transfiguring light source" while that of the *Allegory of Faith* conceals only an empty, dead space. The difference in the context within which the two canvases were conceived (lay vs. religious, private vs. commissioned) makes further elaboration of this comparison necessary.

46. On the development in the seventeenth century of a religiosity of darkness (a negation, but an indispensable complement to spiritual light), see Rzepinska 1986, 97f., who stresses the importance of a "theology of darkness" in St. John of the Cross and recalls St. Ignatius closing windows and doors, depriving himself of daybreak so as to reach a better spiritual contemplation.

47. Gowing 1953, 94; Snow 1979, 102.

48. Chastel 1960, 51.

Appendix 2

1. Blankert 1978, summarized in Blankert 1986, 200.

2. Wheelock 1988, 100.

3. One can add the peculiar treatment of the tapestry that serves as background to the panel. Not only is its motif exceptional, difficult to identify, but the tapestry is shown flat, parallel to the plane of the image, with no folds—by contrast with the usual treatment of tapestry in Vermeer but identical to the tapestry that serves as background for the *Girl with a Flute*, which is not by Vermeer.

4. On the numerous copies of Vermeer at the end of the eighteenth and beginning of the nineteenth century, see above, page 10. It should be noted that of the six paintings of the National Gallery in Washington formerly attributed to Vermeer, only two are now incontestably recognized as such (*Woman Holding a Balance* and *Lady Writing a Letter*, fig. 11), two are among those recognized as "in the manner of," and the last two are the *Girl with a Flute* and *Girl in a Red Hat*.

5. Wheelock 1977, 441.

6. "The *Lacemaker* . . . is a more composed, purer composition. The subtle fusion of the yarn into abstract shapes of color suggests a greater awareness of the character of the unfocused image of a camera obscura than that apparent in the robes of girls in the Washington paintings. In these paintings, the globules are indiscriminately applied to the material, often in a discordant fashion." Wheelock 1977(C), 298–99.

7. Wheelock 1988, 100.

8. De Vries 1948, 44, who, however, considers these two panels authentic Vermeers.

9. On the prices reached by the paintings of Vermeer and their prestige among collectors at the end of the eighteenth century, see above, page 10.

Adhémar, H. 1966. "La Vision de Vermeer par Proust, à travers Vaudoyer." *Gazette des Beaux-Arts*, 6th series, 68:291ff.

Alberti, Leo Battista 1950 (1435). *Della Pittura*, ed. L. Mallé. Florence: Sansoni.

Alpers, S. 1983. *The Art of Describing: Dutch Art in the Seventeenth Century*. Chicago: University of Chicago Press.

———— 1990. *L'Art de dépeindre*. Paris: Galimard.

———— 1991 (1988). *L'Entreprise de Rembrandt*. Paris: Galimard.

Arasse, D. 1985. "Les Miroirs de la peinture." In *L'Imitation*.

Aliénation ou source de liberté. Rencontres de l'Ecole du Louvre. Paris: La Documentation française 1985, 63–88.

———— 1989. "Le Lieu Vermeer." *La Part de l'oeil* 5:7–25.

Asemissen, H. U. 1989 (1988). *Vermeer. L'Atelier du peintre ou l'image d'un métier*. Paris: Biro.

Baldwin, R. 1989. "Rembrandt's New Testament Prints: Artistic Genius, Social Anxiety and the Marketed Calvinist Image." In S.K. Perlove, ed., *Impressions of faith*. Dearborn, Mich.: University of Michigan Press, 24–35.

Bazin, G. 1952. "La Notion d'intérieur dans l'art néerlandais." *Gazette des Beaux-Arts*, 6th series, 39:5–26.

Berger, H. 1972. "Conspicuous Exclusion in Vermeer: An Essay in Renaissance Pastoral." *Yale French Studies* 47:243ff.

Bianconi, P. 1968. *Tout l'oeuvre peint de Vermeer*. Paris: Flammarion.

Blankert, A. 1978 (1975). *Vermeer of Delft. Complete Edition of the Paintings*. Oxford: Phaidon.

———— 1980. General introduction. In *Gods, Saints, and Heroes: Dutch Painting in the Age of Rembrandt*." Washington: National Gallery, 15–33.

———— 1985. "What is Dutch Seventeenth-Century Genre Painting?" Holländische Genremalerei im 17. Jahrhundert Symposium, Berlin, 1984. *Jahrbuch Preussicher Kulturbesitz* 4:9–32.

———— 1988. "Vermeer's Work; Vermeer and his Public." In Gilles Aillaud, J. M. Montias, and Albert Blankert, *Vermeer*. New York: Rizzoli.

Brock, M. 1983. "Gérard Dou ou l'infigurabilité du peintre." *Corps écrit* 5:117–26.

Broos, B.P.J. 1976. "Rembrandt and Lastman's *Coriolanus*: The History Piece in 17th-century Theory and Practice." *Simiolus* 8:199–228.

Brown, Christopher 1984. *Images of a Golden Past: Dutch Genre Painting of the 17th Century*. New York: Abbeville.

Carroll, M. D. 1981. "Rembrandt as Meditational Printmaker." *Art Bulletin* 63:585–610.

———— 1984. "Rembrandt's *Aristotle*: Exemplary Beholder." *Artibus et Historiae* 10:35–56.

Cennini, C. 1975. *Il libro dell'arte o Trattato della pittura*. Milan: Longanesi.

Chastel, A., ed. 1960. *Traité de la peinture*, by Leonardo da Vinci. Paris: Club des Libraires de France (Editions Chastel-Klein).

Chastel, A. 1978. *Fables, formes, figures*. Paris: Flammarion.

Christin, Olivier 1991. *Une Révolution symbolique. L'Iconoclasme huguenot et la reconstruction catholique*. Paris: Minuit.

Claudel, Paul 1946. *Introduction à la peinture hollandaise*. Paris: Gallimard.

Crary, J. 1990. *Techniques of the Observer. On Vision and Modernity in the Nineteenth Century*. Cambridge, Mass.: M.I.T. Press.

Damisch, H 1972. *Théorie du nuage. Pour une histoire de la peinture*. Paris: Seuil.

Didi-Huberman, G. 1986. "L'Art de ne pas décrire. Une aporie du detail chez Vermeer." *La Part de l'oeil* 2:113ff.

Elsky, M. 1980. "History, Liturgy and Point of View in Protestant Meditation Poetry. *Studies in Philology* 77:70–83.

Fehl, P. P. 1981. "Franciscus Junius and the Defense of Art." *Artibus et historiae* 3, 2:9–55.

Félibien, A. 1972 (1685–1688). *Entretiens sur les vies et les ouvrages des plus excellents peintres anciens et modernes*. Geneva: Minkoff.

Fink, D. A. 1971. "Vermeer's Use of the Camera Obscura: A Comparative Study." *Art Bulletin* 53:493–505.

Freedberg, David 1989. *The Power of Images. Studies in the History and Theory of Response*. Chicago: Univ. of Chicago Press.

Gaskell, I. 1982. "Gerrit Dou, His Patrons and the Art of Painting." *Oxford Art Journal* 5,1:15–23.

——— 1984. "Vermeer, Judgment and Truth." *Burlington Magazine* 126:557–61.

Gioseffi, D. 1966. "Optical Concepts." In *Encyclopedia of World Art*, 10.

Gelder, J. G. van 1958. *De Schildekunst van Jan Vermeer*. Utrecht: Kunsthistorisch Instituut.

Georgel, Pierre 1987. "Allégories réelles." In *La Peinture dans la peinture*. Paris: Biro.

Goldscheider, L. 1958. *Jan Vermeer: The Paintings*. London: Phaidon.

Gombrich, E. H. 1976. "Mirror and Map: Theories of Pictorial Representation." *Philosophical transactions of the Royal Society of London*. B. biological science 270, no. 903:119–49.

Gottlieb, C. 1975. "The Window in the Eye and Globe." *Art Bulletin* 66:313–32.

Gowing, L. 1952. *Vermeer*. London: Faber and Faber.

——— 1953. "An Artist in His Studio: Reflections on Representation and the Art of Vermeer." *Art News* nov.:85ff.

Gudlaugsson, S. J. 1959–1960. *Gerard Ter Borch*. La Haye: Nijhoff.

Guillerme, J. 1976. "Art figuratif." In *Encyclopaedia universalis* 6: 1080–82.

Haak, Bob 1984. *The Golden Age: Dutch Painters of the Seventeenth Century*. London: Thames and Hudson.

Henkel, Arthur, and A. Schöne 1967. *Emblemata. Handbuch zur sinnbildkunst des XVI und XVII Jahrhunderts*. Stuttgart: J. B. Metzlerschen Verlag.

Hirn, Yrjö 1912. *The Sacred Shrine: A Study of the Poetry and Art of the Catholic Church*. London: MacMillan.

Houghton, W. E. 1942. "The English Virtuoso in the Seventeenth Century." *Journal of the History of Ideas* 3:51–73 and 190–219.

Hulten, D. G. 1949. "Zu Vermeers Atelierbild." *Kunsthistorik Tidskrift* 18 (Oct.):90–98.

Huvenne, Paul 1984. *Pierre Pourbus, peintre brugeois 1524–1584*. Brugge: Crédit Communal et Ville de Bruges.

Jongh, Eddy de 1969. "The Spur of Wit: Rembrandt's Response to Italian Challenge." *Delta* 12,2:44–67.

———— 1971. "Réalisme et réalisme apparent dans la peinture hollandaise au 17e siècle." In *Rembrandt et son temps*. Exh. Cat. Brussels.

———— 1975. "Pearls of Virtue and Pearls of Vice." *Semiolus* 8,2:69–97.

Juren, V. 1974. "Fecit faciebat." *Revue de l'art* 26:27–30.

Kahr, M. M. 1972. "Vermeer's *Girl asleep*: A Moral Emblem." *Metropolitan Museum Journal* 6:115–132.

Kemp, Martin 1990. *The Science of Art: Optical Themes in Western Art from Brunelleschi to Seurat*. New Haven: Yale University Press.

Kirschenbaum, B. D. 1977. *The Religious and Historical Paintings of Jan Steen*. New York: Allanheld and Schram.

Koerner, J. L. 1986. "Rembrandt and the Epiphany of the Face." *Res* 12 (autumn):5–32.

Koningsberger, H. 1967. *The World of Vermeer*. New York: Time Inc.

Koslow, S. 1967. "De Wonderlijke Perspectyfkas: An Aspect of Seventeenth-Century Dutch Painting." *Oud Holland* 82:35–56.

Larsen, E. 1967. "The Duality of Flemish and Dutch Art in the Seventeenth-Century." In *Atken des 21. Internalen Kongresses für Kunstgeschichte*. Berlin, 3:5–65.

————, and J. Davidson 1979. "Calvinist Economy and 17th-Century Dutch Art." *University of Kansas Studies* 51. Lawrence: University of Kansas.

———— 1985. *Seventeenth-Century Flemish Painting*. Freren: Luca Verlag.

Lecoq, A.-M. 1987. "Donner à voir." In *La Peinture dans la peinture*. Paris: Biro.

———— 1987(B). "Gumpp et Velazquez: la double vue du peintre." *La In Peinture dans la peinture*. Paris: Biro.

Lewalski, B. K. 1979. *Protestant Poetics and the Seventeenth-Century Religious Lyric*. Princeton: Princeton University Press.

Liedtke, A. 1976. "The View of Delft by Carel Fabritius." *Burlington Magazine* feb.:62.

Lindberg, D. C. 1986. "The Genesis of Kepler's Theory of Light: Light Metaphysics from Plotinus to Kepler." *Osiris* 2nd series, 2:5–42.

Malraux, A. 1951. *Les Voix du silence*. Paris: Gallimard.

Marin, Louis 1977. *Détruire la peinture*. Paris: Galilée.

———— 1980. "Les Voies de la carte." In *Cartes et figures de la terre*. Paris: Pompidou Center, 47–54.

———— 1983. "The Iconic Text and the Theory of Enunciation: Luca Signorelli at Loreto (c. 1479–1484)." *New Literary History* (Charlottesville, Va.) 14, 3:553–96.

———— 1984. "Logiques de secret." *Le Secret, Traverses* 30–31:60ff.

Meiss, M. 1945. "Light as Form and Symbol in Some Fifteenth-Century Paintings." *Art Bulletin* 27:43–68.

Merleau-Ponty, M. 1969. *La Prose du monde*. Paris: Gallimard.

Misme, C. 1921. "L'Esposition hollandaise des Tuileries." *Gazette des Beaux-Arts* 63:325–37.

———— 1925. "Deux boîtes à perspective hollandaises du XVIIe siècle." *Gazette des Beaux-Arts* 67:156–66.

Montias, J. M. 1978. "Painters in Delft 1613–1680." *Simiolus* 10:84–114.

———— 1982. *Artists and Artisans in Delft*. Princeton: Princeton University Press.

———— 1987. "Cost and Value in Seventeenth-Century Dutch Art." *Art History* 10,4:455–66.

———— 1989. *Vermeer and His Milieu: A Web of Social History*. Princeton: Princeton University Press.

———— 1990. *Vermeer, une biographie. Le peintre et son milieu*. Paris: Biro.

Naumann, Otto 1981. *Frans van Mieris the Elder (1635–1681)*. Doornspijk: Davaco.

Nicholson, Benedict 1966. "Vermeer's Lady at a Virginals." *Gallery Books* 12. London.

Olin, M. 1989. "Forms of Respect: Alois Riegl's Concept of Attentiousness." *Art Bulletin* 71:282–99.

Panofsky, E. 1932. "Zum Problem der Beschreibung und Inhaltsdeuting von Weken des bildrenden Kunst." *Logos* 21:103–19.

———— 1939. *Studies in Iconology; Humanistic Themes in the Art of the Renaissance*. N.Y.: Oxford University Press.

———— 1955 (1940). *Meaning in the Visual Arts*. Garden City, N.Y.: Doubleday.

———— 1991 (1932). *Perspective as Symbolic Form*. Trans. Christopher Wood. New York: Zone.

Paris, Jean 1973. *Miroirs, sommeil, soleil, espaces*. Paris: Galilée.

Pliny 1985. *Histoire naturelle*. Ed. and trans. J. M. Croisille. Paris: Guillaume Budé.

Podro, Michael 1982. *The Critical Historians of Art*. New Haven: Yale University Press.

Price, J. L. 1974. *Culture and Society in the Dutch Republic during the 17th Century*. London: B. T. Batsford Ltd.

Proust, Marcel 1988 (1923). *La Prisonnière*. Vol. 3 of *La Reherche du temps perdu*. Paris: Gallimard.

Rebeyrol, P. 1952. "Art Historians and Art Critics, 1: Théophile Thoré." *Burlington Magazine* 44:196–200.

Recanati, F. 1979. *La Transparence et l'énonciation*. Paris: Sevil.

Ripa, Cesare 1970 (1603). *Iconologia, overo descrittione di diversi imagini cavate dall'antichità, e di propria inventione*. New York: Hildesheim.

Robinson, F. W. 1974. *Gabriel Metsu (1629–1667): Study of His Place in Dutch Genre Painting of the Golden Age*. New York: Abner Schram.

Rosand, D. 1975. "Titian's Light as Form and Symbol." *Art bulletin* 57,1:58–64.

Rzepinska, M. 1986. "Tenebrism in Baroque Painting and Its Ideological Background." *Artibus et historiae* 13:91–112.

Salomon, N. 1983. Vermeer and the Balance of Destiny. In *Essays in Northern European Art Presented to Egbert Haverkamp-Begemann* Doornspijk: Davaco, 216–221.

Schama, S. 1987. *The Embarassment of Riches: An Interpretation of Dutch Culture in the Golden Age*. New York: Knopf.

Schwarz, H. 1966. "Vermeer and the Camera Obscura." *Pantheon* 24:170–82.

Seymour, C. 1964. "Dark Chamber and Light-filled Room: Vermeer and the Camera Obscura." *Art Bulletin* 46,3:323–31.

Slive, S. 1956. "Notes on the Relationship of Protestantism to Seventeenth-Century Dutch Painting." *Art Quarterly* 19:3–15.

Smith, D. R. 1982. "Rembrandt's Early Double Portraits and the Dutch Conversation Piece." *Art Bulletin* 64,2:259–88.

———— 1985. "Towards a Protestant Aesthetics: Rembrandt's 1655 *Sacrifice of Isaac*." *Art History* 8,3:290–302.

———— 1987. "Irony and Civility: Notes on the Convergence of Genre and Portraiture in Seventeenth-Century Dutch Painting." *Art Bulletin* 69,3:407–30.

———— 1988. "I Janus: Privacy and the Gentlemanly Ideal in Rembrandt's Portrait of Jan Six." *Art History* 11,1:42–63.

———— 1990. "Carel Fabritius and Portraiture in Delft." *Art History* 13,2:151–74.

Snow, E. A. 1979. *A Study of Vermeer*. Berkeley: University of California Press.

Stechow, W. 1969. "Some Observations on Rembrandt and Lastman." *Oud Holland* 84:148–62.

Steinberg, L. 1990. "Steen's Female Gaze and Other Ironies." *Artibus et historiae* 22:107–28.

Straten, R. van 1986. "Panofsky and ICONOCLASS." *Artibus et historiae* 13:165–81.

Sutton, P. C. 1984. "Masters of Dutch Genre Painting, and Life and Culture in the Golden Age." In *Masters of Seventeenth-Century Dutch Genre Painting*. Philadelphia: Phildelphia Museum of Art, xiii-lxvi and lxvii-lxxxviii.

Swillens, P.T.A. 1950. *Johannes Vermeer, Painter of Delft 1632–1675*. Utrecht-Brussels: Spectrum.

Thoré-Bürger, W. 1866. "Van der Meer de Delft." *Gazette des Beaux-Arts* 21:297–330, 458–70, 543–75.

Tolnay, C. de 1953. "L'Atelier de Vermeer." *Gazette des Beaux-Arts* 41:265–72.

Toussaint, H. 1977. *Gustave Courbet (1819–1877)*. Paris: Edition de la Réunion des Musées Nationaux.

Valerius Maximus. 1935. *Actions et paroles mémorables*. Ed. and trans. P. Constant. Paris: Garnier.

Vasari, G. 1983. *Les Vies des meilleurs peintres, sculpteurs et architectes*. Ed. A. Chastel. Paris: Berger-Levrault.

Vaudoyer, J.-L. 1921. "Le Mystérieux Vermeer." *L'Opinion* 30 April, 7 May, 14 May.

Vries, A. B. de 1948. *Jan Vermeer de Delft*. Paris: Pierre Tisné.

Welu, J. 1975. "Vermeer: His Cartographic Sources." *Art Bulletin* 57:529–47.

—— 1978. "The Map in Vermeer's *Art of Painting*." *Imago mundi* 30:9–30.

—— 1986. "Vermeer's *Astronomer*: Observations on an Open Book." *Art Bulletin* 68,2:263–67.

Wheelock, A. K. 1977. *Perspective, Optics and Delft Artists around 1650*. New York: Garland.

—— 1977(B). "Constantin Huygens and Early Attitudes towards the Camera Obscura." *History of Photography* 1,2:93ff.

—— 1977(C). Review of Albert Blankert, *Johannes Vermeer van Delft 1632–1675*. *Art bulletin* 59:439–41.

—— 1985. "Pentimenti in Vermeer's Paintings; Changes in Style and Meaning." Holländische Genremalerei im 17. Jahrhundert. Symposium Berlin 1984. *Jahrbuch Preussicher Kulturbesitz* 4:385–412.

—— 1986. "St. Praxedis: New Light on the Early Career of Vermeer." *Artibus et historiae* 7:71–89.

—— 1988. "The Art Historian in the Laboratory: Examination into the History, Preservation and Techniques of 17th Century Dutch Painting." In *The Age of Rembrandt. Studies in Seventeenth-Century Dutch Painting*. Papers in Art History from the Pennsylvania State University 3:220–245.

—— 1988(B) (1981). *Jan Vermeer*. New York: Abrams.

——, and C. J. Kaldenbach 1982. "Vermeer's *View of Delft* and His Vision of Reality." *Artibus et historiae* 7,3:9–35.

Zamplenyi, A. 1976. "La Chaîne du secret." *Du Secret, nouvelle revue de psychanalyse* 14:313ff.

✣ *Index* ✣